)8

)99

)9

)

AERIAL PHOTOGRAPHY

*For we are dwelling in a hollow of the earth
and fancy we are on the surface.*
—PLATO

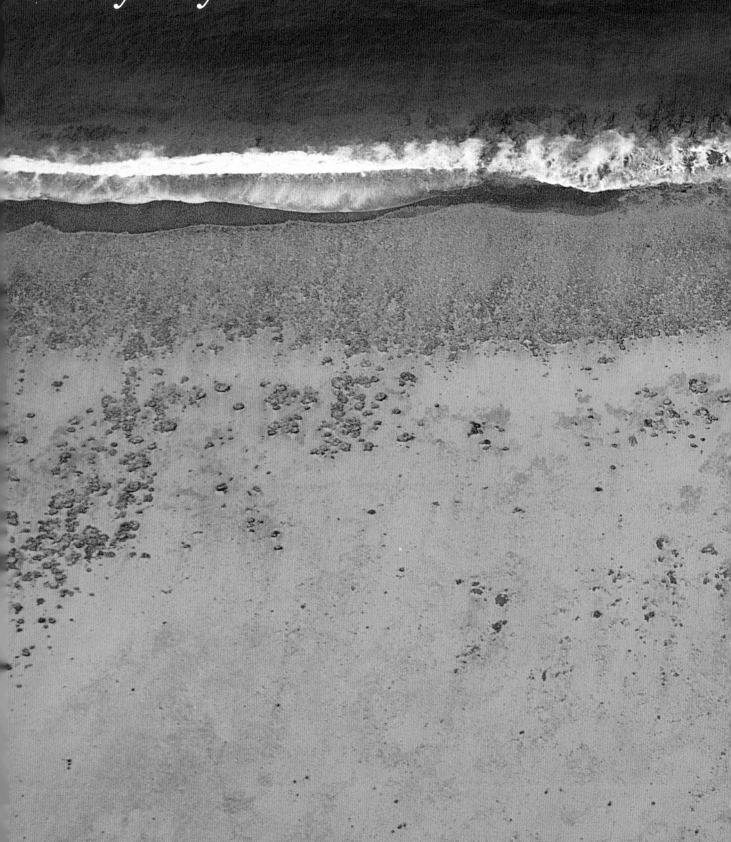

AERIAL PHOTOGRAPHY

Harvey Lloyd

AMPHOTO

An imprint of Watson-Guptill Publications/New York

Harvey Lloyd is an internationally known aerial photography specialist, writer, and director. His many clients include Royal Viking, Cunard, Princess Cruises, Boeing, The Heard Museum, Four Seasons Hotels, and TWA among others. A recent president of the American Society of Magazine Photographers, his home and base is New York City. A multiple award winner for his films, aerial, editorial, and advertising photography, Lloyd also teaches at the International Center for Photography in New York, and at the Maine Photographic Workshops. His work has been published in *Photo Design, American Photographer, Camera Arts,* and *Communication Arts,* and has been exhibited in Europe and the U.S.

Copyright © 1990 by Harvey Lloyd
First published 1990 in New York by AMPHOTO,
an imprint of Watson-Guptill Publications,
a division of Billboard Publications, Inc.
1515 Broadway, New York, NY 10036

Library of Congress Cataloging-in-Publication Data
Lloyd, Harvey.
 Aerial photography : professional techniques and commercial
applications / Harvey Lloyd.
 p. cm.
 ISBN 0-8174-3292-2—ISBN 0-8174-3293-0 (pbk.)
 1. Photography, Aerial. I. Title.
TR810.L6 1989
778.3'5—dc20 89-27962
 CIP

Manufactured in Singapore
1 2 3 4 5 6 7 8 9 / 98 97 96 95 94 93 92 91 90

Edited by Philip Clark
Designed by Jay Anning
Graphic Production by Hector Campbell

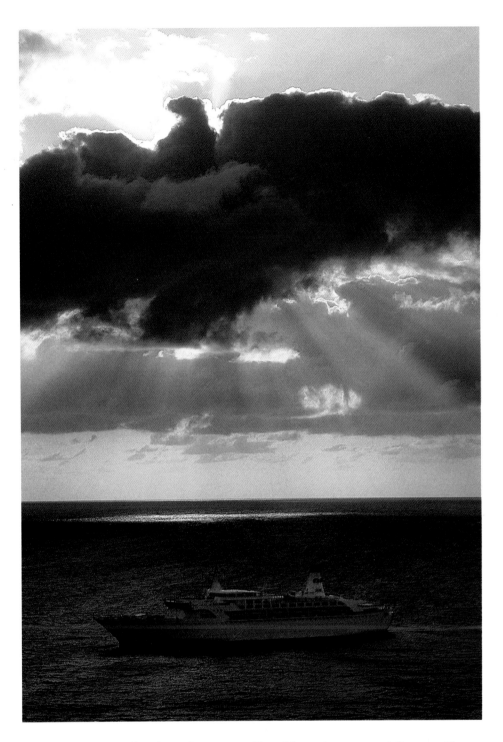

I dedicate this book to the many pilots I have known and flown with,
whose skills, instincts, and judgements make aerial photography the art it is.
And also to those associates, like my friend Steve 'Captain America' Booker,
who have gone down in a rare moment of mechanical or human failure.
I also dedicate this book to all of you who would seek adventure in the air,
to browse in these realms and fly like birds or spirits
in order to more fully know the wonders therein.

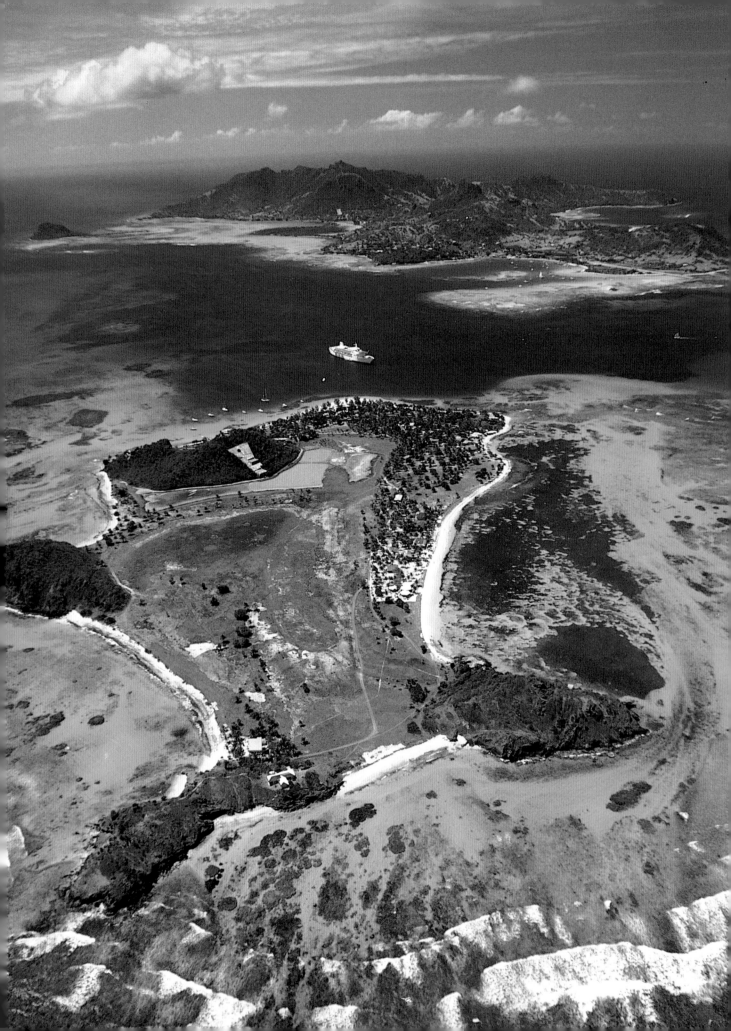

CONTENTS

I want to thank those dear ones and friends who have helped and sustained me over a million miles of journeying throughout this earth—Andrei Lloyd, Shirlee Price, Sally Lloyd, Richard Steedman, Elaine and Marty Adler and family, Jill DeVries, Larry Press, Ted Rubin, Alexey Brodovitch, and so many others around the world whose lives and mine have touched.

INTRODUCTION

The photographers who take to the air will understand my compulsion to write this book and my need to share stories of aerial photography. Although there are books on the subject, exploring a vast scope of regions worldwide, I know of none that also deal with the many technical and practical concerns that the aspiring professional encounters—both in the air and on the ground. The very subject of aerial photography raises many questions: What type of aircraft should you select, fixed-wing or helicopter? Is the pilot qualified to fly your mission? How can you best communicate with your pilot? What equipment should you take aloft? What are the safety rules before, during, and after flight? What are the dangers? How can you evaluate weather conditions? And—the heart of the matter once you are in the air—how can you successfully accomplish your mission?

I will answer these questions and many others based on knowledge gained during 25 years of photographing and 12 years of flying around the world—a period that, as far as I am concerned, is only the beginning of a lifetime's work. Much of my experience has been acquired the hard way. I have flown in a great variety of aircraft, from an ancient, single-engine plane in Malta (the pilot advised me to keep my feet off the central control wires that ran below my seat), to an Alouette helicopter (resembling an Erector Set), to the latest Bell Jet Rangers, Hughes 500s, French A-Star 350s, Cessnas, and Pipers.

But this book must be more than a textbook. As an aerialist, you cannot help becoming an artist as well as a technician because of the inherent beauty and mystery found in the air. The art of aerial photography is both precise and fantastic: precise because you must develop necessary instincts; fantastic because you shed the shackles that hold you to the earth and become a spirit as well as a mere mortal during those splendid hours aloft.

In the course of many assignments in the air, I have encountered strange, heartwarming, and sometimes dangerous adventures. Aerial photography is a difficult art. There is no room in it for errors and no tolerance for inexperience—whether at the controls of the aircraft or behind the camera. Your sense of reflex is integral. You must learn to think on your feet quickly, to make rapid judgments and decisions. You must deal calmly with any potential hazards.

Aerial photographers must learn to trust their instincts, too. These become second nature only after many flights. You must also trust your visions. As professional photographers, as dedicated aerialists, you will seek out the right time of day, the right angle of the sun, and the colors and forms of unique subjects—not only to record the scene but also to make your viewers' dreams come alive.

Climbing into the heavens to capture the earth's beauty and the seas spread out below has only been possible thanks to the technical imagination and talent of some amazing people. Their skills are fundamental to your art. Flying with a gifted pilot is like being hoisted on a mobile crane with a built-in zoom lens. A good pilot can put you in the right position, known as vectoring, and can regain that precise position when the wind veers you away from the target. Such precision

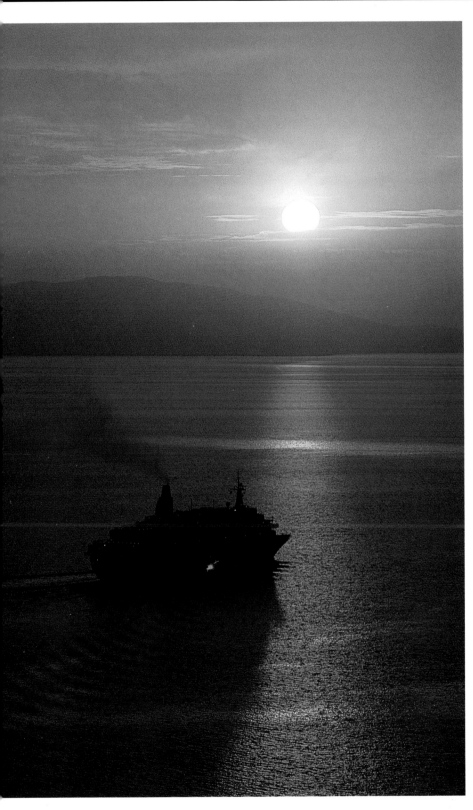

In this image, taken near the waters off the coast of Crete, a golden sunset casts its strong light and color on the surrounding landscape.

requires difficult aerial maneuvers and real teamwork—a true partnership of skill and communication—between you and the pilot.

The craft of aerial photography also demands that your camera equipment be top-of-the-line and constantly maintained for high performance. Yet your equipment alone cannot make you an aerial photographer. You must learn to anticipate and react to the inevitable and unexpected occurrences on any aerial flight. Once while photographing a flaming sunset over the open sea near Crete, I turned to see the pilot and his military chaperone bent over the instrument panel. The chaperone held a lit cigarette lighter to the gauges, and the two men jabbered excitedly in Greek. I asked no questions. I knew, but I did not want to know. I just stared out the open door of the aircraft. The full moon over the Aegean Sea was beautiful. We had been in the air a long time, and we were 10 miles from land. After we landed, I asked our pilot what the problem had been. He answered gruffly that he had taken off with less fuel than normal so the plane would be more maneuverable. I vowed from that day on to tell every pilot I flew on assignment with to *fill* the tank.

As I roam the world looking for helicopters and light planes to shoot from, I do not take chances. A world-famous guide once said that his rule for survival was, "Pay attention!" The survival-minded aerial photographer would also add, "Bracket!" I photograph everything an assignment calls for, and a great deal more. I get paid to make images, but that isn't primarily why I do it. In fact, aerial work pays less than other kinds of photography, but its challenges and joys are reward enough for me.

Much of my life in this work is spent traveling. It is my love and vocation. I spend at least half of each year on the road on these adventures, taking 14- and 18-hour days in stride, solving problems, loving the life. At distant locations around the world, the difficult is always present. Learning how to solve problems under unusual circumstances is a necessary part of being a successful photographer.

In San Juan, Puerto Rico, this dawn exposure revealed the first light in the sky as the city lights came on.

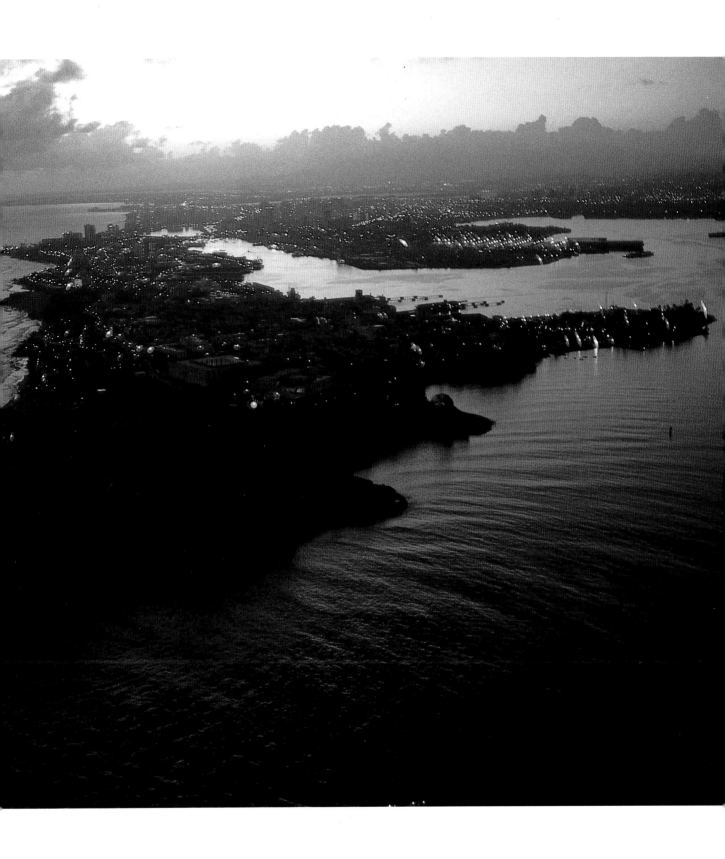

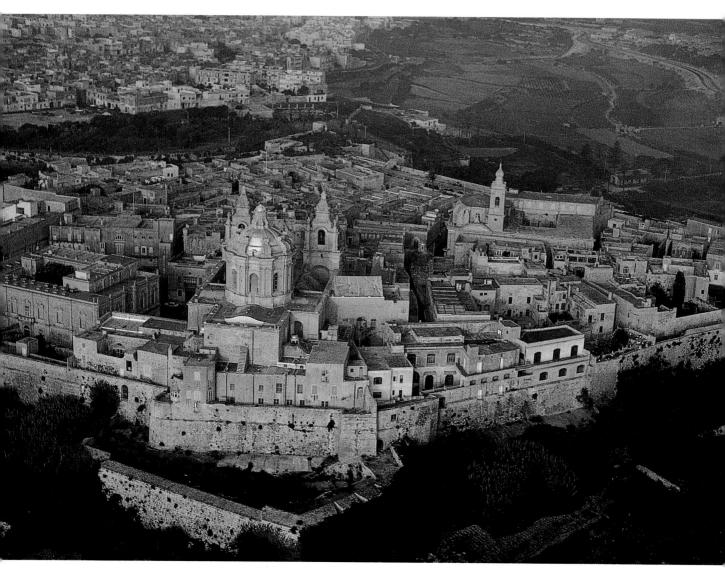

The skyline of Malta, above, is slowly defined by late afternoon light and shadows in this example of low-light exposure.

The town of Villefranche in the French Riviera, shown on the right, is composed in a dynamic framing that balances the contrast of dark and light in this scene.

First and foremost, you must learn to communicate and deal with people. As in no other art, your life and your success as an aerial photographer depends on the people with whom you work—and must trust. Many rewards come from making new friends and sharing both the dangers and triumphs with them. Once you learn to share, communicate, and get along with men and women of cultures different from your own, you'll receive unexpected gifts of friendship and discover that your work is better than ever.

Although much of the world has already been photographed and seen from the air and from space, much still remains undiscovered. Even what has already been photographed never looks the same twice. There is always a new way to see something. In this book, I offer you my understanding of the aesthetics of aerial photography, and I hope it will aid in your unique discovery of it. In addition to instructing you in the operations of aircraft and equipment, I also describe enough of the choreography of aerial work and the equation of light, color, and composition to help lift your photographs above the ordinary. The goal is to make images that will truly record and preserve the wonders and beauty you encounter above the earth.

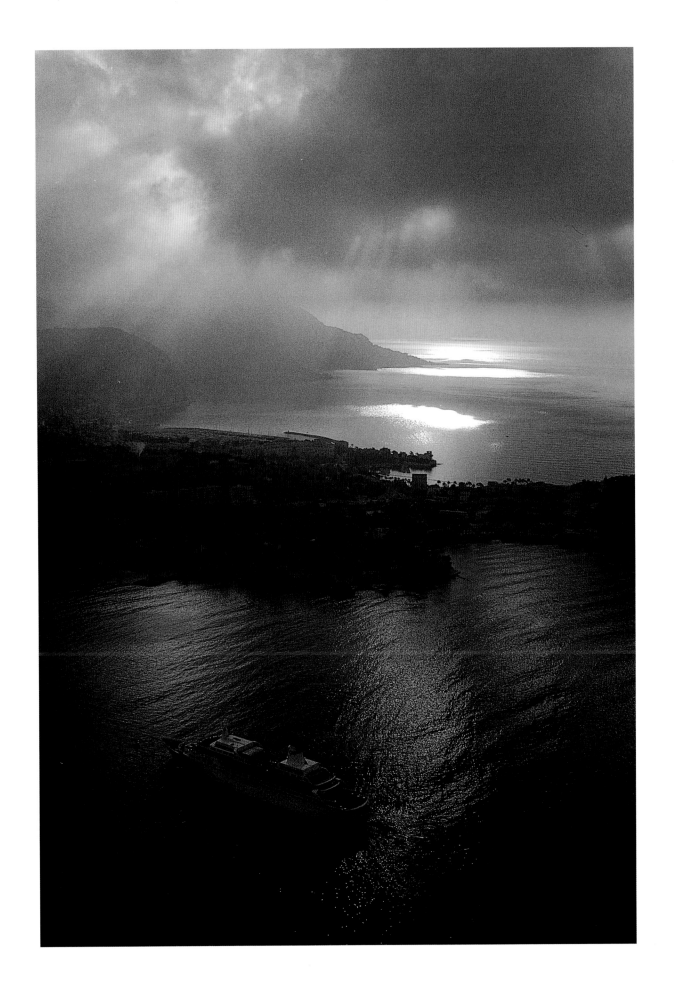

STARTING OUT

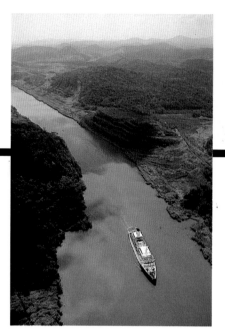

It's the small details that are big concerns

At decisive moments I've asked myself how I got into this work. Hovering at a few hundred feet above some scene—over glaciers and canyons, or wheeling among the ruins of some ancient civilization—cold and hungry, buffeted by high-force winds, loud rotors, and unpredictable weather changes, I often turn to my companion in the aircraft and shout, "What are we doing here!" But in the excitement of a shoot, my eye glued to a Nikon F3 viewfinder just when a perfect symmetry of color and light combine in a spectacular image, I soon realize the incredible joy I experience in my work. *That* is why I do it. That is how I started doing it.

Aerial photography is always a journey. Certain assignments will take you to far places—new faces, new customs, new challenges. As in any journey, you must prepare for it—going over the big and small details that must be checked and followed up on before you leave solid ground. There are hotels to book, aircraft to hire, people to enlist to help you in your mission. Communication is important. Organization is mandatory. Once you are at your location you want as much time as possible to do what you do best: take pictures. If you are caught up with the paperwork and red tape of organizational details then, you'll lose valuable shooting time—which a client is paying for. Before you start on your journey, plan everything. Give yourself an amount of "prep" time in which you can get all the necessary details of the assignment down on paper. Make a checklist of everything you must do, and review it carefully.

Before you leave, confer with your client and go over important details of the trip. Call ahead to hotels to confirm reservations and arrival times. Check the airport for your flight information. Talk to everyone you can who will be working with you and confirm all dates, times, and places of your assignment. If you are lucky enough to have a great assistant, much of this can be taken care of. But you still should review the important details with your assistant. Don't leave things to chance. No one likes to feel the added pressure of late appointments or unexpected changes in the itinerary.

PACKING: CLOTHING AND GEAR

My travel rule is: light on clothes, heavy on gear. You'll always need less clothing than you think. I usually take one good sports jacket, one dress shirt and tie, and one pair of good trousers (that could be worn to a formal restaurant if the occasion rises). The rest of my clothing for a trip consists of casual work wear: cargo pants with pockets for film and small accessories, *comfortable* walking shoes with high tops to keep sand and dirt out, medium-weight shirts that are wash-and-wear. When I know I'll be traveling in colder climates, I of course make sure to bring warm clothing—not double of everything, just warmer of everything! My shaving kit is large, and I fill it with anything I need, packing plenty

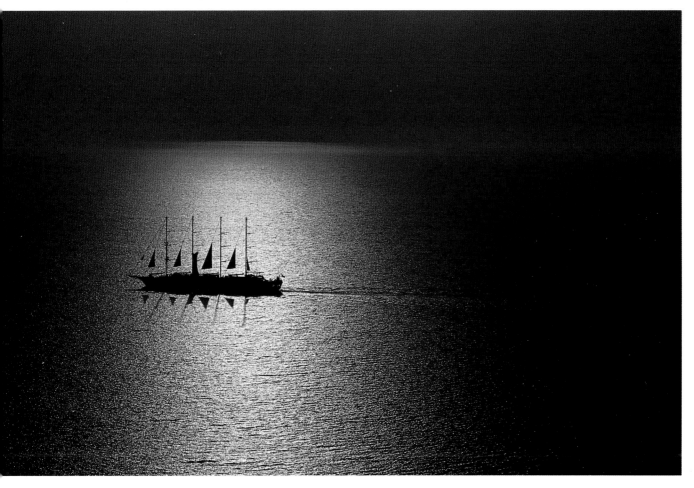

of extra vitamins and medical supplies. As far as luggage goes, I try to get by with two large, hard-sided suitcases for my clothes and gear. I carry my maxi-sized camera bag loaded with cameras and lenses, and I also carry an expandable shoulder bag replete with pockets for airline tickets, passport, address book, wallet and traveler's checks, and other odds and ends. A wheeled luggage cart is occasionally helpful when going to and from the airports or landing strips.

Aerial images require planning and preparation. Weather conditions, choice of aircraft, and scheduling of air time are just a few of the many things you must prepare for before going on an assignment.

AIRPORTS AND AIRLINERS
Although you can be sure of a lot of things, airline schedules are not one of them. Give yourself plenty of time to and from the airport! This includes transportation to it, as well as check-in time when you're there. The worst nightmare is being stuck in traffic 100 yards from the airport and watching the plane leave without you. Sure, there's always another plane, but there may not always be another shoot.

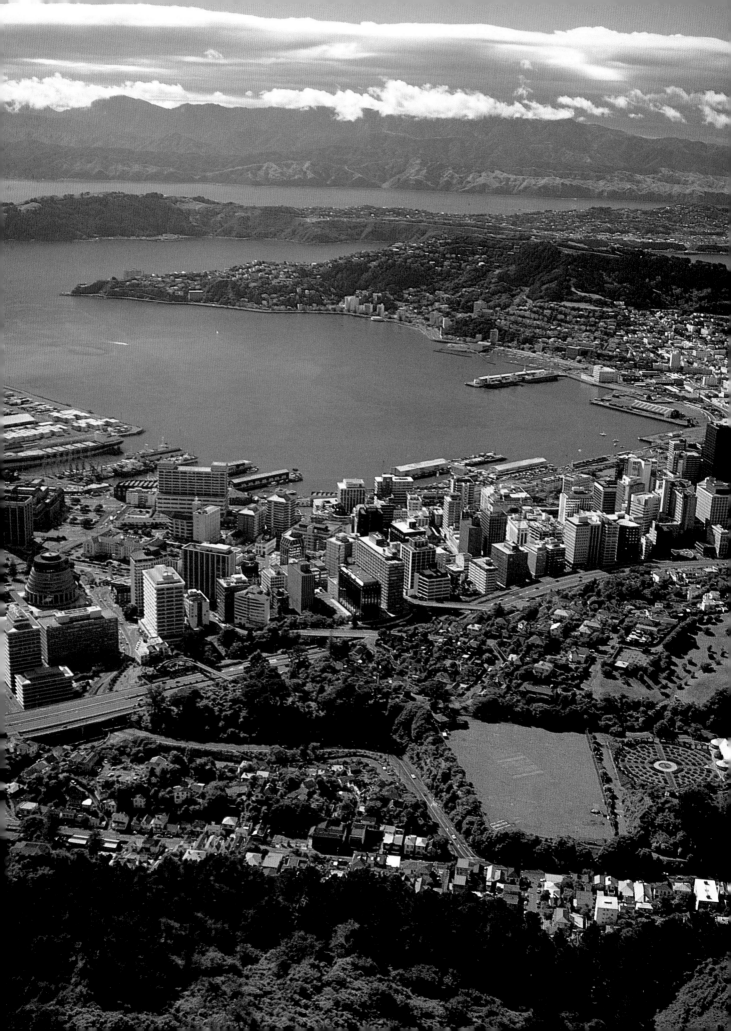

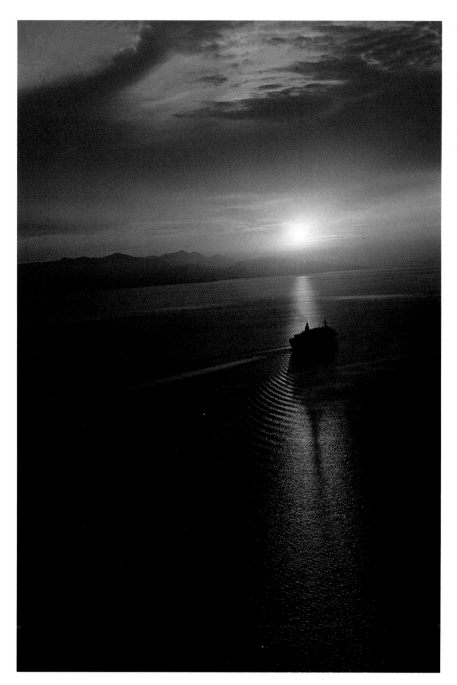

Scouting a prospective location is a useful practice that will help familiarize you with your subject terrain, such as the scene on the opposite page, shot above New Zealand, and help you plan your shots. In the image at left, taken in Crete, the weather was clear enough to capture this dramatic view.

Film and X-ray Machines. I do not suggest packing your exposed film in luggage you plan to check-in at the airport. If the luggage gets lost, so does your film. You can pack some back-up rolls of film if you're carrying quite a bit, but trust your film to your own hands. I do not use lead-protected bags to store my film. The danger of X-ray damage is much too minimal in my opinion. I prefer to use see-through plastic bags of the Ziploc™ variety. This permits security people to see my film clearly and keeps it protected from any moisture. I have my film hand-checked at all possible times. There are a few countries where this is not done. In those cases, I do take my chances. Always be polite and patient going through the airport procedures—if you wait long enough, smile often, and always act courteously—security personnel will be more helpful when you hand them three dozen or thirty dozen rolls of film to hand-inspect.

Never send *exposed* film in the hold of an aircraft. In a crunch I would sooner send the cameras and equipment in the hold. They can be replaced; so can unexposed film. But the film you've exposed after your assignment is irreplaceable.

On the Plane. I always book economy class for my travel needs. In this business it's a matter of the bottom line, and any unnecessary extravagance comes out of my hide. And, if I spend big on plane travel, although I may be more comfortable for the ride, I'll have less money for the other extras I'll need once I've reached my location. Besides, flying coach class is not that uncomfortable if you set your mind to a few pre-flight exercises. Board early! You will want to stow your carry-on luggage and camera equipment before all the spaces are gone. On long flights, if the plane is not filled, watch like a hawk for empty rows; get there first and try to stake out extra seats. You'll need your rest before starting your journey. If you can, try to sleep on the plane, do whatever you have to do to get it. Relax, but not with the help of drugs of any kind. If you're concerned about jet lag, you can do one of two things: worry about it, or ignore it. Ignore it.

Customs. I travel the world trying to avoid calling attention to myself. Customs is one place where you don't want to call attention to anything more than what little you need to just get through. I carry no fancy cases, no silver Halliburtons to advertise what I do and tempt thieves, and I sport no big boxes of equipment to provoke over-curious customs officials to open them. Shoulder bags and nondescript luggage are all I travel with. If possible, try to cable ahead for a car and driver, or arrange with the local representative of the company you'll be working with to meet you at the airport. Local reps can often help you through customs by asking you to send an equipment inventory in advance. It's always a good idea to have someone meet you who can represent you in a foreign country.

Certain countries require that you get visas in advance, and may ask you to specify whether you are traveling on business or as a tourist. Canada is very difficult for photographers to get into on business. India is also very careful about admitting photographers. Most of the time you'll avoid hassles by simply stating that you're traveling as a tourist. Before you leave, make sure you inquire about any difficulties you might have upon entering the country you'll be working in.

A sartorial tip: dress neatly. Dirty clothes, shaggy hair, unkempt beards, or other general sloppiness mark you as suspect, especially at customs. You'd be surprised at what can prompt an inspection.

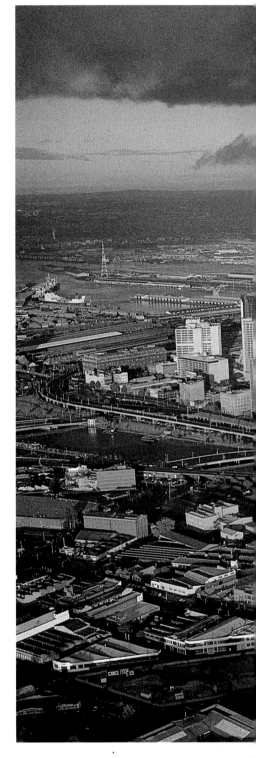

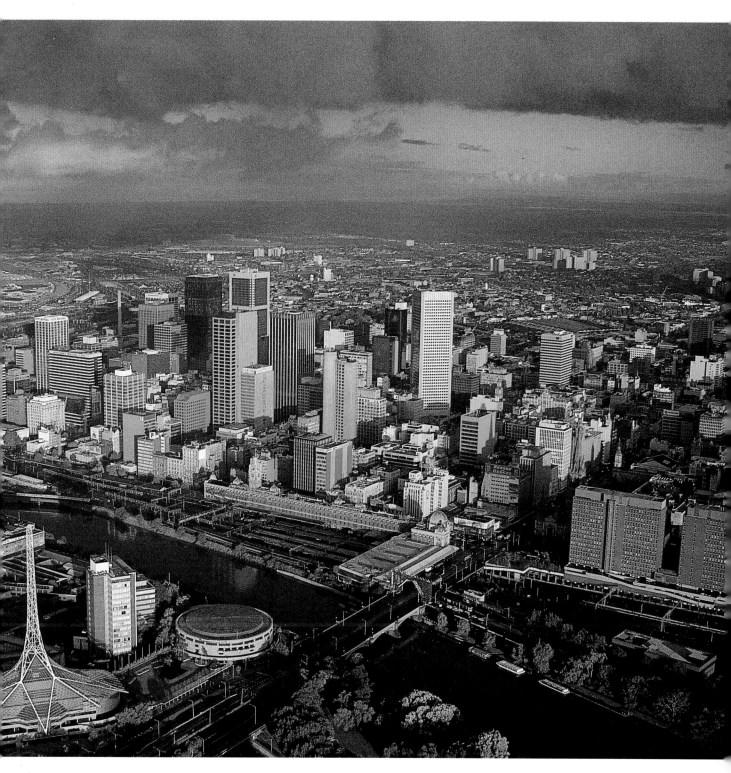

This view of Melbourne, Australia, was taken with a wide-angle lens to encompass the interesting foreground light and the dark background horizon.

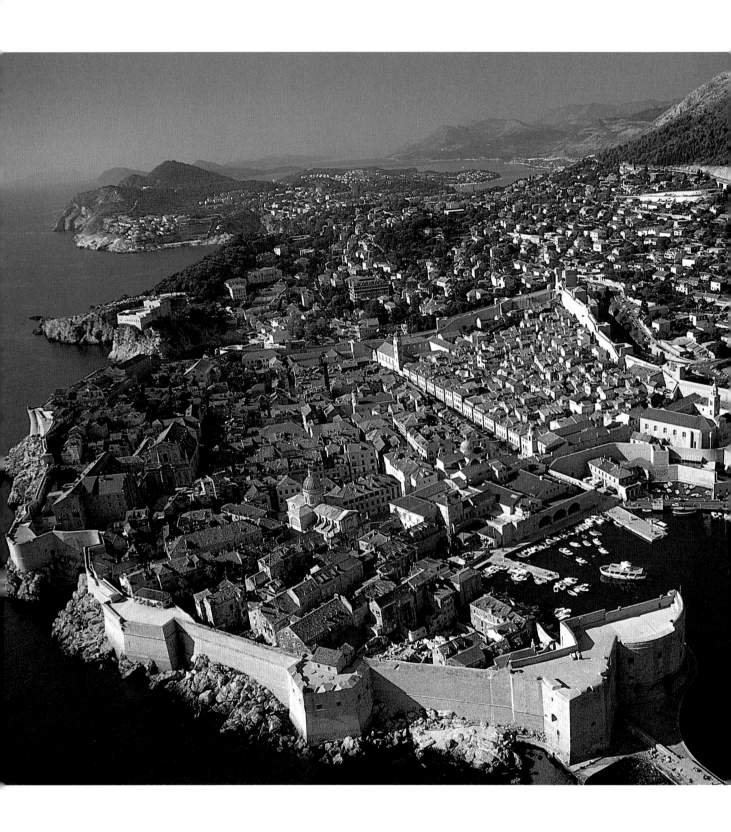

GROUND TRANSPORT

Arrange ahead to have an English-speaking driver meet you at each destination. Also make sure the car you hire can be on 24-hour call; you can't depend on public transportation when you need to get somewhere fast and on-time. "English-speaking driver" is a term often used in some of the more remote places of the world to describe someone who is somewhat more than a transport guide. These drivers are also a guide to the local area—they will be very helpful to you when it comes to communicating with local people, getting people to pose for you and sign releases, as well as keeping a watch on your gear when you're off shooting. I have never lost any gear in the custody of one of these drivers. Drivers and cars can be expensive. Check the rates in advance and keep track of the time you use the car. Rates are often expensive, but these rates are also often negotiable. Sometimes it's better to just use a local cab service, especially if you need transport for only a few hours. Your hotel is usually the most expensive way to hire your drivers; on the other hand, hotel-hired drivers will of necessity be more responsible—they can get a bad reputation fast by word-of-mouth if they do not do their best for the customers.

A word about bus transportation and guided tours: You can use a variety of tour buses to get around the city you are in, but the big drawback is that you will always be under a time limit getting off and on at designated stops. I once had only 15 minutes to photograph China's Tiananmen Square simply because the tour bus I was riding had to get its passengers back to their cruise ship. Guided tours also put you at the mercy of a crowd of people, which may be a hindrance when you want to get going at your own speed.

At each port of call on your aerial assignments, make sure you take time to become familiar with the geography, the local cities and towns, and the people.

In this photograph of the Golden Gate Bridge in San Francisco, California, the mirror image on the water adds an intriguing element to an often-photographed subject.

HOTELS

Even when I am traveling purely for pleasure and my own photography, a fine hotel is something I always put good money down for. A comfortable hotel eases the strain of tight travel schedules, has people who can always guide you to the area and its inhabitants, and is an excellent base for gathering your resources after a long day. Stay at the best places—it pays off in the long run in terms of morale and energy level. The staff will be very accommodating when it comes to travel arrangements, ticket reservations, and innumerable details you will encounter during your assignment. When making hotel reservations, I make a point of asking for a high room with a view. This way I can get some excellent location shots from my room at dawn or sunset. In the Caribbean or the Pacific islands, a beach-front hotel provides excellent photographic opportunity for stock work.

It is a good idea to thoroughly check the listings in a good travel guide, such as Fodor's, Fieldings, or Michelin. These books, which are updated annually, list the ratings and full descriptions of the hotels for each area. This is a good time to do some comparison shopping. The guides will also list the highlights of the local and surrounding areas, and this will help you in scouting your locations.

ON LOCATION

It is important to get a sense of your surroundings before you go on an aerial assignment. Although you will be photographing from the air, scout the general area by foot to familiarize yourself with landmarks, places of interest, local customs, and the people. Depending on the assignment schedule and budget, you may also be able to do an aerial scout of your location—getting a good idea of what you'll encounter in terms of terrain and weather. I also make it a habit to buy a handful of the local postcards. Good, bad, or indifferent, they show you the main points of interest and many of them are aerial views. I keep notes as I scout locations and refer to these during shooting.

The best time to get your picture-taking energy started is on these scout trips. You'll have an opportunity to meet directly with the people and the land, learn its history—local and national—and get a good feel for its geography.

Always be courteous! You are a guest in another person's country. Smile a lot; never get angry or threaten anyone (you won't get any information, needless to say photos, that way). When you raise your camera to take a portrait, ask permission first, make some contact that is friendly *before* you snap the shutter. If your subjects do not want to be photographed, then oblige them by leaving them alone. You will find that most people, when approached properly, will be more than happy to pose for you. When you are photographing in a particular site, such as a museum or place of worship, find out first if you are allowed to take pictures there, and whether or not you can use flash. If you ask permission first, rather than just shooting away, you will not have to risk having a security guard asking you for the film in your camera.

The time and work you put into scouting your location before an assignment will be to your advantage when you finally get into the air. You will have a feel for the land below you, and a better sense of it on purely visual terms. You will come back with much better pictures. Your client will be happy, and so will you.

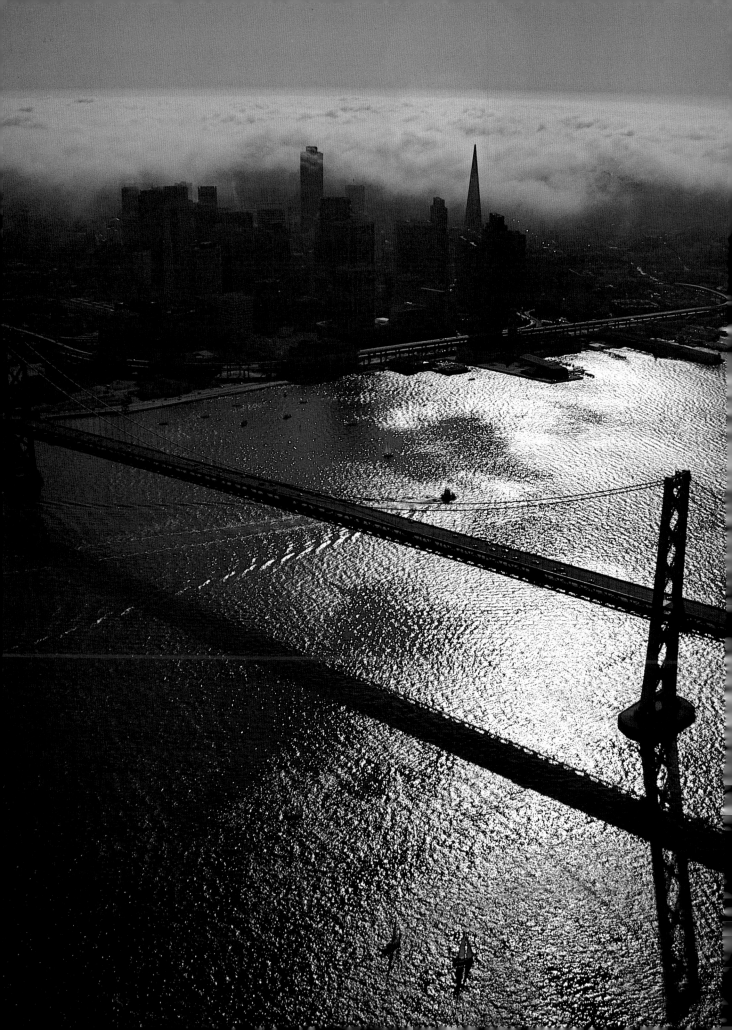

EQUIPMENT AND MAINTENANCE

Your equipment—cameras, lenses, film, and accessories—is the mainstay of your aerial work. You must use the best equipment possible and maintain it to the highest degree of performance. Once you're in the air, it's too late to find out that your shutter is stuck, your zoom lens won't focus at certain apertures, or that the film you are using is the wrong film for the lighting situation at hand. Make equipment checks *regularly*, and certainly one just before you're about to go on an actual assignment. Although this responsibility often falls to an assistant, make sure *you* also are confident that everything is in working order before you fly.

The tools of your craft must meet the standards of your vision

CAMERAS AND LENSES

My maxi-sized camera bag contains four motorized Nikon F3 bodies and more than 12 Nikkor lenses, which include: a 25-50mm *f*/4, 35-105mm *f*/4, 80-200mm *f*/4.5, 20mm *f*/4, 24mm *f*/2, 28mm *f*/2, 35mm *f*/1.4, 50mm f/1.2, 55mm macro, 85mm *f*/1.8, 105mm *f*/1.8, 135mm *f*/2.8, 180 mm *f*/2.8, 300mm *f*/4.5, and, when necessary, a 500mm *f*/8 and a 15 mm *f*/5.6. I include a selection of tele-extenders also, to rapidly change focal lengths if needed.

The zoom lenses are principally for use in the air—when I must change focal lengths quickly. I prefer single-focal-length lenses on the ground: they give a much brighter image in the viewfinder, which makes them easier to focus, and they are sharper. I also have two spare F2AS Nikon camera bodies in my suitcase when I travel. These are mechanical-shutter models, and I use them as backups for my electronic-shutter Nikon F3s.

Every six months or so, all my lenses are measured for accuracy. They are *collimated* (aligned with the bodies), checked for sharpness at infinity, and given a general checkup. The bodies are cleaned, all filters are checked for alignment—defective ones are rejected if the glass is found not to be parallel to the filter ring. Putting a bad filter on a good, expensive lens just weakens the effectiveness of the lens. *All* components must be in top working order. In special instances I use skylight, ultra-violet, polarizing, and a few color-warming filters, depending on what the situation calls for. All are checked to be sure the glass is properly mounted in the filter holder.

EXPOSURE: METERING AND BRACKETING

All my cameras contain meters. In rapidly changing light conditions, there is seldom time to take individual readings of a scene. I have a Minolta digital spotmeter (for difficult exposure situations), which can average three readings and give a readout of exposure. In high-contrast lighting conditions, it works as an accurate check for exposure. Yet, all metering decisions first require the photographer's personalized

Chapter Two

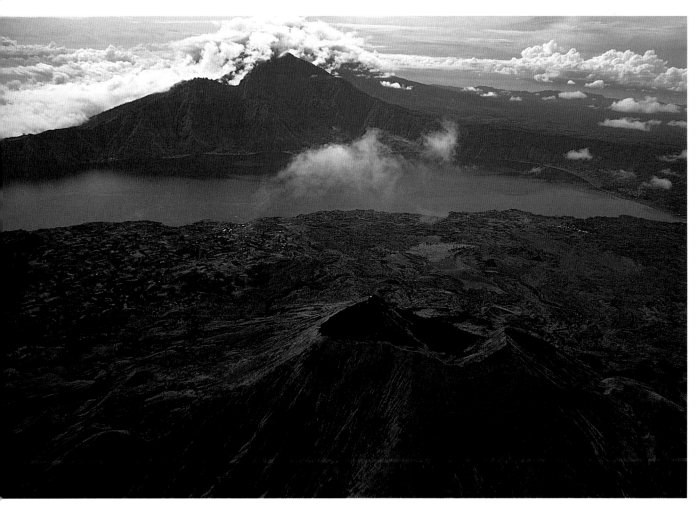

judgment, experience, and interpretation to gain desired results. You can't become too dependent on electronics; that would lessen your creative instincts. In addition to digital-spotmeters, I also use incident-light meters, as well as reflectance meters in my Nikons. I often use an 18-percent gray card to check my exposure readings.

Getting the right exposures in the air is extremely difficult. You are rushed all the time, under pressure, buffeted and blown about by winds and air currents. Whatever equipment you have, there is always one fail-safe method for good exposures: bracketing your shots. It's worth it to use up film by bracketing. It's less expensive in the long run and you'll come back with more picture possibilities. Never let ill-maintained or faulty equipment be your excuse. In back-lit or high-contrast situations, bracketing is the only hope you have of success. There's no "correct" exposure, although I try to shoot for a slight underexposure, to produce more saturated, richer tones in my aerial

When a subject contains a large range of contrast, such as this mountain range in Bali, bracketing your apertures and shutter speeds will enhance the possibility of your getting a better range of exposures.

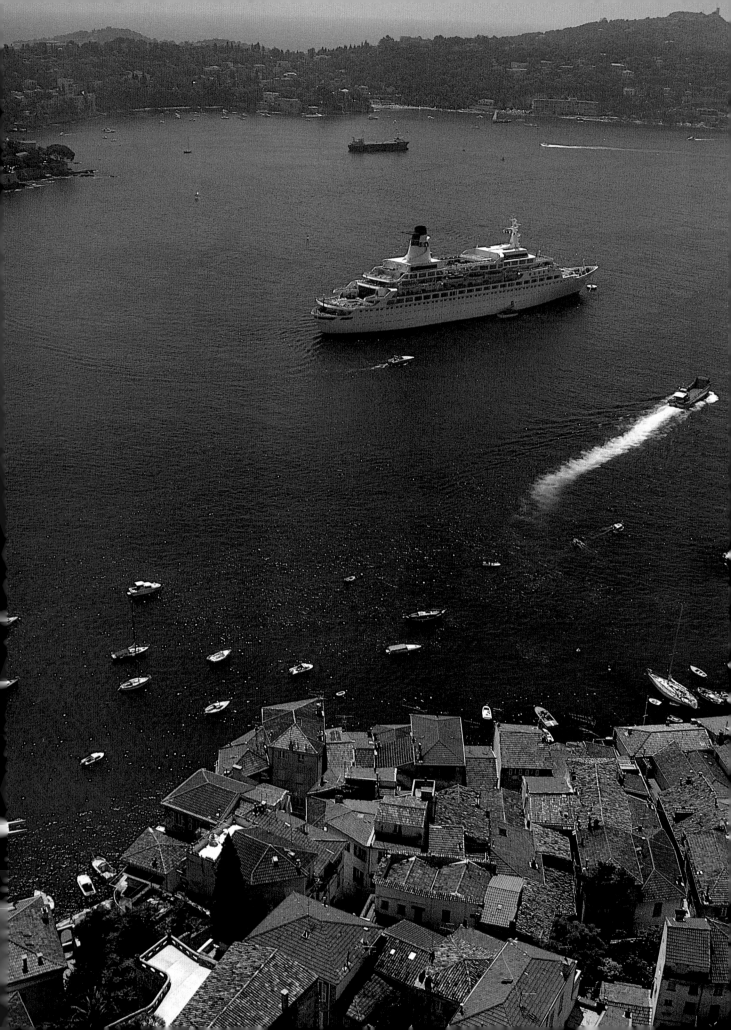

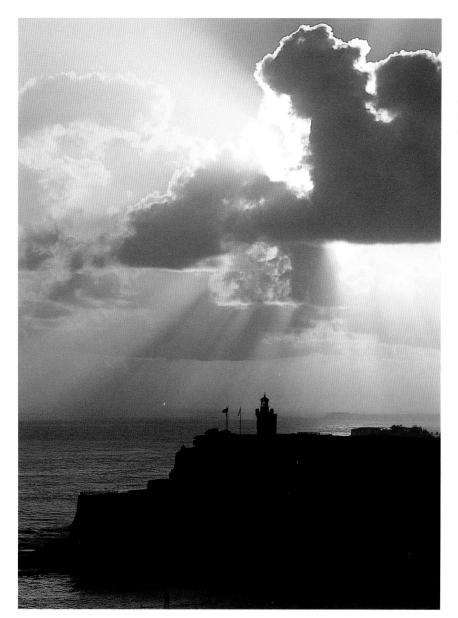

The contrast of color values in the image on the opposite page was achieved by bracketing for the rooftops and the reflections on the water. Bracketing is also very helpful when photographing backlit scenes, such as this sunset at El Morro Castle, San Juan, Puerto Rico.

images. I set my film rating speed at normal, and bracketed one or two stops on each side. Exposure choices can vary widely. When you are shooting into the sun or over water, snow, or ice, any of six exposures may be "correct." I change the aperture up or down by half-stops or full stops, depending on the amount of contrast in the scene. Sometimes I rotate the *f*-stop ring through the entire series of apertures and then change shutter speeds.

I make it a point to shoot the widest possible variety of images for the art directors and designers who will later create layouts from my work. My clients need and appreciate a large selection of both vertical and horizontal shots. *You cannot go back!* A professional comes home with the completed assignment, never with excuses.

FILM CHOICE

All lenses are most precise at certain *f*-stops, which are usually two or three stops down from wide open. Too often you can't select this optimal range because many factors dictate the adjustment: the amount of light available, the film speed, and the shutter speeds

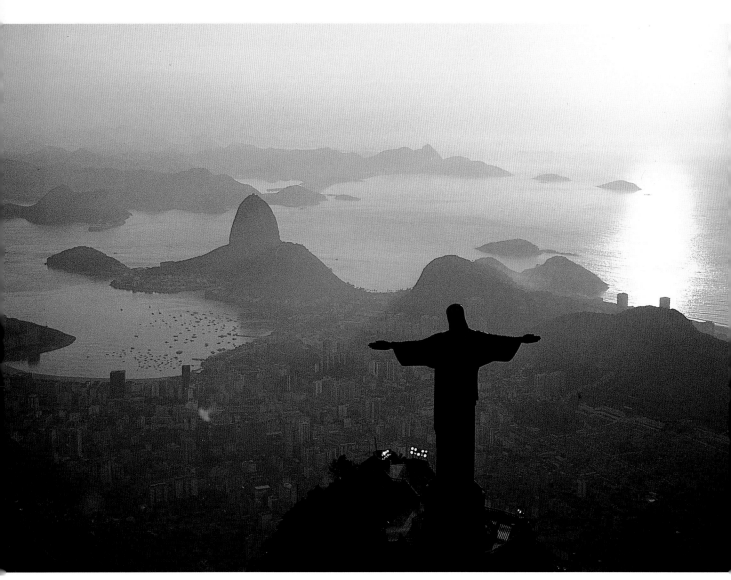

Your film choice must match the color cast (warm or cool, magenta or blue) of your subject. In the image, right, of the Whitsunday Islands, Australia, a blue cast enhances the color of clouds and water; above, Rio de Janiero's famous Christ on the Mount is dramatically rendered in a warm glow against a sunrise.

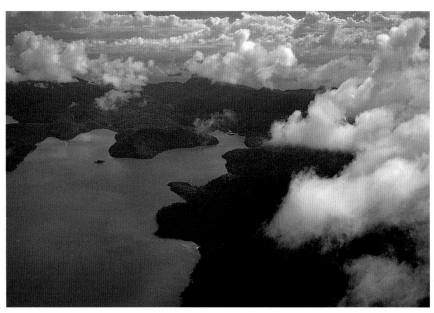

necessary. Film choice is crucial to this situation. Knowing the best film for the widest range of conditions will help you bring back much better images. But you must know the trade-offs. Fast film is not always a solution to slow shutter speeds and wide apertures. These films are very grainy and will denigrate the image as much as camera shake does. What you want in the air is the sharpest, slowest, most fully color-saturated film you can use.

I have never been completely satisfied with the results of using very high-speed film for airborne shooting. I prefer a film that holds fine detail, unless the shot is being made strictly to impart a particular impressionistic effect. Kodachrome 64 and Fujichrome 50 are the two fine-grain films I use most frequently. The Kodachrome usually runs toward a magenta cast, with warmer colors overall throughout the exposure range. The Fujichrome produces excellent blues and greens, and generally more vivid color saturation. But film choice remains a matter of personal preference. You must experiment with different film types, under many different weather and light conditions, and then decide what best suits you.

When shooting, I always wear a fishing vest—the kind with many pockets—to enable me to hold 30 to 40 rolls of film, extra lenses, filters, batteries, and a host of other small but significant gadgets. It's amazing how necessary these vests become when you're traveling with a lot of equipment.

EXPOSURE AND THE GYRO-STABILIZER

When there is sufficient light, shoot at high shutter speeds: 1/500 sec. to 1/2000 sec. or faster, if your camera allows. The shutter speed you select depends on the focal length of the lens and the relative motion of the aircraft and subject below you. In a chopper, you must guard against vibration and turbulence; in a light plane you must deal with air speed and the gravitational forces that accompany you as the plane circles around the subject.

On the ground, the rule-of-thumb for minimum shutter speeds is approximately one divided by the focal length of the lens. That is, a 105mm lens should be handheld at no slower than 1/125 sec., a 300mm lens at 1/500 sec., a 50mm lens at 1/60 sec., a 24mm lens at 1/30 sec., and so on. In the air, I try to triple or quadruple these speeds, except when using the gyro-stabilizer. With this device, when I'm working in low light—such as the glow of dawn or the afterglow of sunset —I can shoot from a chopper at very slow shutter speeds because the gyroscope keeps the camera stable at all speeds. The gyro-stabilizer is an egg-shaped object about three inches in length and weighs about two pounds. It attaches to the camera body's tripod mount and is connected by a cable to a rechargeable battery pack. The stabilizer steadies the camera against *pitch* (up-and-down motions) and *yaw* (side-to-side) motions. Inside the egg, the two gyroscopes are set at right angles to each other. They rotate at 20,000 rpm and take about six minutes to get up to speed. You must always position the nose of the gyro-stabilizer in the direction you are shooting. (I once met a *Fortune* magazine photographer who had it sideways. It didn't work.) During one year, I used it to photograph the dawn over El Morro castle in Puerto Rico; the twinkling lights around the harbor of Charlotte Amalie on St. Thomas; a full moon in a glowing pink sky near Wellington, New Zealand; and a dawn at Auckland; among other "impossible" scenes.

Overleaf:
The peaks of Nevis, St. Kitts, were photographed with slow-speed film to bring out the fine detail in the mountain landscape.

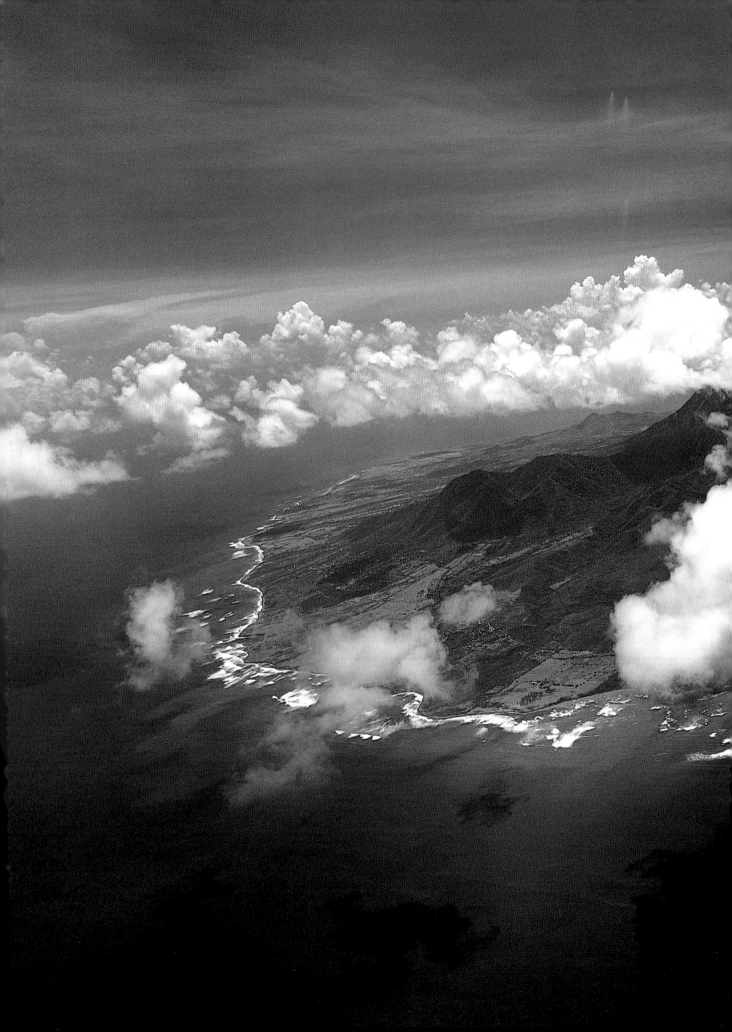

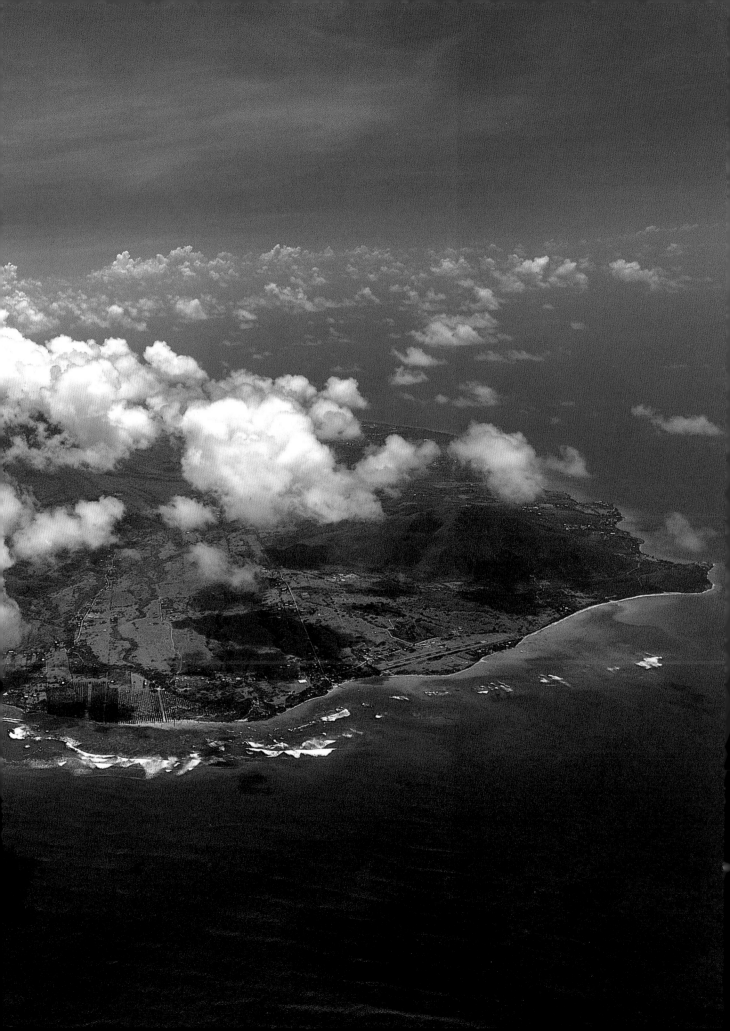

This image, photographed at moon-rise in Wellington, New Zealand, required the use of a gyro-stabilizer to obtain the proper exposure in this dawn setting. The sunset in Tahiti on the far right was bracketed to create silhouettes of the trees and huts.

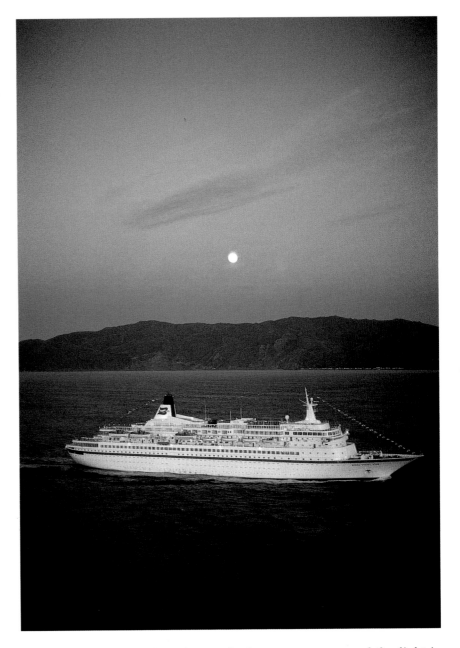

Once the gyro-stabilizer is attached to my camera, and the light is bright, I can cover much of what is needed for shooting with a 25-50mm or 35-105mm zoom lens. The zooms allow quick shift of focal lengths—a great help in the air, where air time is always short. As I mentioned before, we're not always in control of shutter speeds. When shooting over the open sea, in bright sunlight, with a polarizer on an $f/3.5$ or $f/4$ lens, with my favorite slow film, the best shutter speed I can get is often 1/250 sec. I must slow down to 1/125 sec. to bracket fully. Only the use of the gyro-stabilizer makes this possible for sharp images. Using fast single-focal-length lenses, such as 50mm $f/1.2$, 35mm $f/1.4$, or a 24mm $f/2$, you can obtain acceptable sharpness at shutter speeds of 1/30 sec., or perhaps even 1/15 sec. I try to stay in the range of 1/30 sec. or faster. The longer the focal length of the lens, the smaller the area of the scene it takes in—and the slightest shake will be proportionately multiplied. In the air, the rule is: The longer the focal length, the higher the shutter speed required. As a general rule, I always use the gyro-stabilizer in the air.

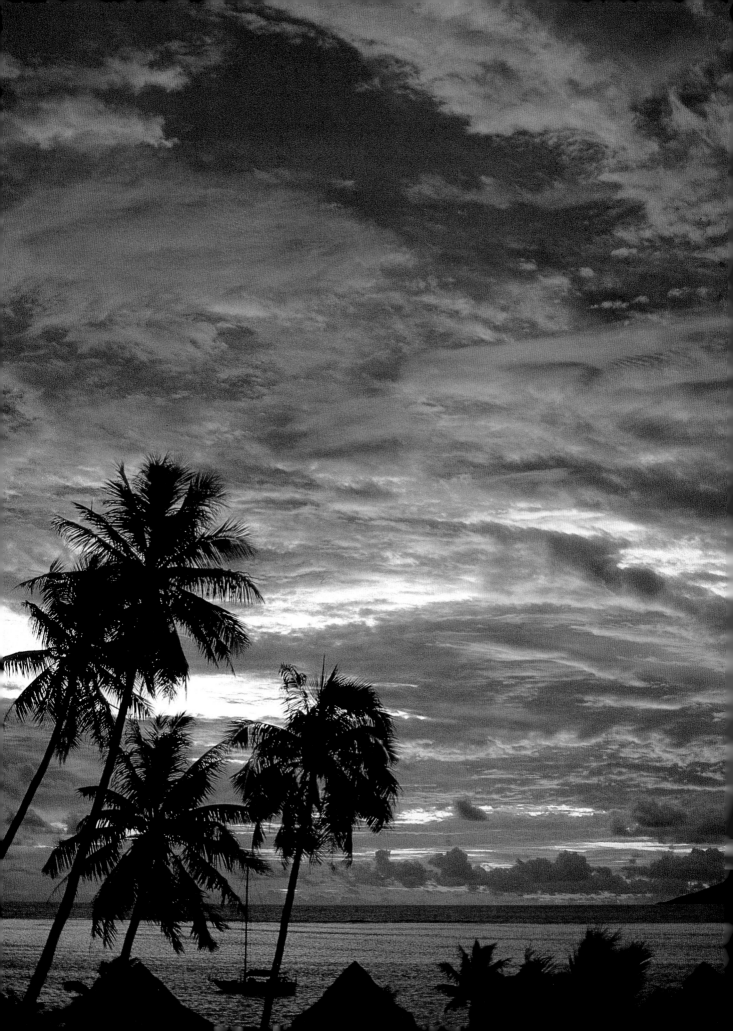

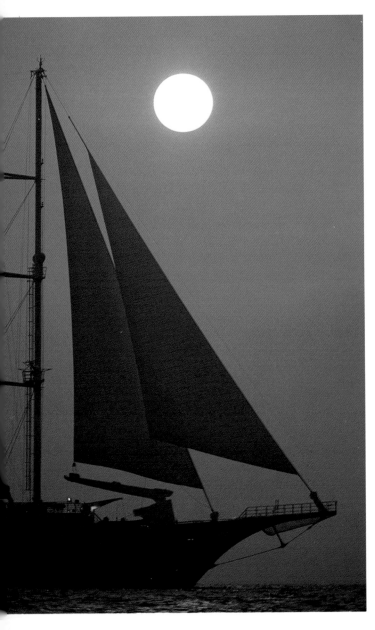

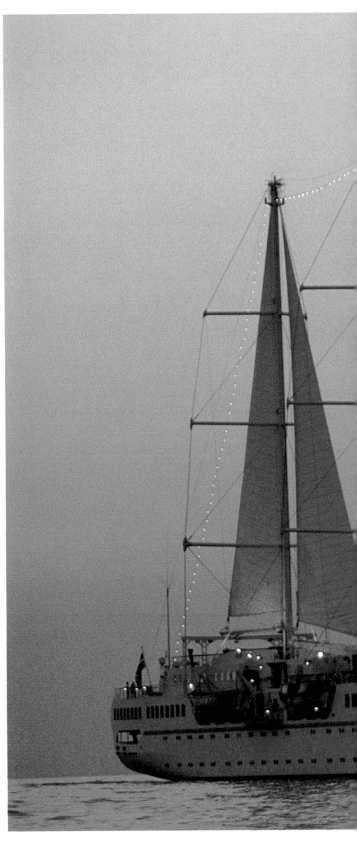

Both of these images were made with the use of a gyro-stabilizer and fast prime lenses. Above, the position of the sun balances the composition. At right, even the blue light cast from the deck onto the sails is visible in this low-light exposure.

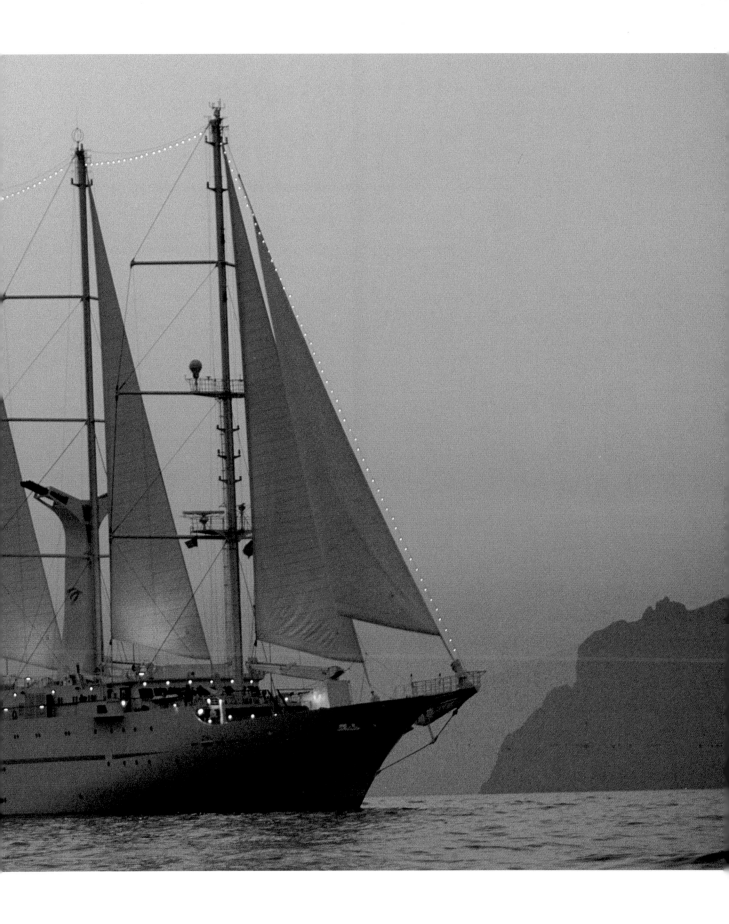

AIRBORNE STRATEGIES

Go up with the best, and come back with the best

Airborne! The ideal moment—your chopper or light plane maneuvers, hovers, swoops, circles, dives; you are alert and poised, sensitive to light, color, and your vectored position—you concentrate on shooting spectacular photographs. But long before this ideal moment, you must make innumerable decisions that will affect how successfully you spend your time in the air and whether you indeed will come back with those great shots.

After you have prepared the details from scouting your location, checking equipment, and mapping out a schedule of your air time, you must select a pilot and aircraft to fly in. Every situation will be different and it is important to make the right choices. Airborne technique is a communication of two people, you and the pilot, out to obtain the same end result: a successful aerial assignment. The machine you go up in and the pilot who operates that machine are the tools you must match to your own standard of safety and critical performance. You must select them as carefully as you select your cameras, lenses, and film. Once you have made these decisions, you must also learn the intricacies of photographing while inside this ever-moving machine in an environment that is continually changing. Weather conditions must be understood. You must be able to predict and be prepared for a variety of airborne situations—and constantly maintain a strategy for solving both creative and technical problems. Instinct is your greatest ally. Learn to develop it. All the time you are bouncing about, subjected to dizzying lurches and gravitational forces, entangled with gear, your instinct and your reflexes will trigger your shutter, shot by shot.

Once you have freed yourself from having to wonder about your pilot or your aircraft's safety and performance, you can confidently go about the business of taking aerial photographs. This chapter will introduce you to all aspects of these important technical concerns, as well as give you some grounding in what creative choices you can make during your assignment.

PILOTS AND THEIR MACHINES

I subscribe to several flying magazines to gain information about pilots and aircraft, not because I want to pilot the plane, but to learn what a plane or helicopter can do safely, under what conditions, and with what kind of pilot behind the controls. Good pilots know not only how to fly well, but also how to fly various types of aircraft well under many conditions. They will enable you to gain valuable shooting time in the air and not take you wandering aimlessly around the sky.

Finding a good pilot is a snap judgment. I've flown in a wide range of aircraft and my feelings about the pilots I've flown with have always been a gut reaction. I look every pilot over the first time and ask myself if I would buy a used car from this person. Talk to your pilots—get them involved in your assignment. Always try to plan your shoot with them—

show an outline of the vector positions you'll need, or the angle of approach you want that will give you the best light or composition for your subject. It's important to let your pilot understand what you are attempting to map out on the assignment. You may encounter in-flight problems that, with some pre-flight communication, can be easily resolved. More than once I had to photograph while facing backward out of an open door in the craft. This problem can be solved by letting your pilot try to visualize what you see when you are positioned this way. (If possible, work from the side of the aircraft that will put you in the best position to see your target. I often prefer to remove only one door on a helicopter. Otherwise, the cabin becomes a wind tunnel and all the gear moves around.)

I always inspect the aircraft in advance and try to decide whether or not it is ready for flight. At each port of call, I meet new pilots and am a passenger on many new light planes or helicopters. Opinions about the best kind of aircraft vary widely. The choice of aircraft is a personal one once you have determined the best choice for the *technical* needs of the shoot. I prefer to shoot from helicopters when I can. I like the extra room they offer, such as in the Jet Rangers and the spacious, comfortable French A-Stars, both of which offer sliding doors. In these models I can fly the mission fast and in comfort (although the upholstery in the A-Stars tends to flap around in any wind).

Your pilot is your teammate on aerial assignments; you must communicate your needs to him clearly, with a full understanding of his and the aircraft's limitations at any given moment.

This glacier run in Juneau, Alaska, was a difficult subject over which to vector because of shifting air currents. Having a pilot who is trained to fly over such terrain is essential.

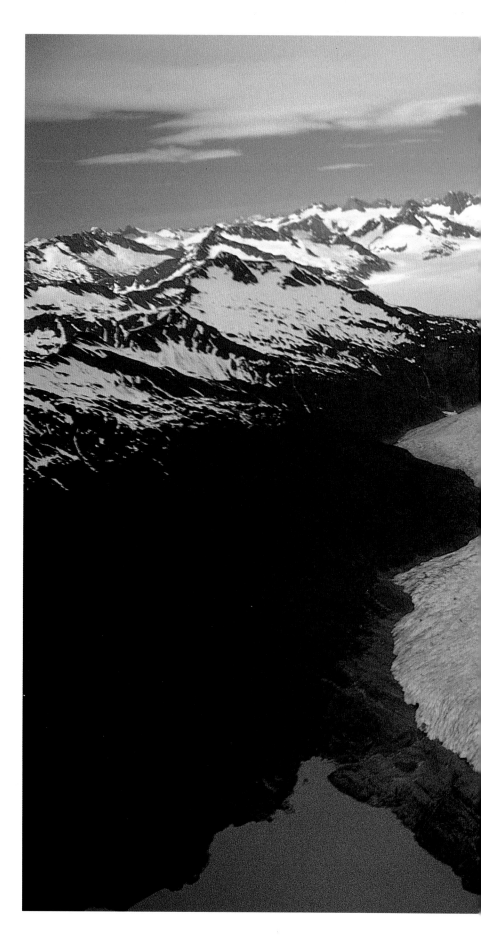

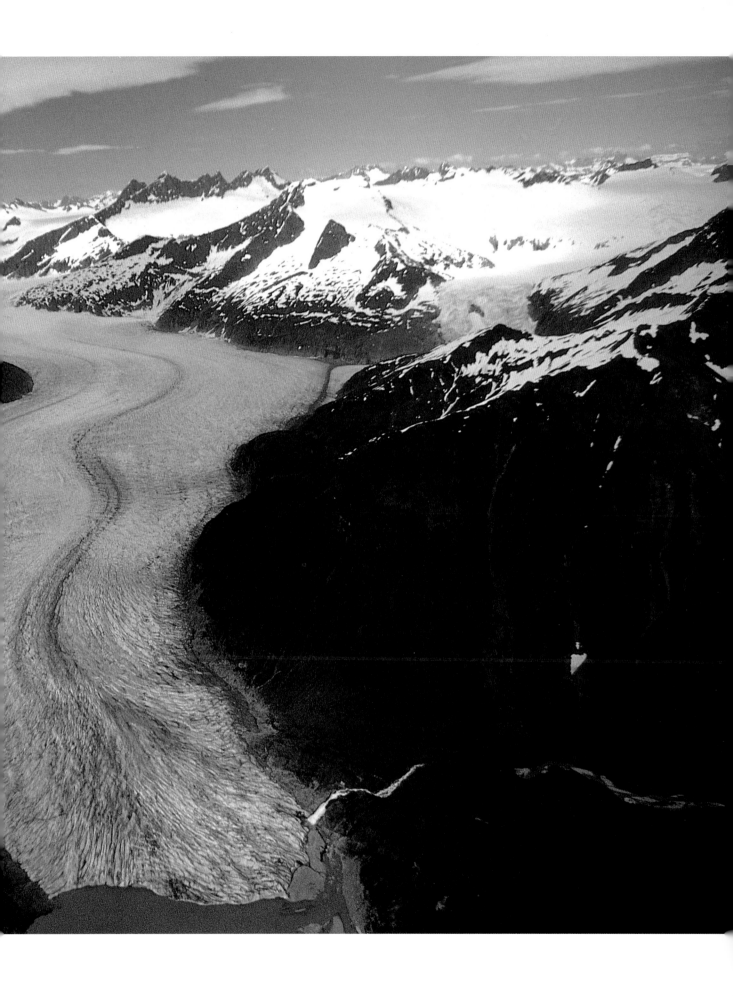

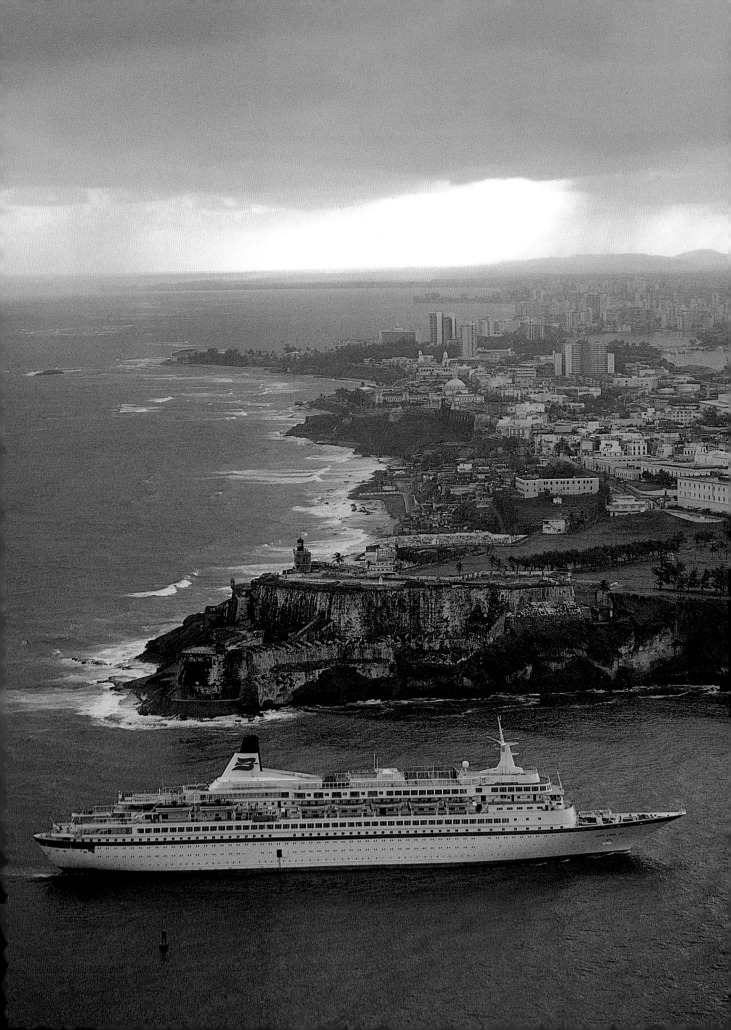

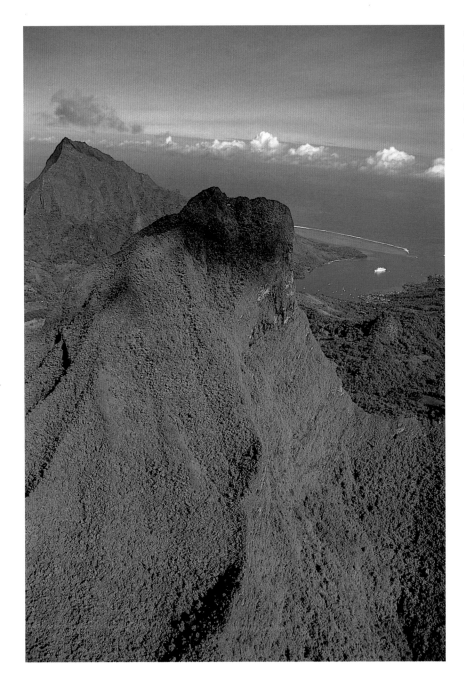

Light planes are the preferable air-craft for photographing from a high altitude, as in the image at left of the mountains over Bora Bora. For shooting at closer vantage points, such as the landscape of San Juan on the opposite page, helicopters are a better choice of aircraft.

LIGHT PLANES

Any light plane, but preferably one with a high-wing design, can be used in aerial photography. A light plane takes time to maneuver into position over your target subject. At close range, these planes circle at a minimum speed of 50, 60, or 70 knots. At slower speeds, they have a tendency to stall, and their landing-gear warnings go off loudly. On this type of aircraft, you may have too little time to frame shots using different focal lengths for compositional variety. If you ask the pilot to go into a rapid fly-by, you risk losing sharpness—especially if you're using a focal-plane shutter, which moves in the opposite direction of the fly-by. (For close work, helicopters are a surer bet.) While it's possible to make excellent images from high-wing light planes, the work is difficult. Above 1,000 feet or so, light planes—Cessna 172s, 180s, or 210s—maneuver excellently. Below that altitude it's harder going. In the 210, the rear door comes off; in the other models, you

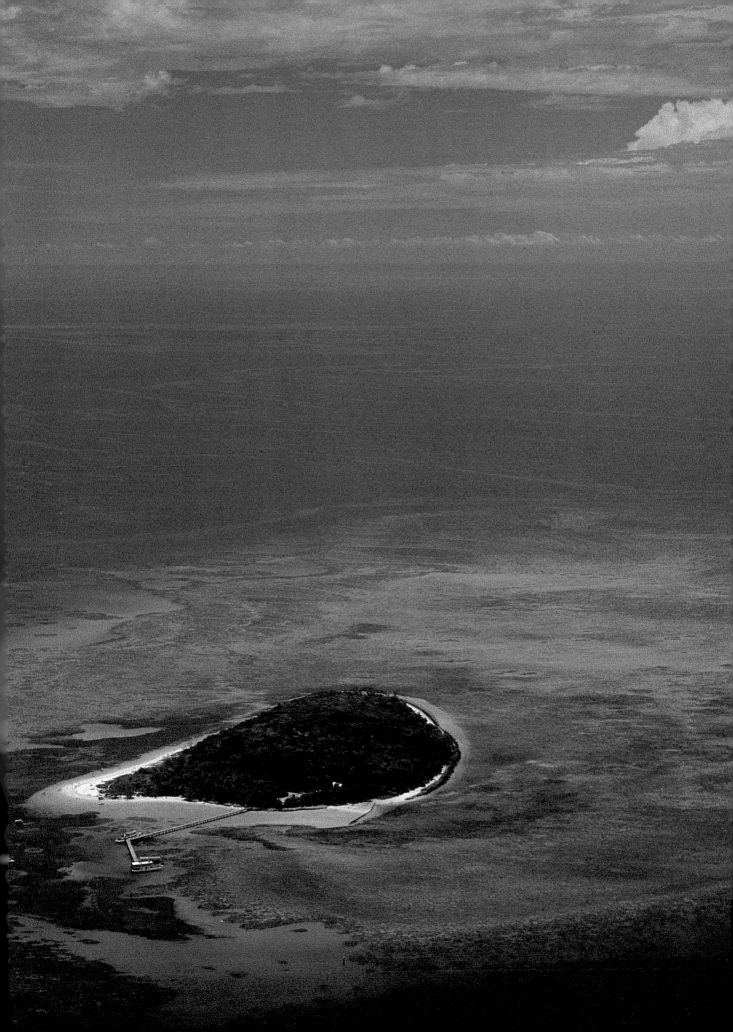

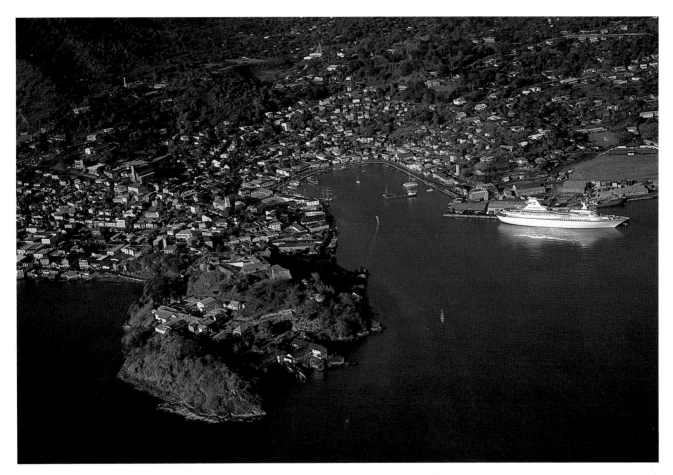

shoot with the window held open by the slipstream or the pilot. I remove the front door in the smaller planes for better visibility. At altitudes of 1,000 feet and higher, subject and landscape change reference points slowly, which permits you more time to shoot. At lower altitudes, closer to the subject, you have only a few moments to shoot before you must then circle slowly around to get back into your position—a constant and tiring roller-coaster ride. A pilot experienced in aerial photography can help you by knowing how to take a proper angle of approach, and by flying close to stalling speed (safely!) to increase your shooting time during circles. When you arrive over your target in the precise position again, be ready to fire off shots rapidly.

But, despite the need to shoot quickly and get enough images, you must only do it between the bumps and jolts of the aircraft—when vibration is minimal. Then, while the pilot is maneuvering the aircraft in another turn, you have time to reload your camera for the next series of shots. Always make sure you time yourself to be aware of the number of exposures made. If you're stuck rewinding film or reloading when you are over the target again, you won't have as much time to get the picture. If possible, have a good assistant with you who will reload for you as you work from camera to camera.

Throughout the flight, use your headset to communicate with the pilot. If you have none in the aircraft, use hand signals and tap the pilot on the shoulder. Keep your directions even-toned and calm. When you must shout over the roar of the rotors or the engine, be aware that you can become too enthusiastic. Don't press your pilot to take unnecessary risks. It makes for safer flying—and better shooting.

Subjects photographed from increasingly higher altitudes change their reference points more slowly. This enables you to shoot for longer periods of time without losing compositional framing.

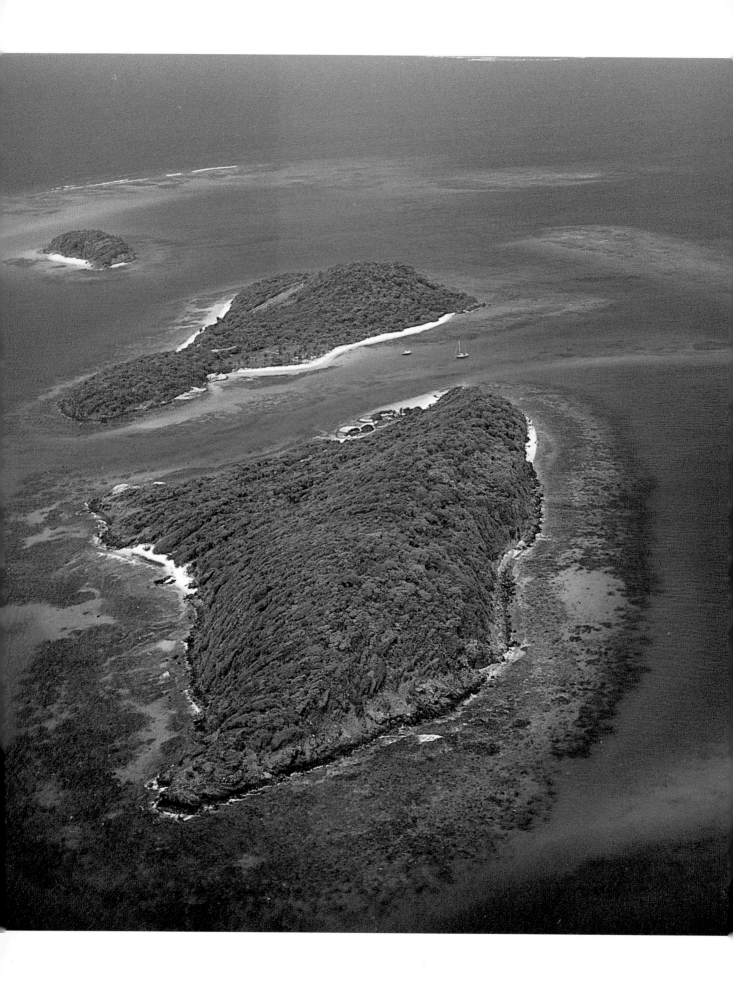

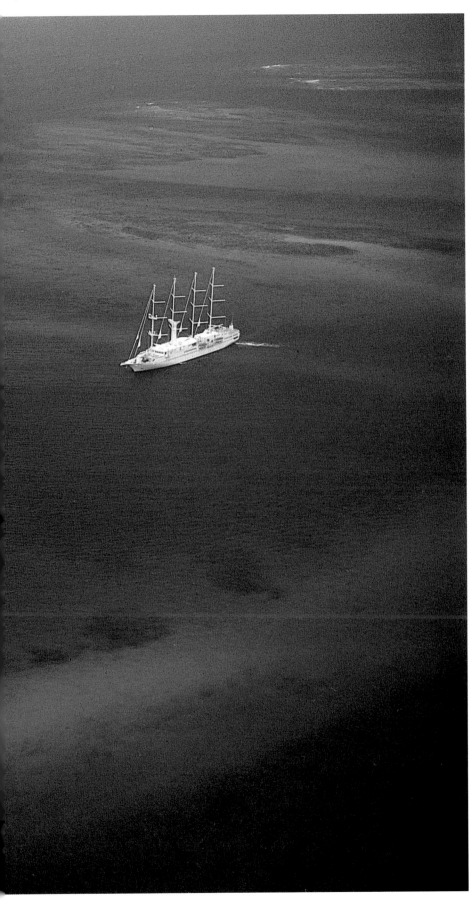

Flying over water is usually not a problem for many pilots, but it does require certain safety precautions when you want your pilot to fly very low over a scene.

Another aircraft option is the Astrovision Lear Jet, modified for use in aerial photography. It comes equipped with periscopes top and bottom, and a windowed nose cone perfect for photography. The periscopes are part of an optical system that enables the pilot and the photographer to monitor video screens of the surrounding scenes during flight. Still cameras and 35mm movie cameras in these planes are rigged for taking photographs at jet speed while flying at any altitude, from just a few feet above the ground to 50,000 feet in the stratosphere. The rental minimum per-day includes four hours of flying time, pilots, crew, and special equipment.

Although the Astrovision is used principally for films, television, and other high-cost work, it is a superb tool for shooting air-to-air stills of jets and other high-speed aircraft. For air-to-ground work this aircraft permits you to take giant steps over the landscape to reach widely separated scenes you want to photograph.

TIPS FOR SUCCESSFUL FLIGHTS

- **Think ahead.**
 Plan your maneuvers in advance, taking into account the time it will take for a circle or turn, and the time it takes to reposition the aircraft over the target. Note the wind velocity and direction. You must learn to continually look up from your camera viewfinder, assess your position, and communicate a direction to your pilot.

- **Speak calmly to your pilots.**
 Pilots have a great deal to think about and do just to control the aircraft. If you have no headset, tap the pilots on the shoulder, and use hand signals for your directions. Do not jostle them or shout in their ear.

- **Do not carry more passengers than necessary.**
 You, your pilot, and an assistant (possibly the client on some expeditions) are all the weight that most aircraft will take and still maneuver well. Make sure that you check passenger regulations with proper personnel.

- **Study the weather.**
 Do not judge the weather by looking out of your hotel room window the day of the flight. Weather changes constantly. Keep in contact with a weather service right up to flight time. But even then, you can often go up in sunshine, fly a few miles, and hit a wall of rain. Your pilot should be able to let you know in advance what oncoming weather conditions will be, but keep your own eye open—you're the one taking the pictures. Always schedule extra days.

- **Watch the time.**
 You must have a fixed plan of what you aim to achieve in the time you have budgeted in the air. You must guide your pilot from subject to subject with this in mind. Air time is often expensive, so use it wisely.

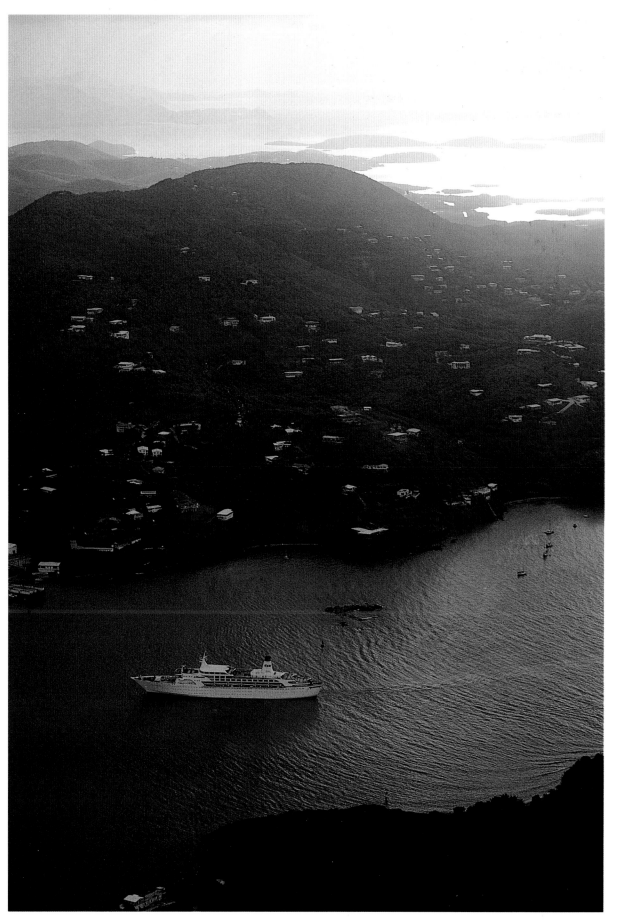

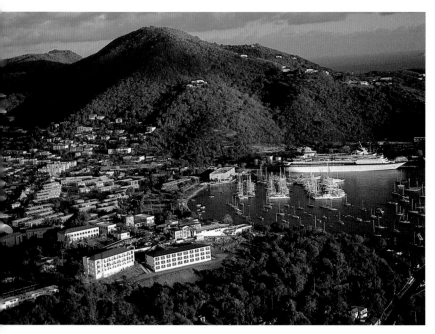

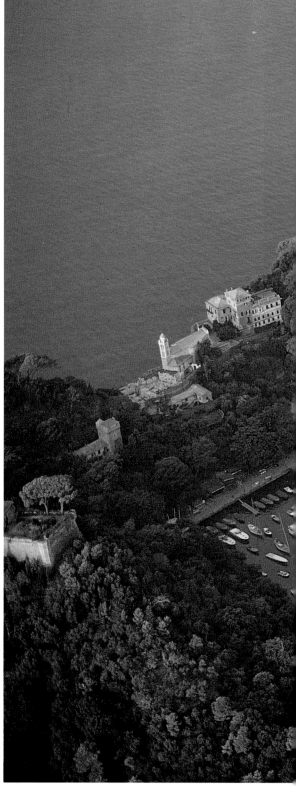

Above, a Royal Caribbean liner is shown at harbor in an aerial shot that includes the surrounding landscape and town.

The town of Portofino, Italy is depicted in this view taken during the early morning.

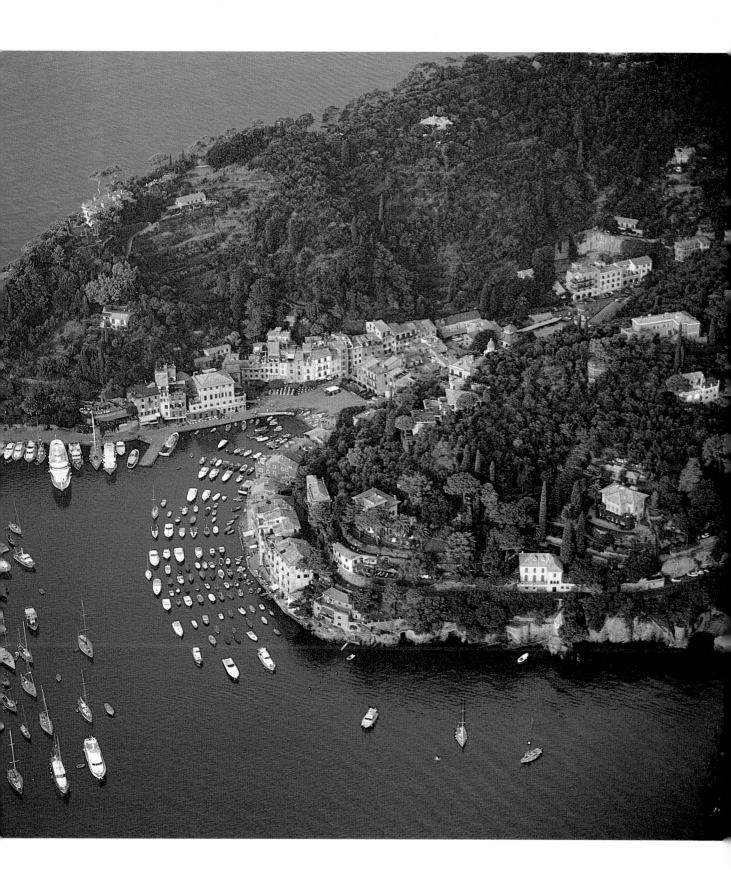

*Helicopters permit low-flying man-
uevers that can lend impact to your
aerial views, as in this graphic shot
taken directly over the bow of a
cruise liner.*

HELICOPTERS AND AERIAL WORK

The aerial platform of choice for me and for many other aerialists is the helicopter. In the hands of an expert pilot on a calm day, it's an unmatched flying machine—literally a flying tripod. But there are risks and rules. Flying over the open sea, some pilots will tell you that below 300 feet and under 60 knots of air speed, you and the chopper are at *high* risk if the engine should malfunction or the rotors fly off (and they can). People speak of auto-rotating, but that is a misnomer: If you fly at very low altitudes and there is a sudden loss of power, you will plummet like a stone into the sea or on land.

At peak performance, a helicopter can hover in place *when the wind is right*: head-on into the wind. Ideally, choppers will perform like a movie crane, raising and lowering you and moving laterally or diagonally on command. But be aware of limitations: Below certain altitudes and speeds, helicopters are vulnerable. Check the rotors to see if they run well. A finely balanced rotor ensures a steady and vibration-free flight, with less likelihood of losing a blade. Vibration is also the enemy of sharp images. When given a choice, a helicopter such as the Bell Jet Ranger or French A-Star 350 offer extremely smooth rides. The Bell Ranger has its motors and gear train mounted on shock absorbers that dampen a good deal of the vibrations.

The Bell Long Ranger's big sliding windows also allow for excellent visibility (although I like to work with both doors off). The new French A-Star has sliding doors also. If a secure passenger tether or harness is available, you'll have more freedom to lean out of a chopper and avoid getting either the skids or the rotor blades in the image. I prefer to use the seat belt in the chopper, loosely fastened. I wind gaffer tape around the buckle several times, leaving about two inches of tape that I fold over. This creates a small tab I can pull to release the gaffer tape in an emergency.

Budgeting Your Air Time. Know what you'll need to do *before* you do it. Air time is expensive and precious. You can't take more time than you need to come back with the pictures you want.

A good light plane with an experienced pilot will cost from $75 an hour for a small Cessna to about $150 an hour for larger aircraft. But prices change. Abroad the rental changes are usually double or triple this figure. Twin-engine aircraft are expensive, even more than most helicopters; they are much more difficult to handle and you are essentially paying for the extra security and experience. Some pilots will also demand higher fees for just having to fly low over water, which they regard as a risk.

A helicopter is expensive, $450 to $800 or more per hour, depending on where you charter it. A chopper ferried in from its base to your shooting location and then back is rented at an hourly rate. If you're booking a considerable amount of air time you may possibly negotiate a lower rate for the ferry time.

Fly Safe. You, too, must beware of risks with some pilots. There's no danger in leaning out of a chopper secured by a seat belt with gaffer tape fastened around it. It may not be dangerous to rocket low over the wave tops with an experienced pilot, no matter how it feels. But there *is* danger in flying with a reckless or inexperienced pilot, or flying in an antiquated or badly-maintained aircraft. In Rio I once booked a new Cessna and hired a local flying instructor to vector me over Sugarloaf for the spectacular sunset. When we arrived at the airport, the service

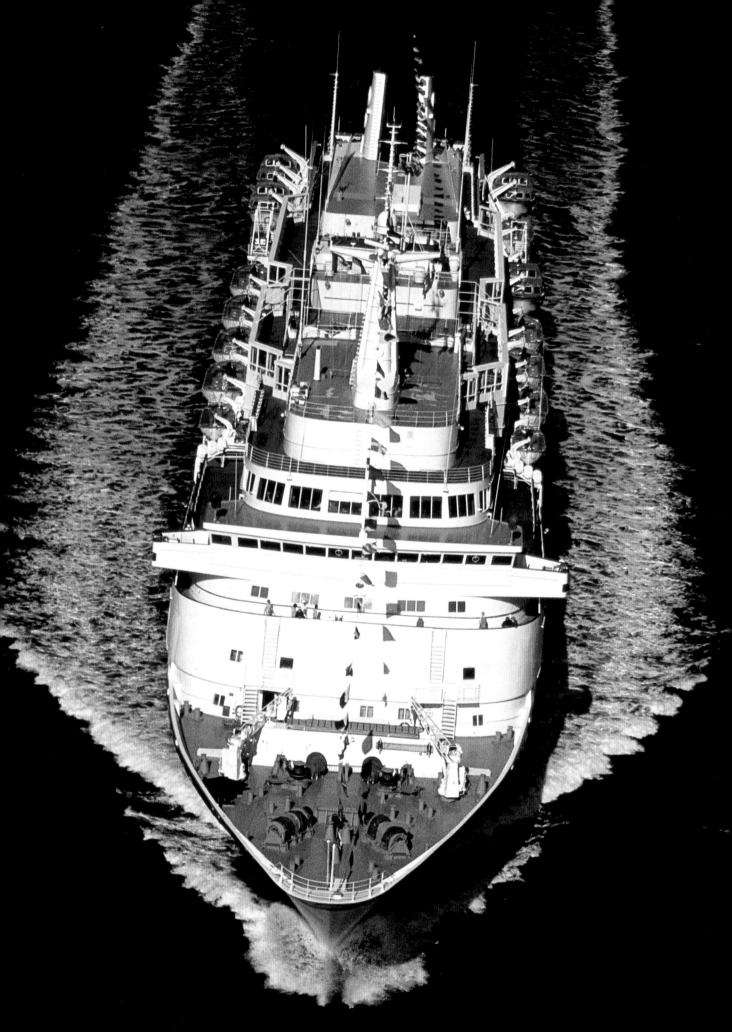

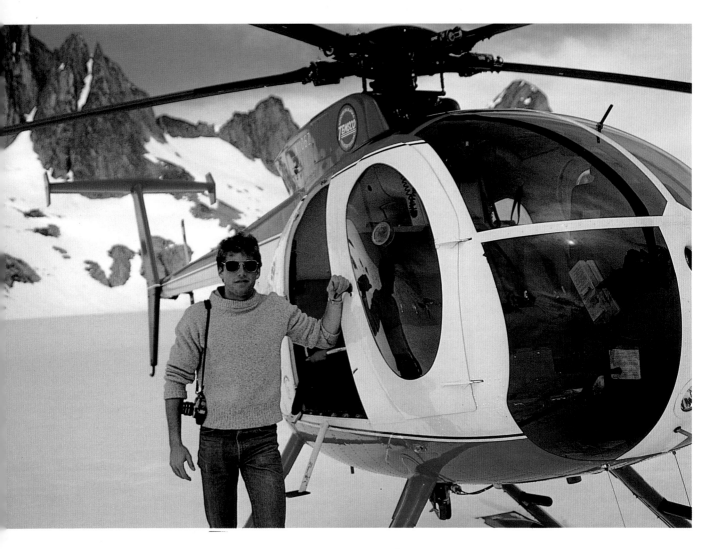

Helicopters allow a greater freedom of flying over a wide range of aerial locations. Above, my son Andrei prepares to fly in a Hughes 500.

representative was full of apologies in Portuguese. "The flying instructor is not available. Would you like to meet the local air taxi driver?" This fellow looked to me like a a seedy character. His plane was a relic of another era; the inside of the craft appeared as if it had been outfitted from parts from an automobile graveyard. I shouldn't have flown with him, but I took a chance. In the air I was nervous for an hour, bouncing around the bumpy air near the Christ of the Andes and the surrounding mountain ranges. My assistant's face was white. I was embarrassed about my hasty decision. Goaded by the pressure to get the job done, I took a risk. Don't you. It's your life up there.

Pilots often become daredevils in helicopters. They are all too human. My adrenalin rises during a mission and theirs does, too. They want to show you how well they can fly. They know all the rules, but they still hover at any altitude and, as they know their machines well, this attitude can be safe in the right hands—and prove the spur for some great shots. Yet, with even the most experienced pilots, you should always take precautions. There are safety measures you should become familiar with. Some helicopters are equipped with floats, attached to the skids, which inflate on impact. Some carry life rafts. Most have life preservers, and pilots will insist that you wear one. I

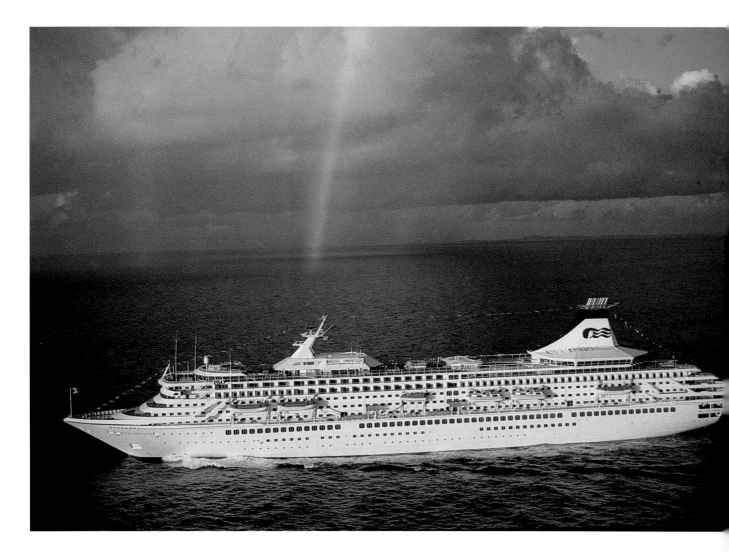

always inquire about fuel supply, and I tell my pilots to go up with an extra hour of fuel in the tank. I prefer safety above maneuverability when it comes to that choice. Flying light of fuel can be dangerous.

In Jamaica, on assignment to photograph a cruise liner, I met my chopper as it landed on a playing field near the harbor at Ocho Rios. Before the flight reservation I had requested life vests, a life raft, and a headset. However, none of these were aboard due to a slight breakdown in communications, despite confirming all arrangements previously. I had to decide: Should I go up without all that important equipment on board? I did. Up in the air, my pilot flew low over the waves to get me a good shooting angle on the ship. He hung the chopper exactly where I needed him to as I shouted directions at him over the roar of the rotors. Below us, the *Song of Norway* plowed a brilliant white wake in the turbulent 25-foot-high seas. We followed the ship until our pilot bellowed that he was low on fuel. Our 45-minute roller coaster ride ended. He gunned the rotors and we raced at 110 mph, scant feet away from the white-capped water toward the distant sight of land. I stared out of the open door and kept repeating to myself, "I hope we make it. . . ." We did, but from then on I vowed *never* to go on an aerial assignment without life vests or life-raft equipment.

This image, taken by flying low in a Bell Jet Ranger, wonderfully captures the moment when a rainbow appeared in front of the ship.

overleaf:
Even in the best weather conditions, follow aircraft safety procedures carefully before flying over any unfamiliar location. The photograph here was taken on a clear day over Cook's Bay, Moorea, in the South Pacific.

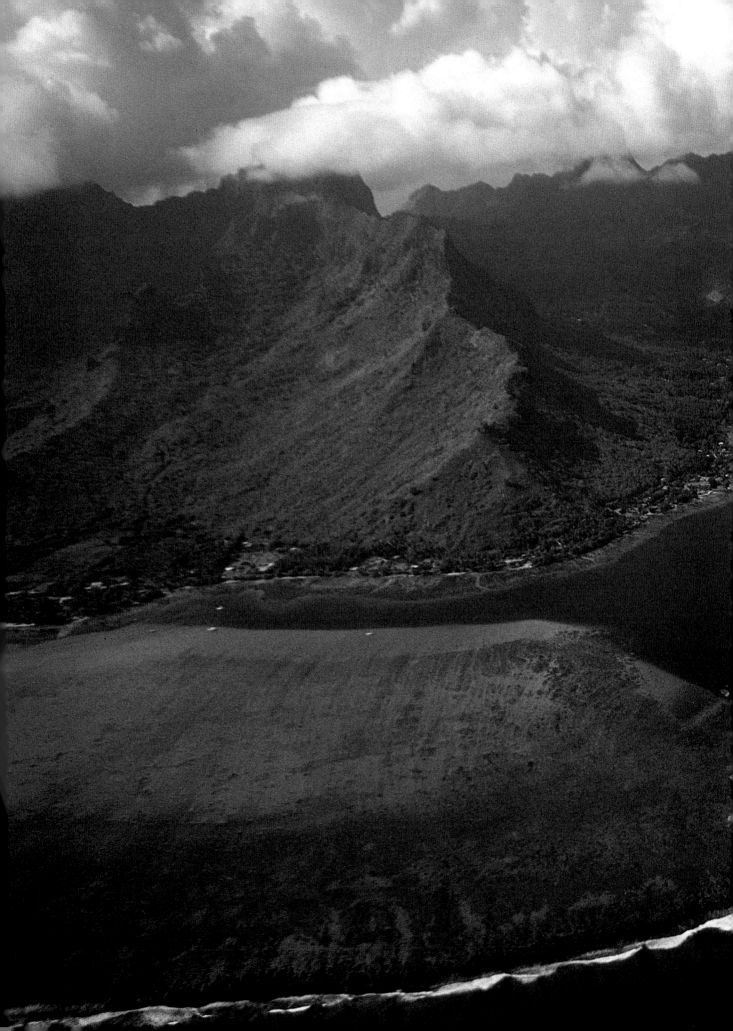

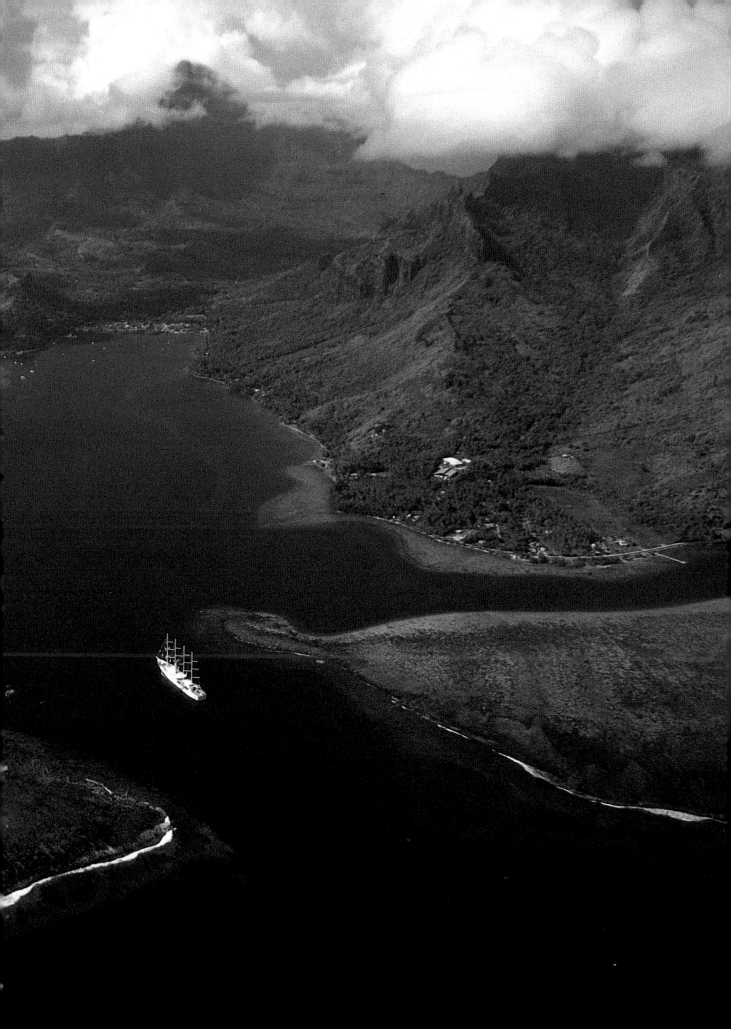

SHOOTING WITH THE LIGHT

I often try to fly at first light of dawn when photographing ships. First light is usually the time when local airports permit you to take off on any flight, weather permitting. I always arrive for a ship assignment before dawn. Minutes matter at this time—the light is changing so fast and comes up so quickly. I don't want to be worried with the many questions I must ask: Will the pilot be on time? How quickly can we prepare the chopper for takeoff? How long will it take to rig my cameras and equipment? It is the light I am nervous about missing. Aboard the chopper I always keep an alert eye on the east. Is it getting too light? Will the cloud banks part?

Within minutes of takeoff I usually sight the ship in the distance, its lights sparkling in the misty atmosphere. I always try to make contact on my marine radio. Unless equipped for sea-rescue missions, most helicopters do not have marine radio channels. If the ship is too far away, I can ask the harbor master to make the ship contact on his more powerful radio and then determine the exact location of the ship to our aircraft. The higher we go, the farther my on-board radio transmitter will reach. I use the standard channel 16. Once we make contact with a ship, I then switch to a prearranged channel and clear the air waves.

At this time of low light, my preferred lens is a Nikkor 50mm f/1.2 or 35mm f/1.4. Zoom lenses, which have maximum apertures of f/3.5 or f/4, are too slow for this light. The first exposures, at 1/8 to 1/15 sec. are possible only with the use of my gyro-stabilizer.

HELICOPTER CHOICES: AIRCRAFT VS. ASSIGNMENT

Two of the most interesting experiences I've had with helicopters involved a Bell Long Ranger and an Alouette. Both are very different aircraft, and the technical situations we encountered on location were also. But these experiences gave me some additional insight into aircraft and the people who fly them. You will fly in various aircraft on your assignments, some you will be comfortable with, some not. The most important thing to ask is: Will this type of aircraft help me get the job done best?

Flying Low in a Bell Long Ranger. On assignment in St. Thomas, Virgin Islands, I was flying with Pat Walter, pilot and president of Air There Airlines. Walter received the 1987 Helicopter Pilot of the Year award for his daring rescue work during the raging hotel fire in San Juan's Dupont Hotel. During that disaster, Walter bravely flew his Jet Ranger into the dense, black smoke on the rooftop, repeatedly put one skid down on the roof edge, and lifted people out of danger. He saved 24 lives. Walter was once a race car driver in Los Angeles—he likes to fly his helicopter as fast and low as he considers safe. But what *is* safe? I always feel calmer flying with a skilled pilot in a good machine at any altitude. But in the course of my aerial work, I've sometimes had to take both pilot and aircraft on faith. I am against recklessness at any time. It is a cliche that there are old mountain climbers and bold mountain climbers, but there are no old, bold mountain climbers. The greatest danger when flying with a "hot" pilot is that in your enthusiasm to get a unique photograph, you might egg him on to execute a potentially dangerous maneuver. Know your pilot! If you trust his work and you decide to go the limit for a great photograph, he will take you there safely. I trusted Walter's experience.

We flew over St. Thomas to wind up a shoot of the new high-tech luxury cruise liner *Seabourn Pride*, which had set out 10 days before

The hour at dawn called "first light" is a time of rapidly changing colors and light. To capture this scene over St. Thomas, Virgin Islands, I shot fast before dawn's colors faded.

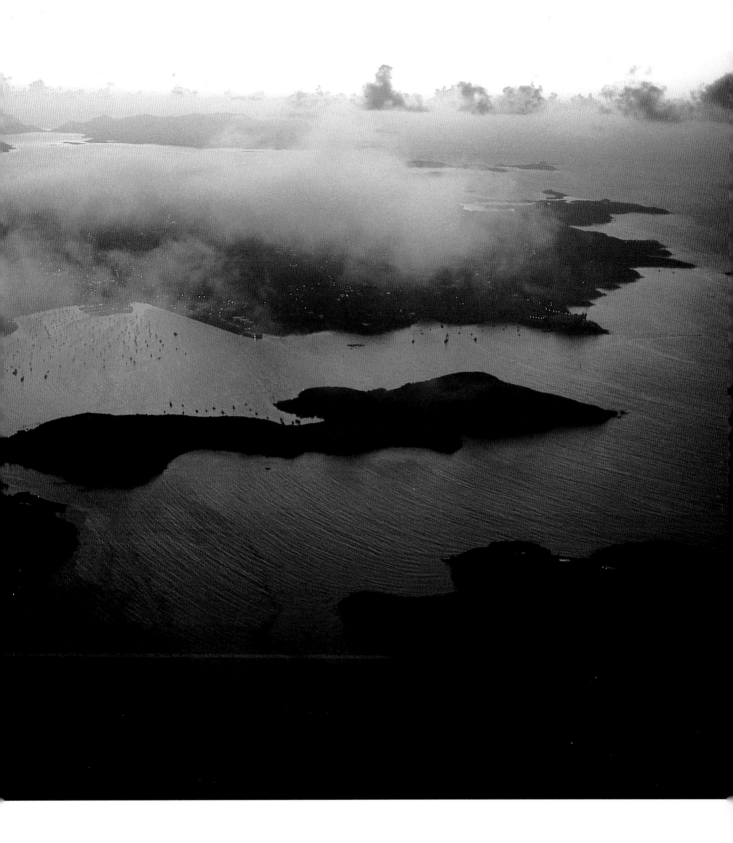

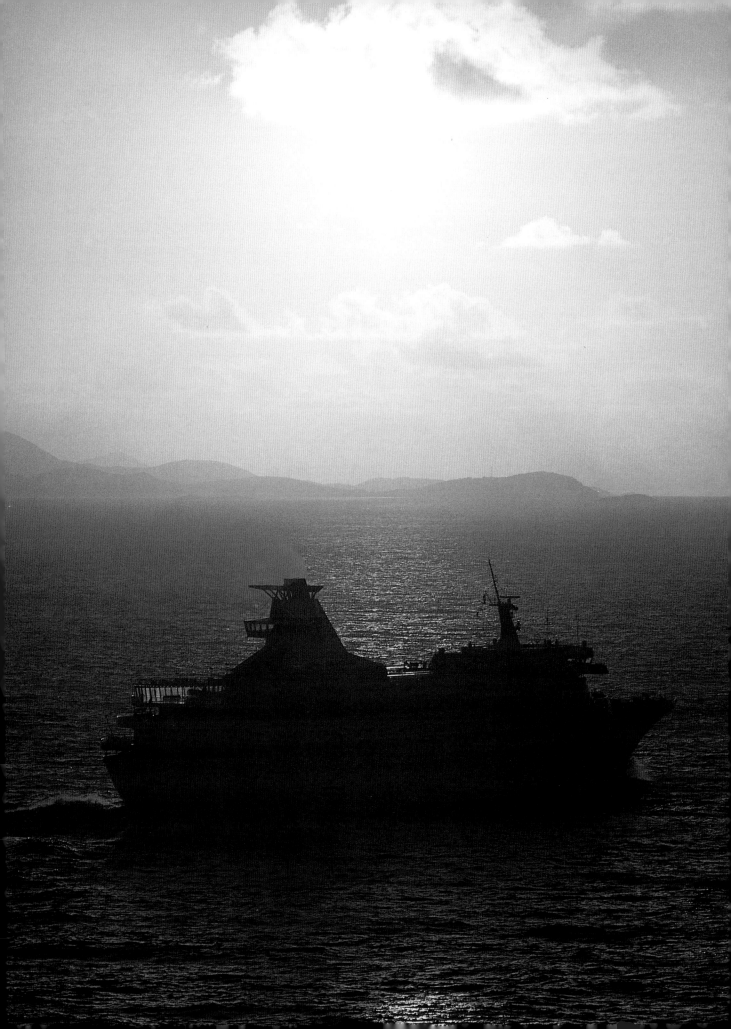

from Manaus, 1,000 miles up the Amazon River. Walter's Jet Ranger was temporarily out of commission, so he ushered me and my assistant, Shirlee Price, into his Long Ranger. We were hovering so low that the downwash from the big rotors was kicking ocean spray up through the open doors of the chopper. "Pat," I shouted, "I'm getting spray on the lens!" "We're waterskiing," quipped Price over the intercom.

I often fly with only one door off an aircraft to keep the wind blast in the cabin to a minimum. But on this trip, our target ship was sailing in various directions, so I decided to fly with both doors off and have better chances to photograph the ship in each direction. I could hover into the wind no matter which way the ship was traveling. The Long Ranger's rear cabin holds up to five people, three facing two. I sat in the center back seat, my seat belt strapped as loosely as it will go, the gaffer tape safety tabbed on the buckle. I was able to lean out to shoot. Because of the slight wind and tropical temperatures on that March day, the cabin was comfortable, with little buffeting about.

We darted around the *Seabourn Pride* like a giant hummingbird while I took photographs of it from low angles. This sleek ship looked best when photographed between 10 and 30 feet above sea level.

The passengers crowded the ship's upper decks, and were obviously delighted with Walter's aerial circus dance. They waved and I enthusiastically waved back. "You don't have to shake their hands," Price admonished me. Walter flung the agile Long Ranger around the ship. "He did a loop!" Price gasped. "He did not," I replied, "helicopters are *not designed* to make loops."

I later asked Walter about the dangers of flying so low. He told me that as long as the sea is calm, there is little problem. But other pilots have warned me against something referred to as the "Dead Man's Curve." That is the deadly combination of low altitude and slow air speed that mark the point of no return. Auto-rotation to a safe descent is rarely possible when you fly within this range. Hovering over water at low altitudes means that, in the event of engine failure, you go in— there is no time to inflate the skid floats. Flying by the book, on the other hand, may mean that you stay above 300 feet and maintain 30 mph of air speed over water. This can be more boring, photographically speaking, but it is much safer. The Long Ranger we were flying in was a superior craft, with plenty of extra power for emergencies. We didn't have to dive at the ocean (a terrifying maneuver) in order to gain flying speed after a low altitude hover.

Walter executed a series of tight turns and semi-loops to keep me in position over the speeding ship and to give me the exact angles I called for over the intercom. Caught up in the passion of the moment, my adrenalin high, I called out my directions. "Pat, hover . . . now back up. Stay in front of her. Now move back, she's gaining on us. Go around. Faster, faster. Stop. Hold it there. Watch the sun, Pat, get the ship between me and the setting sun. Hold it! Closer, lower."

Walter later told Shirlee that he could only do one maneuver at a time. What did I think I was doing? I was glad he was a cool-headed pilot who knew how to deal with an overly enthusiastic photographer. For a finale, Walter circled the ship at very close range, "dipping his wings" at the bridge. I waved good-bye to the ship's deck and passengers as we veered up into the sky.

I'd been photographing the ship for more than an hour. The sun had gone down. Soft pink and pearl-gray light suffused the clouds. I looked back to see a full moon above the ship! I asked Walter to use the marine radio to request the ship's captain to turn the ship in order for me to get a profile under the moon.

The decisive moment is always worth waiting for; in this image a Caribbean sunrise outlines a departing ship just as the sun came out from between the clouds.

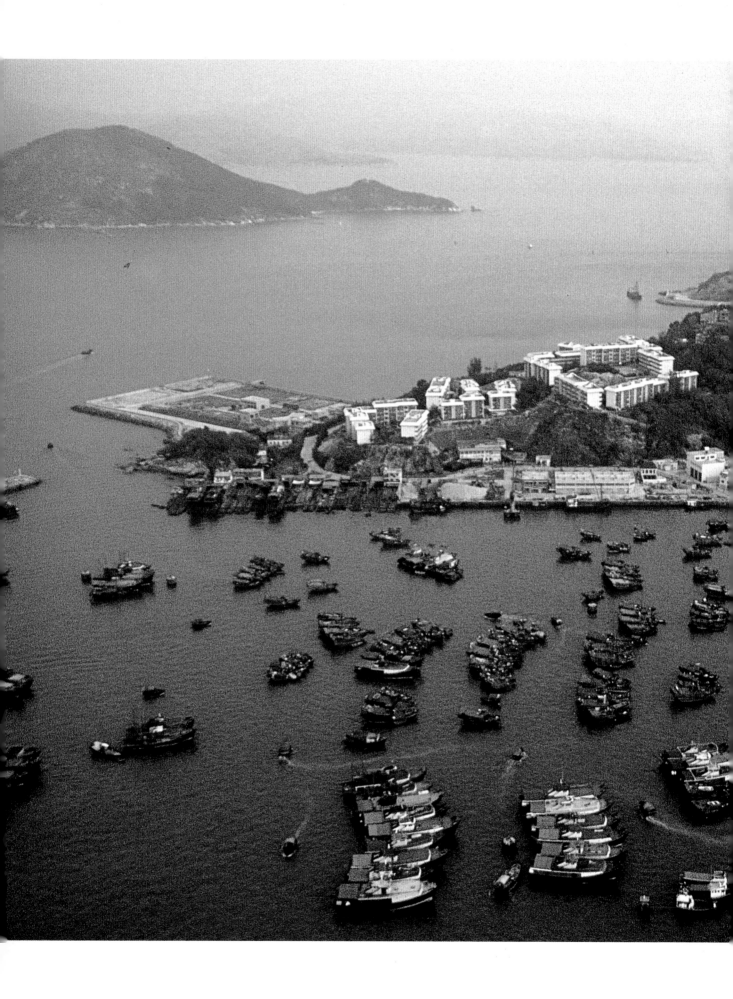

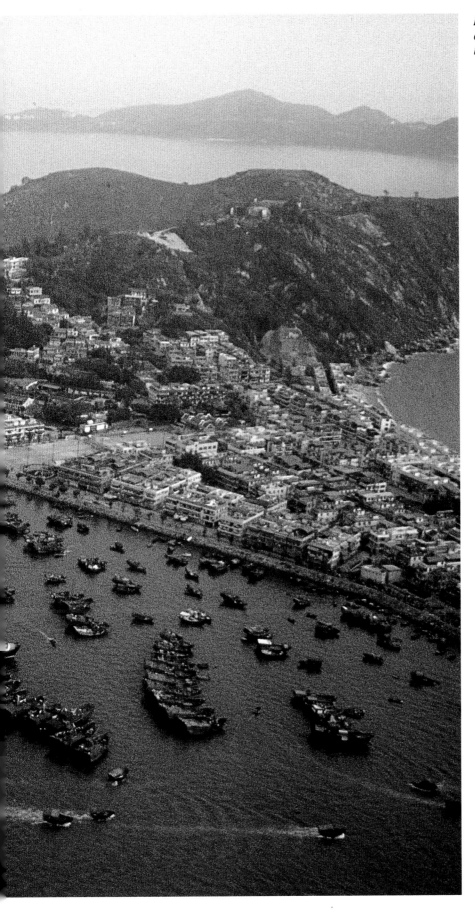

Hong Kong bay is shown in this aerial view taken during heavy traffic on the harbor.

I got my wish. *Seabourn Pride* turned slowly. We were running out of light. My exposures were down to 1/30 sec., with ISO 100 film in the camera. I had a 105mm *f*/1.8 lens to frame the ship for verticals, and a 50mm *f*/1.2 for horizontals. I quickly rated the film at ISO 200 and moved my shutter speed up to 1/60 sec. Only the gyro-stabilizer on my camera could make these exposures possible in this light. I fired away between bumps of vibration during our hover. I got the shots. The *Seabourn Pride* sailed serenely away on the darkening sea.

Climbing High in an Alouette. Another aerial mission had been to photograph the *Wind Song* in French Polynesia, on assignment for *Travel & Leisure* magazine. Pamela Fiore, editor of the magazine, was aboard the ship, and I kept in contact with her using my marine radio during my aerial flight. The helicopter we were using was an Alouette, a fascinating construction of open girders with a clear plastic bubble attached. The chopper resembled an armored insect.

On the runway just after dawn, before the flight, I stared across the 10 miles of ocean separating Moorea from Tahiti. *Wind Song* was due to sail into Moorea in an hour and a half. The sky was then overcast with clouds, and I began to worry. I turned to my pilot, Captain Tromble, and shrugged. I radioed the ship. "Please ask Pamela Fiore to come to the bridge, I must talk to her," I said. Fiore greeted me over the radio. "How is the weather over the ship, Pam?" "Not bad, a pretty dawn, with some clouds." "Okay, we'll try for the photographs."

My pilot and I boarded the Alouette. I quickly snapped on my seat belt, gaffer tape in place, and put on my headset before putting my camera strap over my head. This prevented the problem of tangling the headset cord when I changed cameras. Captain Tromble started the engines. In about two minutes, our turbines at top speed, we took off. "She should be just outside of Cook's Bay," I said.

We crossed the open sea between Tahiti and Moorea. The sky was still overcast, with broken clouds. Dawn light streamed down on the crags and green-covered mountains of Moorea. I spotted *Wind Song* sailing near Cook's Bay. I realized I'd have to photograph her a few miles away from the entrance to the bay. The passageway into Cook's Bay is a narrow inlet cut into the coral barrier reef. *Wind Song* could not risk being caught under sail in the inlet should a sudden wind come up, or it could possibly be driven onto the reef.

She looked great, but the weather had me worried. Suddenly, I got lucky. The high altocumulus clouds broke open. Sunlight streamed through and lit the ship's sails. Moorea's great mountains framed the images. I asked Captain Tromble to keep circling the ship, spiraling higher and higher in the wonderful Alouette. I leaned out of the open door into the cool breeze and fired my camera repeatedly. The now very tiny-looking ship sailed toward the inlet of Cook's Bay. She dropped her sails. My final images were of the bare-masted *Wind Song* entering the beautiful bay. A simple exercise really, but one that taught me something about changing weather conditions. Often you can be fooled by "local" weather. There are times, such as my experience shooting the *Wind Song*, when I had only one chance to photograph, weather conditions notwithstanding.

Helicopters are expensive to rent. The flight over Moorea cost more than $1,100. I called Pamela Fiore for two reasons, not only to check on the weather. I also wanted to get her involved in my decision to go up. When the clients are along, it pays to consult with them and make them aware of options. We both made the right decision that time: go up and fly. The pictures are images of one of the most beautiful places I have ever flown over.

RULES FOR HELICOPTER SAFETY

Safety on any aerial assignment is a concern of utmost importance. Whether the aircraft is one you have flown in before or a new one, you must be sure you are in the hands of a good pilot, and that you make security checks yourself. To go into any aircraft without some review of safety procedures is a bad risk. Your flight crew will usually instruct you capably in safety procedures—*follow them carefully*. Panic is your worst enemy; be prepared in case of any emergency by having at least an understanding of helicopter procedures:

- ***Keep operating launch areas clear.***
 Make sure the approach and ascent areas are clear of all personnel, cargo, and any articles that may be blown around by the heavy downdraft of the aircraft's rotors.

- ***Approach the helicopter with caution.***
 The helicopter is usually safe, but areas such as the rotors (especially the "invisible" tail rotor), skids, and doors should be watched. Make sure the areas around them are clear; don't enter the helicopter without a pilot in sight of your approach. Always approach the helicopter in a crouched position—never stand up.

- ***Secure all equipment and clothing.***
 When entering or leaving the helicopter, make sure any equipment, such as skis, tools, and tripods, are carried *horizontally* below waist level. Never approach the aircraft with equipment raised above shoulder level. Make sure that loose articles of clothing are tightly secured and will not blow up in the direction of the rotors.

- ***Fasten your seat belt.***
 Make sure you are securely fastened into your seat. Use gaffer tape as an extra precaution. It can be removed quickly in case of an emergency. Appropriate life vests should also be worn when working above water. Your pilot will instruct you in its proper use.

- ***Observe smoking rules.***
 Don't smoke at all during a flight if you can help it. Smoking is forbidden in or near the helicopter when it is on the ground. Ask pilot for smoking approval.

- ***Do not slam helicopter doors.***
 Open and shut the doors carefully. If you are unable to maneuver them, ask for assistance.

- ***Be careful with cargo.***
 Load and unload any equipment carefully. Do not drop, throw, or jam your equipment around in the cabin. Hazardous cargo may only be loaded in accordance with safety regulations. Make sure you advise your pilot of the actual weight of any equipment you bring in the cabin.

- ***Always exit downhill.***
 On uneven ground landings, always exit the craft on the downhill side, *never* on the uphill side where the rotors are closer to the level ground.

SCOUTING ON LOCATION: AUSTRALIA

Location shooting in distant places can be a morass of schedules, budgets, equipment, and people. It is important to ensure the success of any involved assignment by getting into the habit of careful planning. Aerial photography involves so many variables. Weather and tight schedules are most likely to cause costly delays in even the best laid plans—you must always have backup plans in case the unexpected happens. It always does in this business.

An aerial scout of a location, when the budget allows one, helps you determine the probable conditions of land and weather, amount of air time needed for the shoot, as well as how much extra work might be entailed in bringing a project to completion. Scouting your location before the final shoot is a good way of mapping your intended assignment; it will give you a feel for the terrain, and is a visual preview of your subject.

One such assignment, for the Royal Viking cruise line, proved a very good lesson in making everything come together on a complex shoot. This project went well because I was ready for it—I planned ahead, budgeted in a great deal of time for weather days, and I made sure to rely on my client and associates to add important suggestions. Two important factors in the following account of this assignment were overcoming changing weather conditions and having to prepare for an extended number of days' shooting.

The client urgently needed the images for a new advertising campaign. I had to work very closely with the creative director of the ad agency. His design ideas had to be realized in my photographs. My aim was to execute his ideas, and to add that "something extra" which I believe make my work stand out. As always, careful planning and teamwork are the keys to success.

Preliminaries—Sydney, Australia. I arrived in this city on January 28, after flying from New York City two days earlier via Los Angeles, Honolulu, and Auckland (losing a day crossing the International Date Line). Rich Silverstein, creative director of Goodby, Berlin & Silverstein, the ad agency, was due to join my crew on January 30; the liner we were assigned to photograph, the Royal Viking *Sun*, was not due into harbor until February 1.

I came to Sydney early in order to arrange a location scouting flight. Also, I wanted to get some shots of this port of call to use as stock images for the shoot—layouts for the ad campaign needed to include scenes of each of the ship's stops. As it turned out, we had excellent weather in the city *until* the day that the *Sun* docked! On that day it rained precisely during the one hour that the ship entered the channel. That's why planning enough weather days is so important.

The ship's next scheduled stop was Cid Harbor; we planned to travel to Hamilton Island, in the Whitsunday Islands, the next day. This location was the nearest to the ship's destination. But it was raining on Hamilton Island, too, and continued to rain for the next three days! Throughout our stay on the island I kept in constant touch with Universal Weather and Aviation, a worldwide forecasting service based in Houston, Texas. The forecasts were not positive: we were in monsoon season for the area and heavy rains were expected. While I usually prefer to choose locations based on good seasonal weather conditions, in this case that was unrealistic. The *Sun* was on her maiden voyage—a time slot we could not change. So, we just had to sit back for a while and wait. Then, the day before the *Sun* arrived, the weather cleared. Elated, we set out on our preliminary aerial scout.

Above, the Whitsunday Islands, Australia, was where we stopped over on the first leg of our location scout. This destination was the closest to the ship's next port of arrival, Cid Harbor.

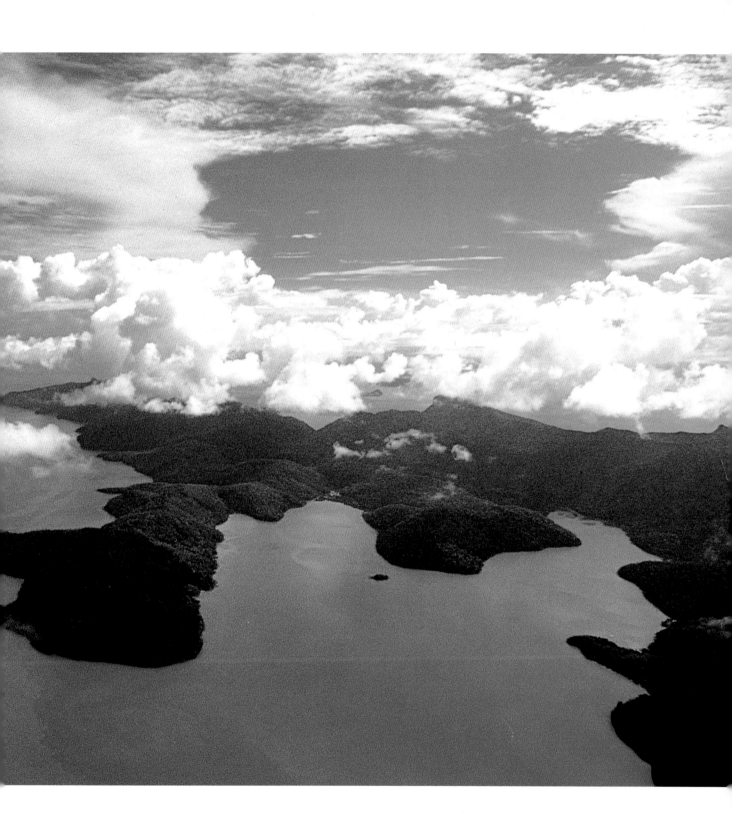

Flight preparations. I stood next to a bright yellow Jet Ranger helicopter, which I decided to shoot from with one of its two doors off. Our pilot helped me prepare for my shoot by buckling part of a heavy safety harness to my legs so that I could lean far out of the helicopter when I needed to. This type of aircraft has large pontoons on it that can get into the picture area when you're shooting with a wide-angle lens; the safety harness would enable me to clear the pontoons when shooting. I sat down inside the open cabin and our pilot strapped the tether to my seat belt straps, twisting a loop in each for added security. I asked my associate, Shirlee Price, to be sure that she could unfasten it quickly in an emergency. She tested it and assured me it was secure.

Price entered the cabin and started preparing the camera equipment. Because it was a very bright day with scattered clouds I planned to use my 25–50mm and 35–105mm zoom lenses. I also attached polarizers to deepen the colors of the water and add contrast to the clouds. In addition, I used several fast single-focal-length lenses: 50mm $f/1.4$, 24mm $f/2$, and 105mm $f/1.8$. Three of my four Nikon F3 bodies were equipped with motor drives for fast shooting. This selection of equipment would give me a wide scope of compositional choices for the shoot. My film was a combination of fine-grain ISO 50 and ISO 100 to bring out detail. The approximately 50 rolls of film were kept in my photo vest, along with extra filters, batteries, lens tissue, and other small accessories.

Price sat across from me, with the door on her side of the cabin closed. When both doors are off during a flight you risk having a strong wind constantly streaming in the cabin. On calm days, I often take off both doors in order to position the helicopter to hover into the wind. (Since I usually prefer to be on the sunny side of my subject, and

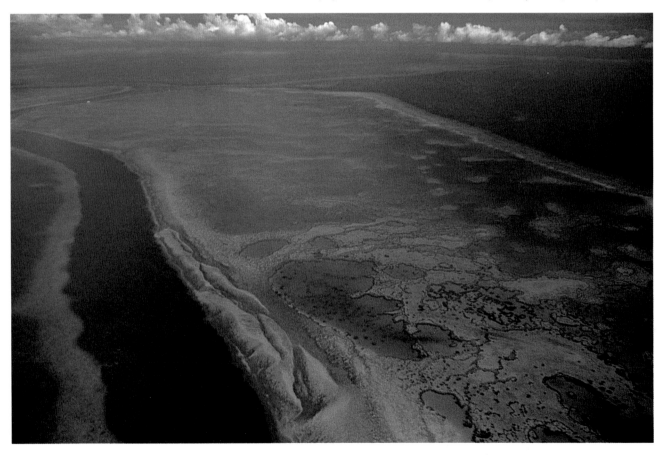

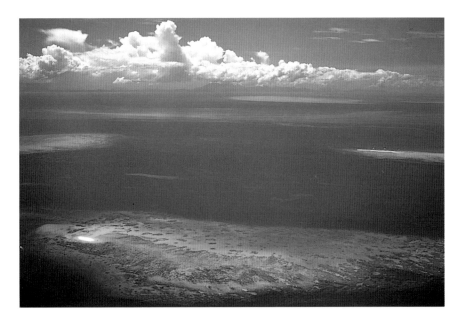

helicopters can only hover going *into* the wind, working with two doors off is the better option). While Price arranged the equipment I started up my gyro-stabilizer and attached a custom-built quick-release device on the bottom of my motor drive. This device prevented my quick-release mechanism from turning under the torque of the gyro. The gyro must face directly forward on the same axis as the lens. It took the gyro about six to eight minutes to get up to full speed. I allow for this time in my flight planning so I won't arrive at the subject before the gyro is ready. I hung my digital spotmeter around my neck, then I put on my headset so that I could communicate with the pilot. Headsets come with either voice-activated or button-activated microphones. Voice-activated models are preferable in most cases, unless you'll be leaning out of the plane a lot—as I was in this instance—the wind activates the mike and the ensuing roar annoys everyone on board. Button-activated mikes are awkward because it's hard to feel for the button and try to talk to the pilot while you're shooting. Luckily, on this assignment I encountered a floor switch for the headset, which made using the button-activated mike ideal for the shoot. After all equipment and communications checks were made we were ready to get airborne.

In the Air. Our aerial scout was a revelation; from ground level we had no idea of the beauty of the terrain of this island chain located 30 miles inside Australia's Great Barrier Reef. The islands are hilly, with scalloped coves and bays covered with bright green foliage. The surrounding waters were emerald green and deep blue; the sky was filled with puffy, cumulus clouds. We flew over the landscape for an hour, and I photographed a quantity of images using the various lenses I had brought along. I felt secure in knowing I had captured a usable amount of images that could be later worked into the proposed ad layouts. The following day, when the *Sun* docked at Cid Harbor, we had another chance to fly up and take many more pictures.

Arrival at Cid Harbor. The ship was scheduled to arrive about five miles from the heliport at Hamilton Island, our base. Our assignment operations were greatly helped during this time by Hamilton Island's Special Events Manager (and general trouble-shooter) Peter Komenda, who was an invaluable associate in keeping schedules arranged and

on time. The *Sun*'s anchor time was scheduled for just after sunrise, at 7 A.M. We would have to be in the air at first light (approximately 6:25 A.M.), find the ship, and follow her in our helicopter. The evening before I asked Komenda to arrange our aircraft, a Jet Ranger, to be ready at 6:00 A.M. Komenda would pick us up at 5:45 A.M. That night I set my alarm *and* called the night desk clerk for a wake-up call as a backup. On nights before dawn flights I usually awake every hour or so; I'm always concerned about how the weather will be. That night there was only rain. I went back to fitfull sleep.

At 5:00 A.M., wide awake, I looked out of my window. Stars! Clearing skies! I went downstairs and waited anxiously for the others. We arrived at the heliport to find our pilot already wheeling the aircraft out onto the runway. Price and I did our pre-flight check and preparation of equipment; I got into my safety harness and waited for further communications from the pilot, who had prepared radio contact with the ship. The *Sun*'s crew responded with her position, seven miles out of Cid Harbor. We were off.

Finding the ship, I was amazed at her beauty in this dawn: she was ablaze with lights, all her flags and pennants flying as had been previously arranged for us with my old friend, Captain Ola Harsheim. There was enough initial light to begin shooting, and I started with my fast 35mm *f*/1.4 lens, set at 1/15 sec. My gyro-stabilizer accommodated my slow shutter speeds. The sky was pink behind the ship; I asked the pilot to hang low just in front of her bow. I framed the ship's silhouette against the dawn glow. Then we circled her, hovering at different altitudes. I photographed using all of my fast single-focal-length lenses, and ISO 100 film.

Rich Silverstein and I were enthralled at the softly changing dawn colors beginning to show in the scattered cloud layers. We were both excited by the picture possibilities as the chopper wheeled around and I fired off shots. Finally, the ship pulled into anchor below us. We took time out to land the chopper on a nearby beach, and waited to go up again at actual sunrise. In the air a short time later, I concentrated on getting shots of the *Sun* from increasing degrees of altitude to reveal the panorama of the surrounding islands. Satisfied, we decided to land once again, and fly up later when the sun was higher in the sky.

Working With a Layout. This break period gave us a needed rest. At breakfast, Silverstein showed me sketches of possible layouts. He had prepared one in particular, in the hope that the weather conditions would permit trying to capture it in a photograph. His sketch depicted a tiny *Sun* at anchor near the group of islands; the scene was viewed from high above, through a hole in a bank of clouds. We had tried for this effect the day before, but our pilot refused to go through the cloud bank at the visibility then available. If the holes in the clouds did not stay open, he didn't want to risk being trapped above the cloud cover. With this day's improved weather and cloud conditions so much better, Silverstein and I decided to try again for the effect in his sketch when we next went up.

At 12:30 we alerted Komenda and went to the heliport for a 1:00 P.M. rendezvous with our pilot. On arriving at the hangar, we saw that our aircraft was there, but the pilot was nowhere in sight. Komenda went to find out if he could locate him. We hoped the pilot just knew to be there on time. Komenda returned. Still no pilot. So, Komenda prepared to pull out the chopper from the hangar by himself. Time was running out. Just as we were getting really nervous about schedules, our pilot

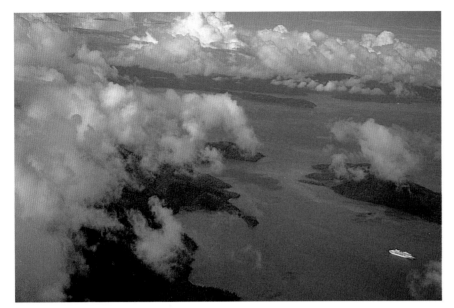

arrived. We breathed a sigh of relief and started our flight preparations.

At takeoff the weather was better than that on the previous day. The sky was clear blue with white cumulus clouds piled layer upon layer across it. We flew to Cid Harbor where the *Sun* lay at anchor. I used my slow zoom lenses this time: 25–50mm, 35–105mm, 80–200mm—because of the bright light conditions. I asked the pilot to fly up over the lower layer of broken clouds first. At about 2,000 feet, we all looked down—uncannily, the scene was almost exactly the scene depicted in Silverstein's sketch for the layout! Far below us, seen through a vast hole in the cloud layer, the tiny ship glistened white on the emerald waters, set like a shimmering pearl among the rolling hills of the Whitsunday Islands.

We circled high and low above the ship looking for different perspectives. I bracketed my shots through roll after roll of film. Finally, I signalled Silverstein a thumbs up. "We have it," I said. He agreed happily. I then directed our pilot to fly out to the Great Barrier Reef, a distance of approximately twenty-five miles.

At the reef I worked with zoom lenses again and used polarizers to deepen the iridescent shades of green and blue appearing in unusual patterns in the shallow waters among the coral reefs. This subject too, proved a fruitful one for the shoot. I took many images, explored hundreds of angles and compositions, and came away satisfied. After a while I told our pilot to fly back down, to prepare another rest before our next scheduled flight at 6:00 P.M. that evening. And so it went, successfully, as we trailed after the *Sun* on her maiden voyage around the world and captured it all on film.

The aerial scouts and the final shoots were successful because we prepared so much in advance. We came back from the assignments with a great deal of usable material, and the client was very happy. The project depended on communication and planning; we all worked together to bring it to this final moment. Good luck played a part, too. But when the light, weather, and your subject are in sync, you must be ready for the moment; you must have all tools in hand, know how to use them to get the pictures you want, and then use them to your advantage. You only get one chance on most assignments, and, like an Olympic athlete, all your training must prepare you for a win.

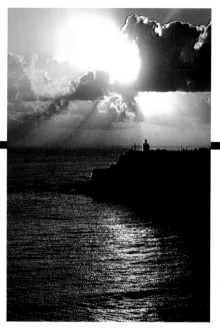

COLOR AND MOOD

Your color instinct will improve with experience

Color has a voice, an ancient voice. That voice sings to you with old melodies that reach deep into your subconscious, deep down to archetypal patterns. Black-and-white images are abstractions of the "reality" around us. Color images are abstract, too, but they stir your passions. You feel color inside your skin. In their book *Seeing with the Mind's Eye*, authors Michael Samuels, M.C., and Nancy Samuels observe, "Psychologists believe that color affects a person directly, below the level of rational thought. Whereas interpretation is necessary to the recognition of form, a person reacts spontaneously to color." They also quote New York psychologist Dr. John Schactel, "Colors are not only—and usually not even—'recognized,' but rather they are *felt* as exciting or soothing, dissonant or harmonious . . . joyous or somber, warm or cool, disturbing, distracting, or conducive to concentration and tranquility."

It has been said, rather simplistically, that color photography is *about* color. Of course, it's about other things as well—composition, content, light, contrast—but if the color in a photograph is poorly presented the image doesn't come together as a whole. In my work I aim to create mood through an image that will be memorable, that will provoke in the viewer a passionate desire to be *there*. Many of my subjects are cruise ships. My experience has shown that a ship looks best in a certain light, a particular hue of color and angle of composition. The surrounding seascape or landscape adds to the image and is affected by the same factors.

Color is the greatest single influence in setting mood in a picture. To create mood in a color photograph, you must learn to see and recognize the different qualities of light. You'll gain an instinct for color, mood, and composition after photographing many images. Instinct is sensitized by experience. Photography is, after all, a reflective art as well as a physical one. To sharpen your color instincts and perceptions, you must *study* color. Have your ever really *looked* at the many differences in the quality and quantity of light? Consider these examples of the ever-changing *presence* of color:

- Dawn, with its golden skies and waters, and the great shadows cast by objects

- the light after a thunderstorm, which lingers with a singular clarity

- the colors at sunset reflected on still ocean waters—the soft pinks, mauves, violets, and purples of the afterglow—often with the evening star or crescent moon hung in a darkening sky

- the great shafts of light that stream through masses of dark clouds

- the luminosity of the light and air in winter skies

- midday light over waters of the Caribbean, revealing shades of aquamarine, turquoise, and sea green

Chapter Four

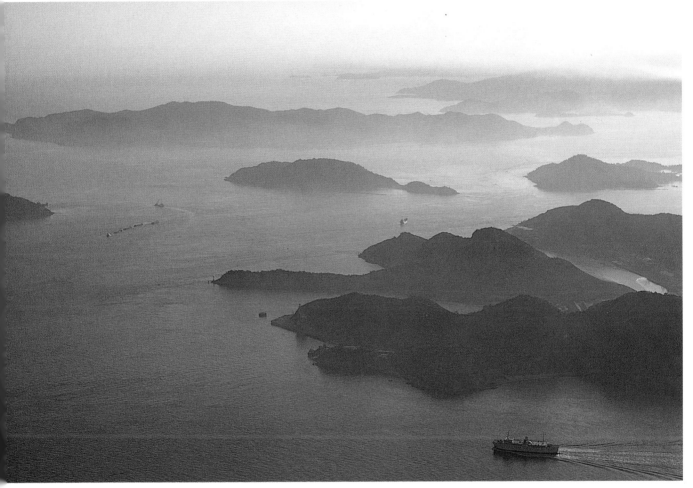

Look around you every day; notice the way light changes, reflects, absorbs, and combines color. There are countless examples of this wonderful medium and ways to express it in your aerial images. To capture the mood I want, I think and prepare, and then I wait for the serendipity of the unexpected. I watch for a radiant palette of light and use it to create images that reveal the beauty of the natural world.

Light creates color and light creates pattern. The recognition of significant patterns in the apparent chaos of nature is what we must train our eyes to see. Nothing of the sky, sea, land, and the light that envelopes them is ever the same twice. The colors you see are only the sum of hue, value, and chroma at a particular moment—and they change constantly. Using too little color in an aerial image or colors that are drab or harsh, tends to dull the viewer's visual interest. These colors are hard on the eyes, and they do not readily catch and arouse our color sense. On your assignments, carefully choose the right time

In this image of the Sea of Japan the quiet mood of early morning is evoked by the soft gradations of blue color shading from foreground to background.

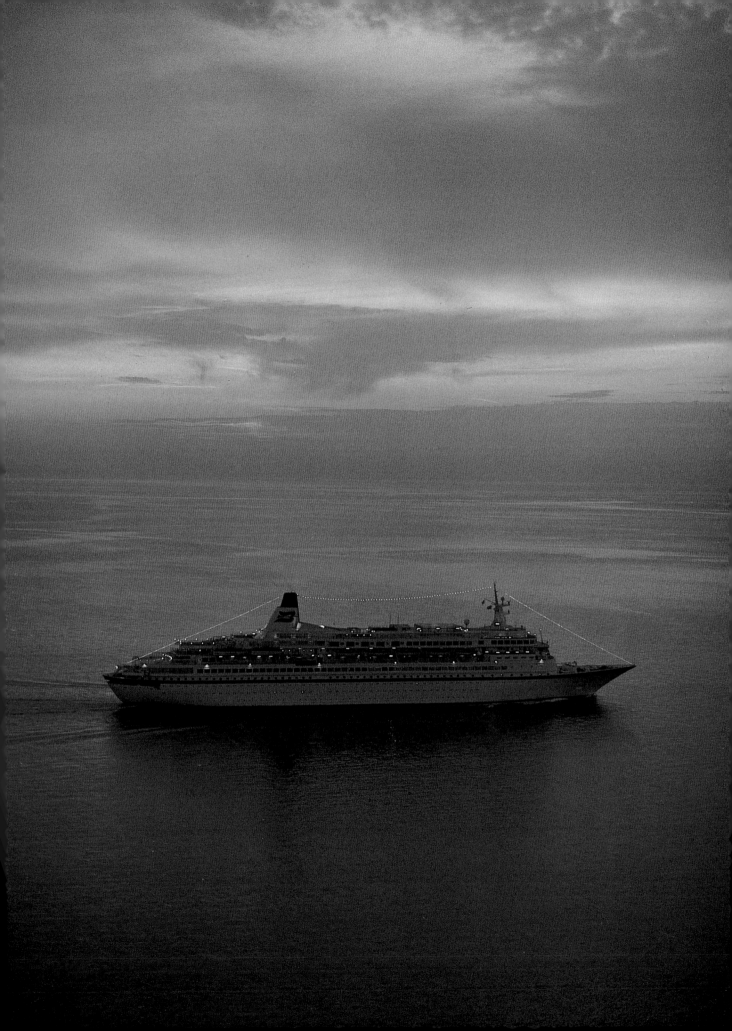

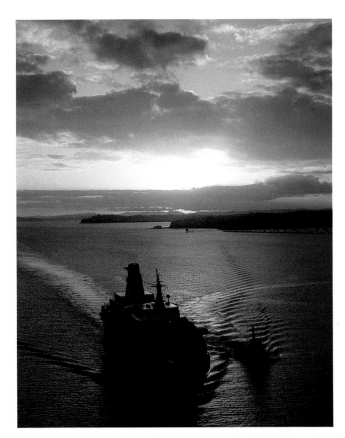 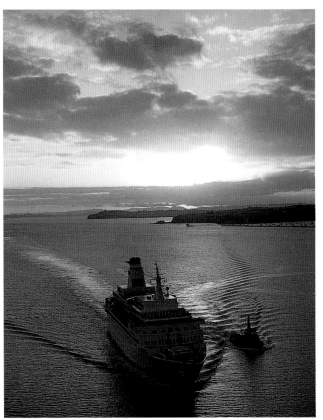

of day and the weather for capturing the kind of color that enhances the mood of your subject and your vision. Look for those notes of pure color that will lift your subject out of its background. Learn to see your subject in more than one light; notice the changes in it during different times of the day. Light and color are catalysts for all of your work— become sensitive to their qualities and how best you can create images with them.

COLOR SENSE AND SENSITIVITY

How can you learn to see colors from a vantage point in the air in a fresh way, and reproduce them in your images? How can you convey to someone who was not there how you experienced the color that moment? First, you must learn to *see* color, and then manipulate it for the strongest use in your compositions. Too many colors crammed into an image create a kaleidoscopic effect; in the same way, colors viewed from the air often blend together in a scene. The aerial photographer must learn to select and isolate the strongest visual signals. This may call for special effort, because, in truth, many of us hardly see at all—even though we're aware that the eye is drawn to strong visual contrasts. Many of us are even timid about color; we tend to see color-film prints as "unreal," or "false" representations of what we physically experience when looking at the natural world.

Astronauts have brought back to us staggeringly new views of the Earth and other planets as seen from space. The extraordinary colors in these scenes have now become familiar to us. Even more, the colors the human eye cannot see directly—the color-enhanced images made by satellites and processed by computer for example—have impressed themselves on our memory as representations of these.

Exposure differences change color contrasts, as can be seen in these images of a sunset over Auckland, New Zealand. The exposure used in the image on the left adds brilliance to the colors of the sky but obscures the detail of the ship. In the image at right, exposure is added to the ship and water, but the sky is still well exposed.

The colors of the sky in the image on the opposite page, taken above the waters off Crete, were constantly changing their hue. I bracketed my shots and got a variety of exposures.

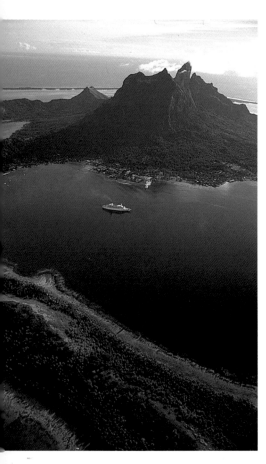

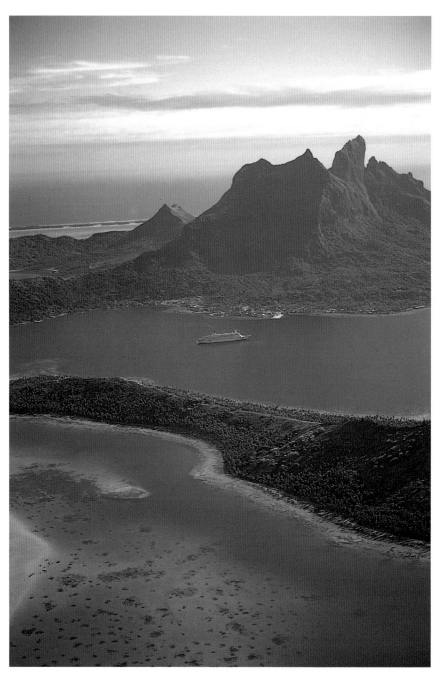

When photographing a subject with close color values (the lightness or darkness of a single color), use a range of different exposures to bring out the color's varying tones.

AERIAL PHOTOGRAPHY

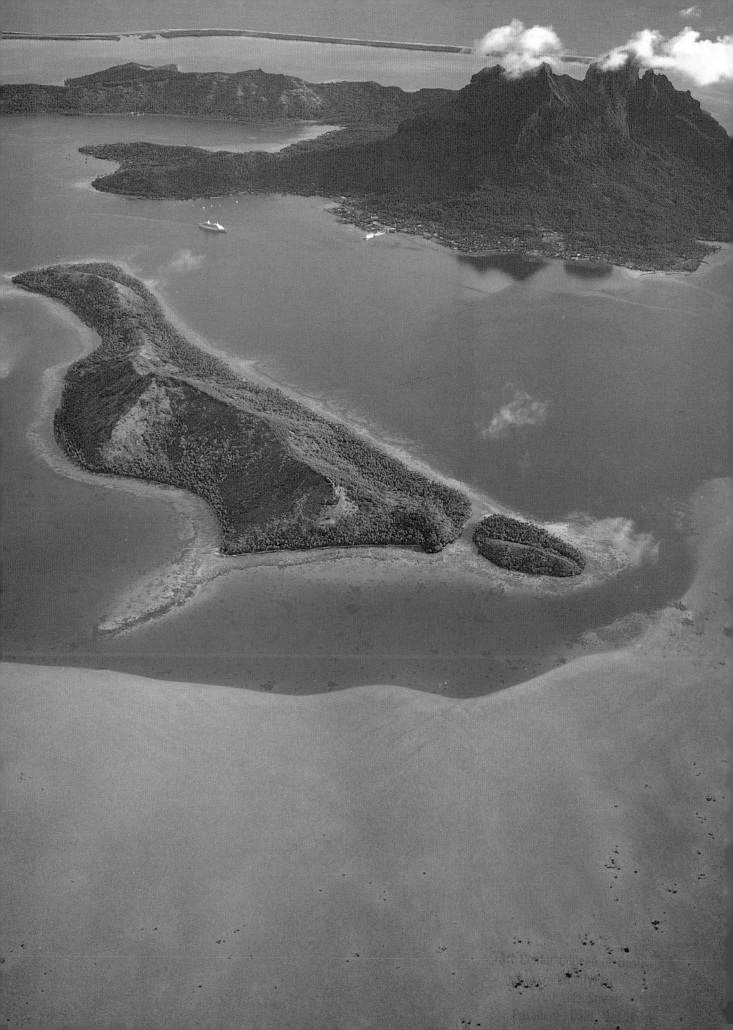

What is "true" color? Which artists have found its essence? Leonardo, Rembrandt, Velazquez—with their rich, yet somber tones; Turner's radiant palettes of light; the intensities of Van Gogh's primary colors; Matisse; O'Keeffe—all of these artists have explored and helped define our perception of color and its effects on our perception of mood. The great color photographers, too—Ernst Haas, Pete Turner, Greg Heisler, Joel Meyerowitz, Steve Wilkes, Alex Webb, to name a few, also explore and teach us about color. Study their work. Are any of their colors less "true"? How do their depictions of objects in the natural world relate (or not) to the way *you* see those objects?

Why do we perceive color at all? The eye processes information at the retina, which is essentially a kind of computer composed of millions of sensory neurons woven together in a fantastic tapestry. The retina selects and organizes an incredible quantity of color information that streams into the eye constantly. The way we interpret color is entirely subjective and culturally conditioned. The ancient Greeks had no word for blue. The Natchez Indians perceived no difference between green and yellow. The Eskimos have *hundreds* of words for the exact hues of snow and ice. In sensitizing your eyes to the way you perceive color, you must free yourself from your ingrained mental color habits. Here are a few simple exercises to help you learn to see color freshly and to take you away from routine visual signals:

• Light has three primary colors—red, green, and blue— and three secondary colors made from combining two of the primary colors— magenta (red + blue), cyan (blue + green), yellow (green + red). Select one of these colors and spend a day finding and photographing it in a variety of scenes. What does this teach you about isolating colors? About letting one color dominate a specific scene—a red balloon in a blue sky, a yellow or blue flower in a green field, an orange chair on a white beach, a blue ski in white snow? Which colors come forward in the image? Which colors recede?

• See how little color you need in a scene to make it "colorful." Consider, for instance, the impact of a few colored marbles on a white table, a red starfish in a green pool, a weathered barn in a wheat field, or a bright blue umbrella on a rainy day. Does the color look the same when it is used with different background colors?

• Look for muted harmonies of color: the pattern of fields as seen from above, a golden river delta at sunset, the blue-purple tints of mountains in the dusk, the different tones of water.

• Photograph a pure white object in different kinds of light: dawn, midday, sunset, overcast, brilliant sunshine, and open shade. Then look at your images and study how the white object reflected color in various situations. How is the object seen in various shades of light and dark in relation to color?

When you have become more sensitive to pure color, you'll begin to incorporate it into your aerial images. You'll be able to perceive the scenes you are photographing in such a way as to make *color* the important player, if not the star, of your work. When you're flying, practice looking through your viewfinder with each of your eyes rather than just the one you naturally use. This will help you strengthen your color perception as well as your sense of visual composition.

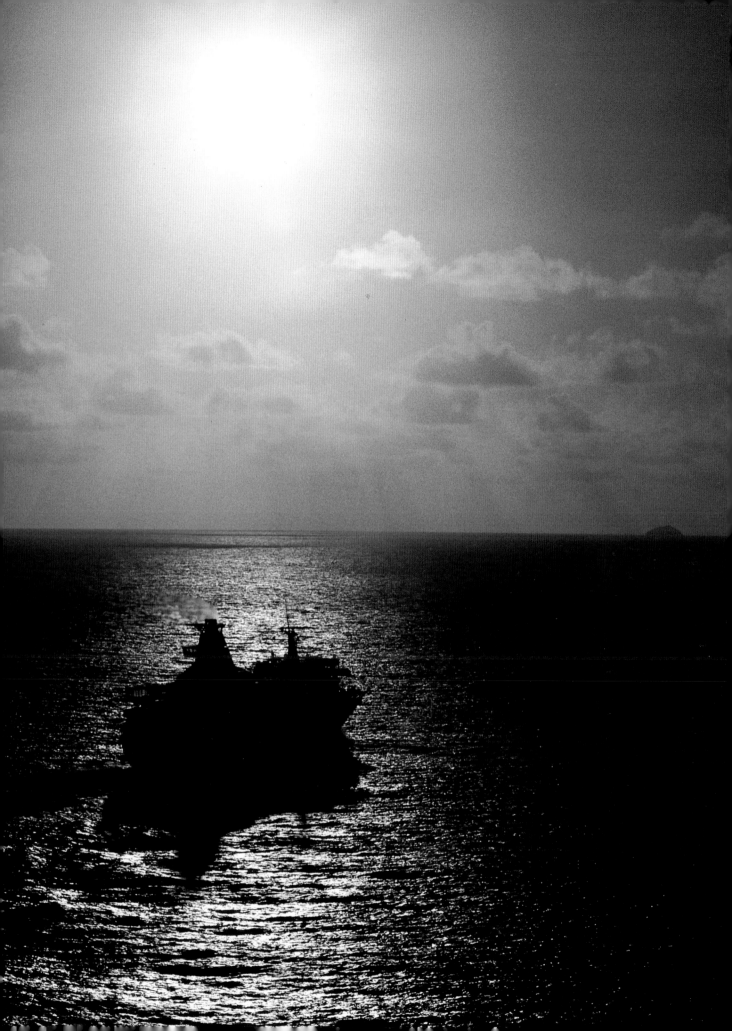

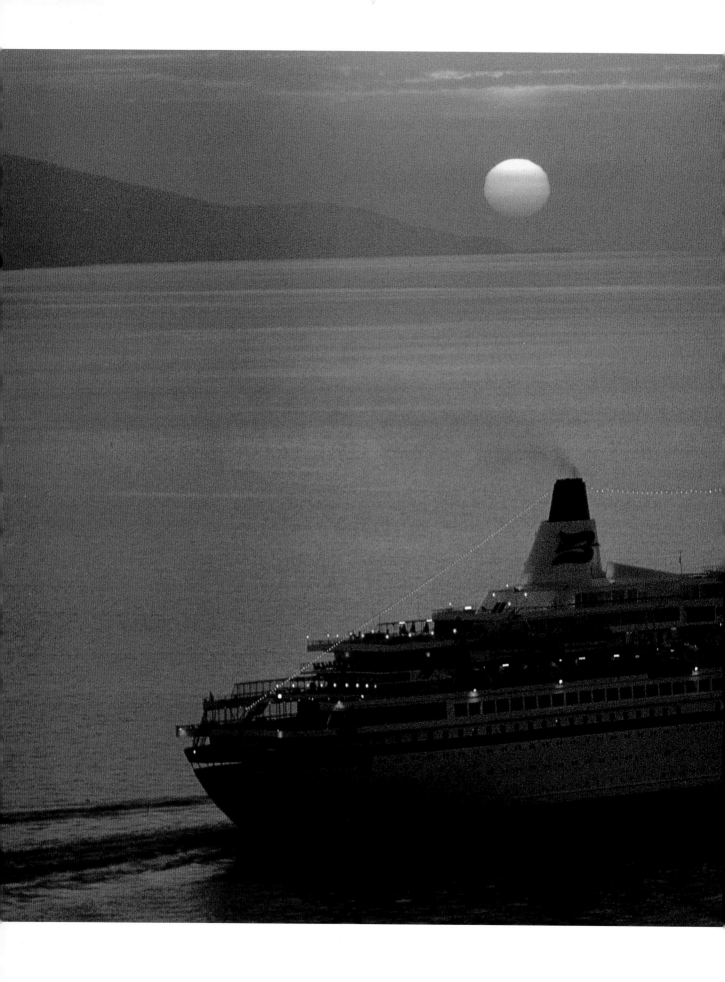

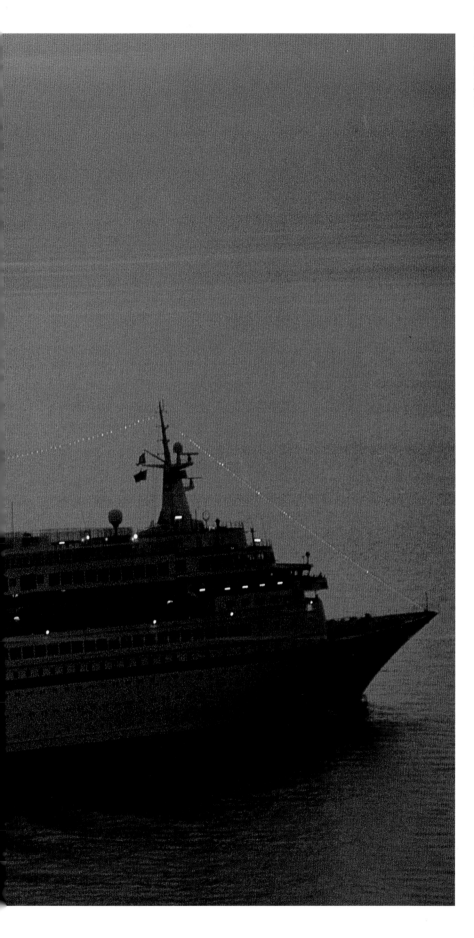

To obtain fine detail and rich color values throughout an image, use the slowest speed film available. Here, all the gradations of color in the sea and sky are crisply defined.

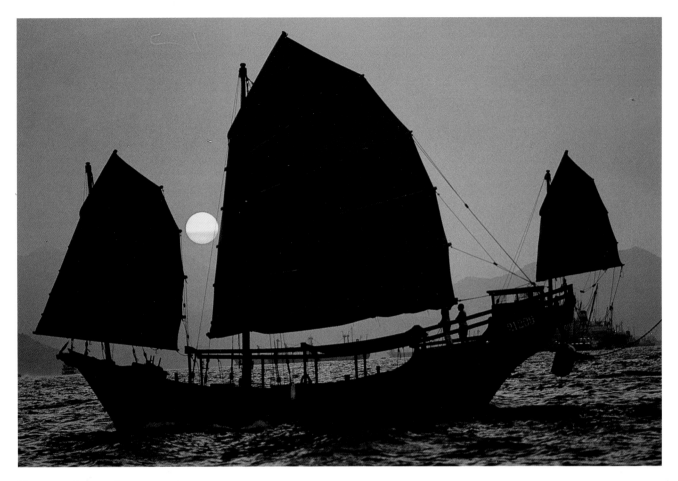

Haze can be used to your advantage in many situations; in this image taken in Hong Kong, the dark foreground helps propel the orange disk of the sun toward the viewer. The haze created the perfect colors for the contrasting images.

The bright white of the sails in the photograph on the opposite page is purely rendered and heightened by the dark background. White is usually one of the most difficult colors to reproduce on film because of varying color casts in film emulsions.

FILM AND COLOR PERCEPTION

Photography's 150-year history has been too brief to evaluate the impact of color on film. Today our film technology is still insufficient to perfectly render the multitude of colors found in nature. In the days of less-costly printing processes books about painters were often printed using seven, nine, eleven, or even more colors of inks in order to match the many colors in the painters's palettes; yet today printers represent natural color by using only the three primary colors of the film emulsion. In a sense, the limitations of film offer a challenge to photographers to create a unique interpretation of color as seen in the context of particular film characteristics.

Students often ask me whether color is different when seen from the air, whether the haze or ultra-violet light affects the film. I always answer that these are the small factors. When photographing in the air, I use the same film and the same filters or polarizers as I use on the ground. It's not a matter of accessories; it's a matter of seeing color, of looking for it, and feeling it.

Choosing the Right Film. Here are some tips to consider when choosing color film for aerial work; some of these pertain to the film itself, such as its grain content; others pertain to saturation, the richness of color film rendered on certain emulsions:

• ***Use the slowest film possible***. Slow films, with ISO ratings of 25 to 100, have much finer grain and therefore can render detail quite easily. When you're high up, your images must have a lot of detail in them to help viewers distinguish particular objects and scenes.

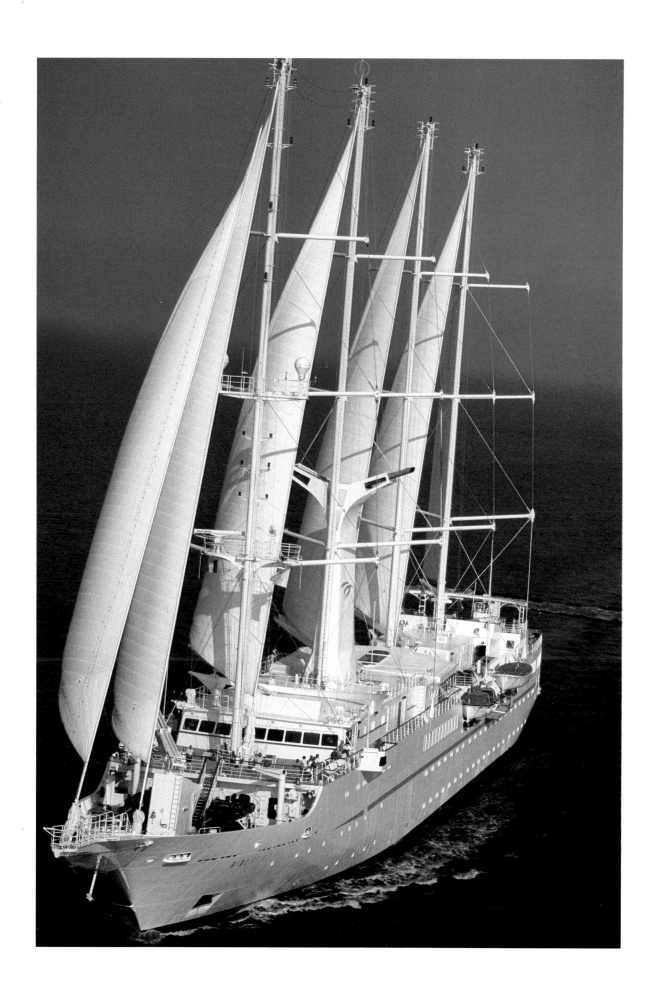

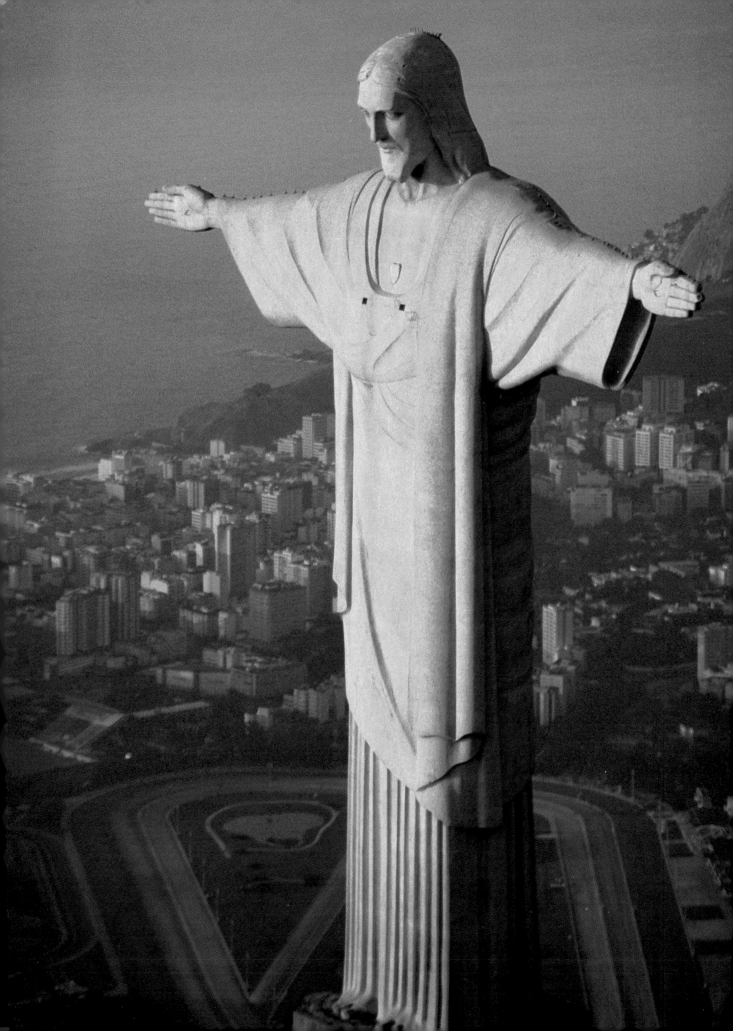

There will be times when you must use a high-speed film—in low-light conditions such as photographing city lights at dusk, or early dawn light—to have a wider exposure latitude. With high-speed film you sacrifice grain, but you gain exposure latitude. You can opt to use grain "creatively," for an impressionistic effect, but use this in moderation. When light is low and the light requires using a fine-grain film, my gyro-stabilizer usually saves the day.

This powerful depiction of the Christ in Rio de Janiero, Brazil, was taken by shooting directly into the sun-drenched statue. A rich color saturation was achieved by exposing the film at a higher ISO rating to deepen the tones.

• *Use a film with good saturation qualities*. In the air, some colors are lost because of haziness or less-than-perfect weather conditions. Hues become washed-out and lack punch. Select a film that will bring out the brightest ranges of any color. The best way to go is to experiment with a variety of films until you personally know the best film choice for the desired saturation quality you want in your images. Color is always more saturated at lower altitudes. At higher altitudes haze, mist, or pollution will usually be present. You can get much richer color if you stay at altitudes under 1,000 feet. Although the air may look clear from ground level, it can become less so when you finally ride up into it. Always check air quality with a weather station in your area, or pilot's who've just landed.

• *Use a polarizer to enhance color and cut through haze*. To make clouds stand out from blue sky, or to enhance contrast in an aerial scene, a polarizer is an excellent accessory. On bright days, using ISO 50 film with an f/4 zoom lens and a polarizer, your shutter speed will vary between 1/125 sec. and 1/500 sec. You must use your gyro-stabilizer under these conditions. The polarizer will work best when you photograph at right angles to the sun. On brilliantly sunlit water, the polarizer will help reduce glare and reveal detail and color.

This image, taken in Bora Bora, French Polynesia, is a good example of a scene that requires using a polarizer to bring out the contrast between clouds and sky.

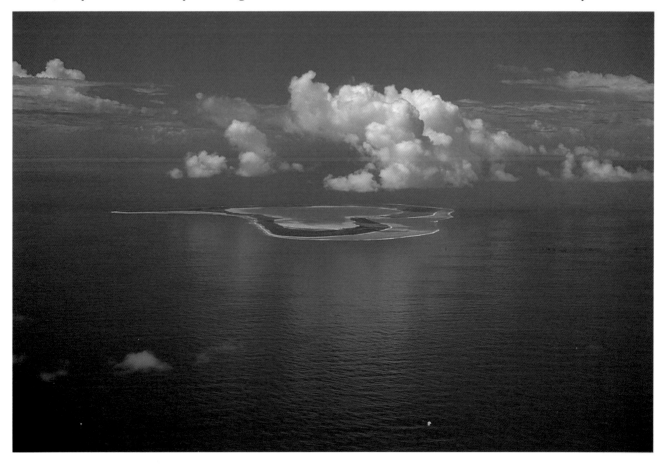

COMPOSITION ON LOCATION

Composition is the architecture of a great photograph

In the introduction to his book *The Decisive Moment*, Henri Cartier-Bresson said, "To me, photography is the simultaneous recognition, in a fraction of a second, of the significance of an event as well as of a precise organization of forms which give that event its proper expression." How much more true this is when photographing in the air—flying, hovering, blown by the currents—and you realize that you must see and compose your images instantly while on the wing.

A successful photograph is a dynamic thing. It must be carefully composed, yet seemingly spontaneous. It must be exact, yet offer a tension. It is a delicate depiction of a balance of opposites. These must come together in the moment of taking the picture. Ideally, it has to all be there at that "decisive" moment; I don't believe in cropping a photograph later to "perfect" its composition. As an aerial photographer, you must constantly train yourself to visualize the final image at the exact second of releasing the shutter. Aerial photographers face an added challenge: to do this while suspended in the air, while selecting vector positions over the target, and while trying to keep up an on-going communication with the pilot in a noisy machine. Not an easy thing to do. Therefore, you must prepare by training your reflexes, both physically and visually.

SELECTION AND COMPOSITION

We all possess "zoom eyes." When looking through the camera's viewfinder, our eyes, much like zoom lenses, selectively focus in on a detail. For instance, if you're looking at a person, your eyes usually go immediately to the subject's face and eyes; you won't notice surrounding objects. With aerial photography you must overcome this natural response. Instead, you must learn to scan the periphery of your images by looking quickly around all four corners of your viewfinder frame. Study everything, select your composition, and then shoot. This is an art that must be practiced until it becomes second nature. Scanning the periphery is vital to the art of composing the image. Good composition is the foundation and architecture of a solid photograph.

Angles of View. It's important to view your subject from every possible angle and also from various altitudes—sometimes as high as 3,000 to 4,000 feet. I make compositional discoveries by going against the grain and flying around or behind a subject to study it from a variety of perspectives. I use a large number of lenses, from 24mm wide angles to 300mm telephotos. When the light in a scene increases I prefer to use the zoom lenses: 25-50mm, 35-105mm, and occasionally the 80-200mm. These lenses enable me to shoot the subject in many different angles of view, thereby increasing my visual awareness of it. Understanding the subject from so many points of view only increases my compositional acuity.

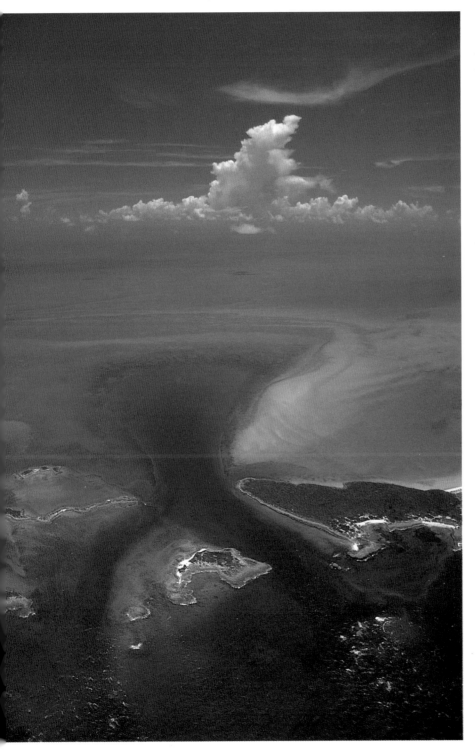

In this striking image, taken in the Bahamas, the composition holds your attention because it keeps your eye moving from the foreground to the vast horizon over a dynamic sense of space.

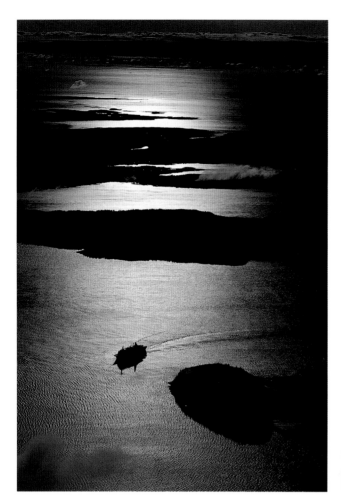
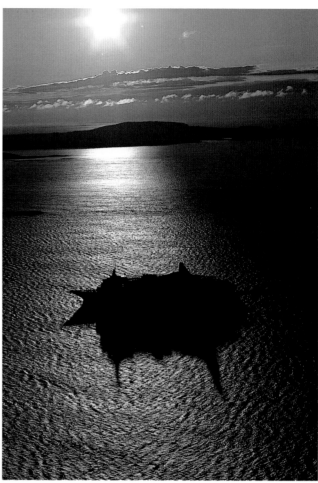

To achieve these images, taken in Bar Harbor, Maine, I directed my pilot to spiral towards the ship at increasingly lower altitudes. This enabled me to explore the ship from various compositional angles and obtain graphic shots using size and scale relationships.

Size Relationships and Scale. *"See distant things as though they were close, and close things as though they were far away."* This adage is useful to bear in mind when photographing in the air. Go closer to your subject than you think you need to. Try to make your subject dominate the frame. I often ask the pilot to make a slow spiral from a low altitude to a much higher one. When framing, avoid the tendency to have too much in your picture. Crop close in your viewfinder. Try not to make images that look like kaleidoscopic mosaics. Find a dominant shape of a significant size, and use it to create a center of interest. Become aware of the scale of objects in the landscape and their relationships within that scale. A mountain will look like a hill if you are high enough and there are no trees or buildings around to provide a scale of reference for the picture. A person in the foreground of an image can seem to tower over a building in the background. You can make a single mountain seem even more enormous if you photograph it with a person climbing up its side.

As you photograph, relate your subject to its surroundings. Notice the scale of both the subject and the landscape you frame it in. Find ways to play them off each other—include people or buildings, or other elements that will change the perspective and proportion of the subject; experiment with framing and cropping to add visual interest; photograph a familiar scene in an unexpected way.

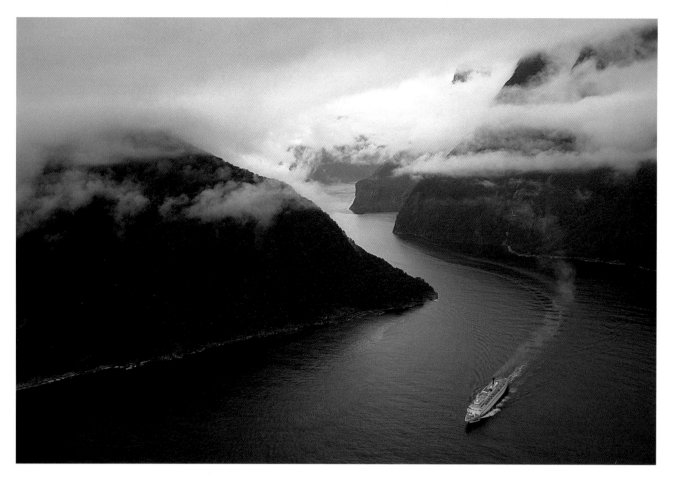

In the images on these pages positive space is used effectively to draw the viewer into the composition. Above, positive space is created by the strong balance of shapes in the dark mountains that frame the surrounding water and clouds. On the opposite page the dominant shapes of the glacier are framed to create the positive space.

Negative and Positive Space. Objects that immediately catch your eye with their strong color, shape, or mood occupy what is called positive space. The principal subject of a photograph—the dominant center of interest—usually occupies positive space. Areas of little active interest in the frame—empty space, small or indistinct forms, or dull colors—occupy negative space. The negative spaces are just as important to the composition as the more immediately apparent positive spaces—each component defines the other.

Photographs taken on location on land always occur in a "stage" setting. You observe and select the "backdrop" you want, then wait for the characters who give life to the set. When you're photographing in the air, the landscape or seascape is the stage set, and the subjects of your photographs—city buildings, homes, factories, ships—are the actors. You must find a harmonious, dynamic, and dramatic way to fit them into the setting. Be sensitive to both negative and positive spaces in the photograph. If you see shapes or patterns around the edges that are not pleasing to your eye, shift your view and composition.

Your goal is to create images in which all the elements of color, light and dark, shape and pattern, are composed into a strong, eye-filling photograph. Learn first to see the thing itself with clear eyes; remember that you must compensate for your "zoom" eyes. There are many principles of composition used by painters to organize their canvases that can also be applied to your photography: S-curves, triangular composition, lines of perspective, and the rule of thirds. This last compositional device incorporates dividing any image into equal thirds vertically and horizontally across the image. The points at which

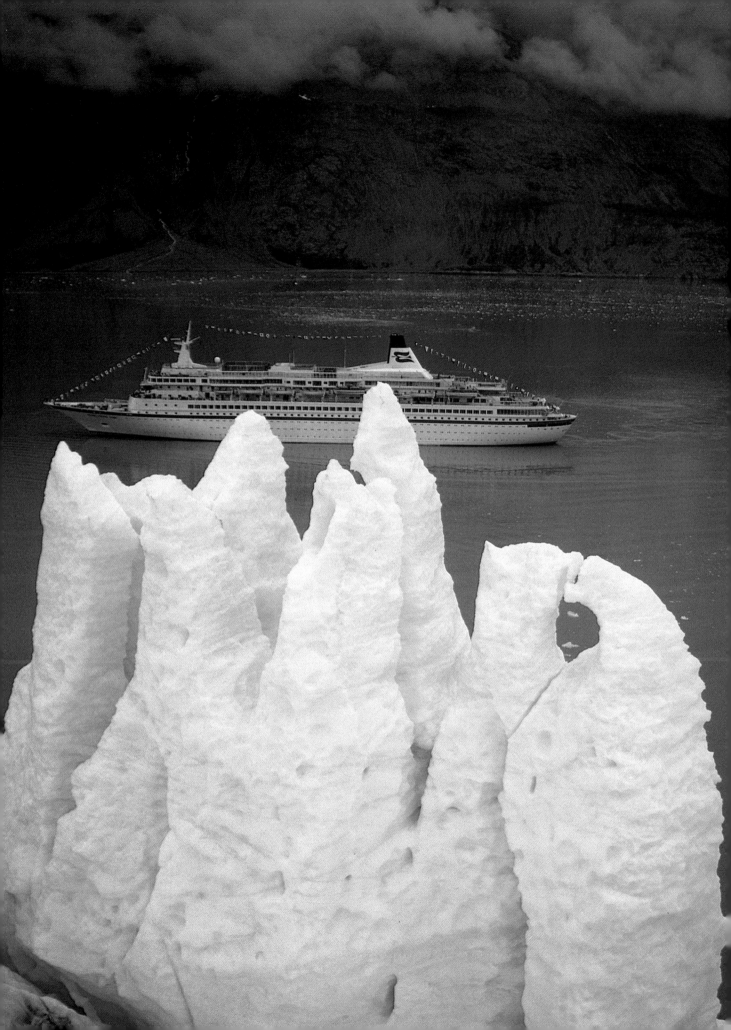

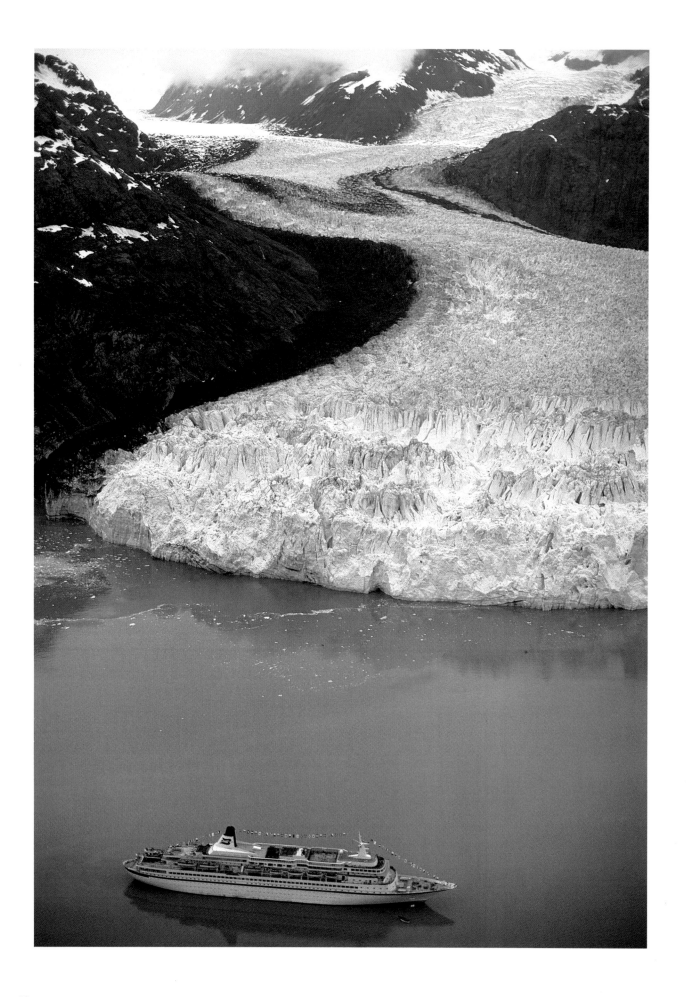

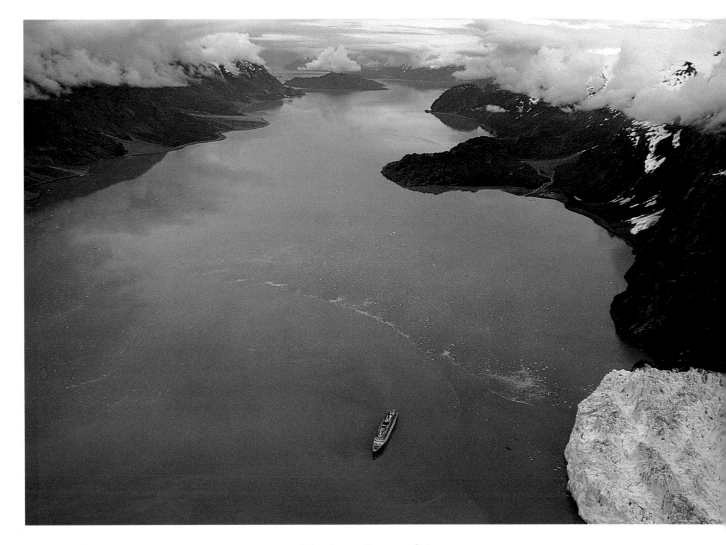

any two of the lines intersect are compositional "points of interest" that will attract the viewer's eye immediately. These points are where you should position subjects of interest.

Other elements to consider in composing your images are tension, rhythm, and syncopation—qualities of movement or slightly irregular visual breaks in images, which give them an added interest. Look very carefully at each compositional element; study the frame and experiment with different ideas. Really learn to see. It's natural that we should respond to tension, it's part of our lives. But too much harmony or symmetry in our images creates boredom. The eye comes to rest too soon, and the viewer isn't compelled to go farther into the image. I strive to create compositions that explore tensions between harmony and disharmony. I like images that are slightly askew yet always on a solid foundation. One way to accomplish this is to deliberately leave out part of the image. This impels the viewer to imagine what is missing and look longer at the image. Another way is to place the center of interest off-center.

You learn rules in order to learn how to break them—creatively. Originality and creativity in any art come from mastering the rules. You can later free yourself to create new rules, new ways of seeing, and make discoveries and images that have not been seen before.

The use of S-curves in your compositions can create strong images, as in this glacier flow photographed in Alaska.

Size relationships and scale can be used effectively in your compositions. In the photograph above, the expanse of the surrounding landscape seems to dwarf the size of the ship on the water.

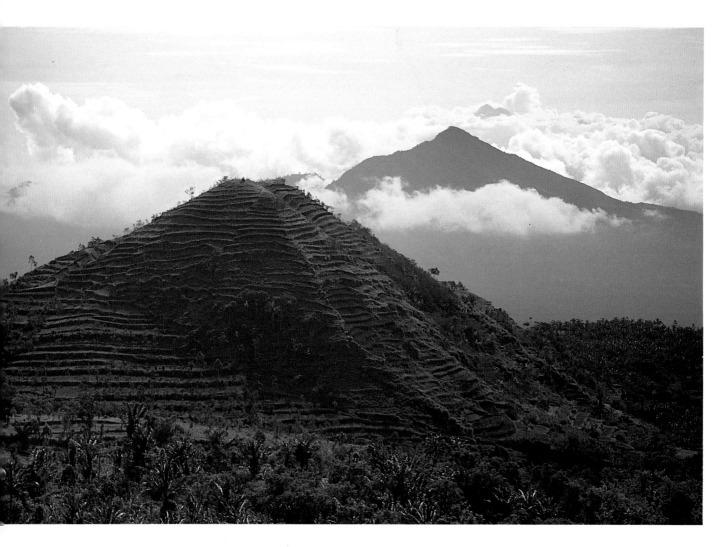

Learn to recognize graphic shapes and patterns when composing your images. Above, the pyramid shape of the foreground mountain is echoed by the peak behind it; at right, the varying lines of this rice paddy create a rhythmic pattern.

Shapes and Patterns. Why are some shapes more pleasing than others? Why do we so admire the Egyptian pyramids, the Taj Mahal, the Parthenon, or the Washington Monument? Something in the shape of these things pleases our eye and continues to fascinate us visually for as long as we look at them. It is their shapes, simple and strong, and their patterns that continuously stimulate our visual sense.

We learn to recognize pattern early in life. Our eyes seem to respond and be stimulated by the repetition of similar forms, particularly faces. Whether patterns are symmetrical, such as road grids, or asymmetrical, such as cloud shapes, they give our images strong visual appeal. Light and color are significant catalysts for pattern. For example, as light grows dim, shadows lengthen, increasing shapes and pattern by extending them. A white picket fence at noon creates a pattern of grids, yet at dusk the grid pattern is doubled with the added shadows cast by the horizontal light. Sometimes we don't notice pattern because we're too close to it. We often have to get above something to see another side of its true shape and pattern. When you stand in a field, all the colors and shapes look the same; yet far above in a plane, you recognize that the field is made up of many various shapes and shades of color. Consciously including shapes and patterns in your photographs will greatly enhance their visual impact.

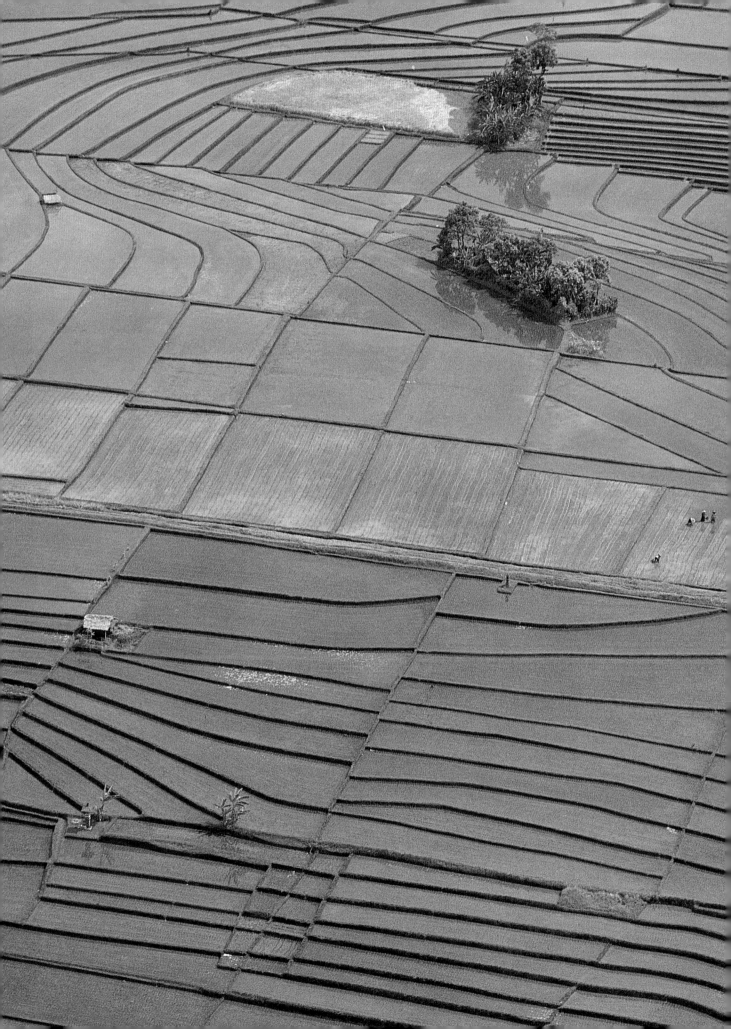

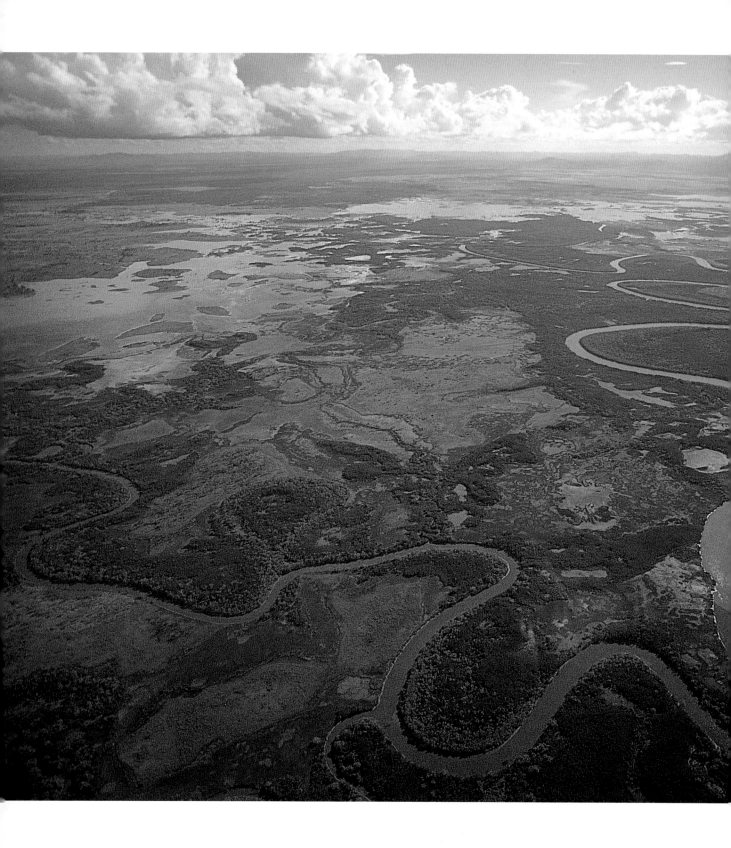

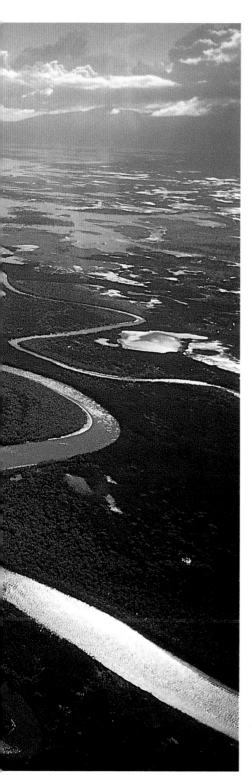

Vectoring for Composition. The true art and craft of aerial photography lies in achieving a significant and precise organization of forms in a split second. To achieve this, your plane (and thus you and your camera) must be in the right position at the right moment. You must learn how to anticipate your next movement and location with only a few seconds lead time. Just as a master chess player doesn't have time to analyze *all* the possible moves in a game, but instead places his or her pieces into winning patterns learned through experience, so the aerial photographer must come to sense winning positions in the three-dimensional chessboard of the sky—the constantly changing relationships between aircraft, subject, and background. As you gain flight times and experience, you'll learn to direct the pilot to position the plane or vector it, consistently for the best image. A pilot experienced in aerial photography can fly you into position time and again with accuracy and a minimum of direction from you. Good pilots will leave you free to photograph. If you fly with a pilot of somewhat less experience, you must give directions clearly, calmly, and in a way that will give the pilot the necessary confidence to get over the target.

ZEN AND AERIAL COMPOSITION

In his book *Zen and the Art of Archery*, Eugene Herrigel writes, "In the case of archery, the hitter and the hit are no longer two opposing objects, but are one reality. The archer ceases to be conscious of himself as the one who is engaged in hitting the bull's-eye which confronts him. This state of unconsciousness is realized only when, completely empty and rid of the self, he becomes one with the perfecting of his technical skill." After long practice with your camera, you may also attain the state where your camera "vanishes" and you are no longer aware of its presence. Then there is no thought of the tool distracting you from your subject. In the act of seeing, you immerse yourself in the thing seen. At the center of your being you are freed to see, in the words of Edward Weston, "the thing itself."

The Japanese have a term, *hacho*, that means "breaking the harmony." It is often applied to *ikebana*, the delicate and difficult balancing of shapes and forms in flower arrangement. It is this creative break with harmony, intuitively recognized, that you will find yourself developing in your compositions.

The ribbons of river seen in this image shot en route to Cairns, Australia, could only be photo-graphed from an aerial view. This composition emphasizes the vast terrain of this area.

*These extraordinary Bahaman wa-
ters excited my imagination as
soon as I saw them. I was working
near a resort that I was photo-
graphing on assignment, and I went
back to them to experiment com-
posing their color, shapes, and pat-
terns. I made these compositions
purely for the joy of it.*

AERIAL LOCATIONS AND SUBJECTS

Often I am asked what my favorite locations are for taking aerial photographs. I love many—Bora Bora and Moorea in French Polynesia, the landscapes of the American Southwest, Tierra del Fuego's archipelagos, the New York City skyline, the Christo and harbor of Rio de Janeiro—all of these offer me different and exciting visual opportunities. I have no "favorites" per se; the world is new to me each time I fly. The light is never the same anywhere—clouds make new castles, seas shimmer and glow in fresh colors—My eye is ever dazzled by rainbows, patterns, colors, and the ever-changing light.

While I would like to choose my own locales for aerial photography, they are most often chosen for me by my clients. As you gain assignments in your own work, too, you will be sent on a variety of locations. Not all of them will be conducive to great photographs. Weather conditions, terrain, lighting, and other concerns will challenge you constantly on location work. You must be prepared to deal with many changing conditions, as well as come to know the "personality" of the place you inhabit on any assignment.

Safety precautions are the first concern: Aerial photography is unforgiving to the careless or unprepared photographer. Know your aircraft, and know your pilot. Check important gear and make sure you and your pilot are traveling in a safe, well-maintained craft before you get off the ground. Though there will be instances where time will not permit a thorough gear-by-gear check of everything, at least make some allowance for a cursory safety check.

I once photographed a difficult subject, the Citicorp Tower in New York City. I went up in two helicopters that day (due to scheduling problems). Neither pilot relished the idea of hovering over the spires and needles of the surrounding skyscrapers. In an emergency, we would go down "on a bed of nails." We made particularly careful checks of fuel, engines, rotors, and instrument panel information. Safety requires a way out, a safe place to set down in all circumstances. In this situation, we had none. We had to *stay* in the air. My first pilot on this assignment, flying a Bell Jet Ranger, was the more nervous, although we knew that the inertia of the heavy blades on Jet Rangers allows flying room in event of engine failure. The second helicopter, a French A-Star 350, highly maneuverable and steady while hovering, has lighter-weight composite rotor blades. They carry less stored energy, and in the event of engine failure during a flight, you may be forced to descend rapidly.

As I do, you will encounter many kinds of locations, some easy, some dangerous, above land and sea. Technical and creative concerns are inherent in any new project; but the first concern is a complete understanding of the machine that gets you to your location.

The following is an overview of some particular locations, conditions, and situations you may encounter on your assignments and the technical points you should consider before attempting to photograph.

The Right Aircraft for the Job. Know the best type of aircraft for a particular location or assignment: A Jet Ranger or other helicopter is best for hovering; at low altitudes, a light plane is usually too fast to capture your subject on film; over water, two-engine aircrafts are preferable to one, or a twin-turbine helicopter. On location in some countries you may find that you have little or no choice of aircraft at all. You must make a reasonable assessment of the pilot and the craft.

Cities are a challenging aerial subject, especially when photographed at night. In this image of New York City's Citicorp Tower, a gyro-stabilizer enabled me to obtain the proper exposure in this scene.

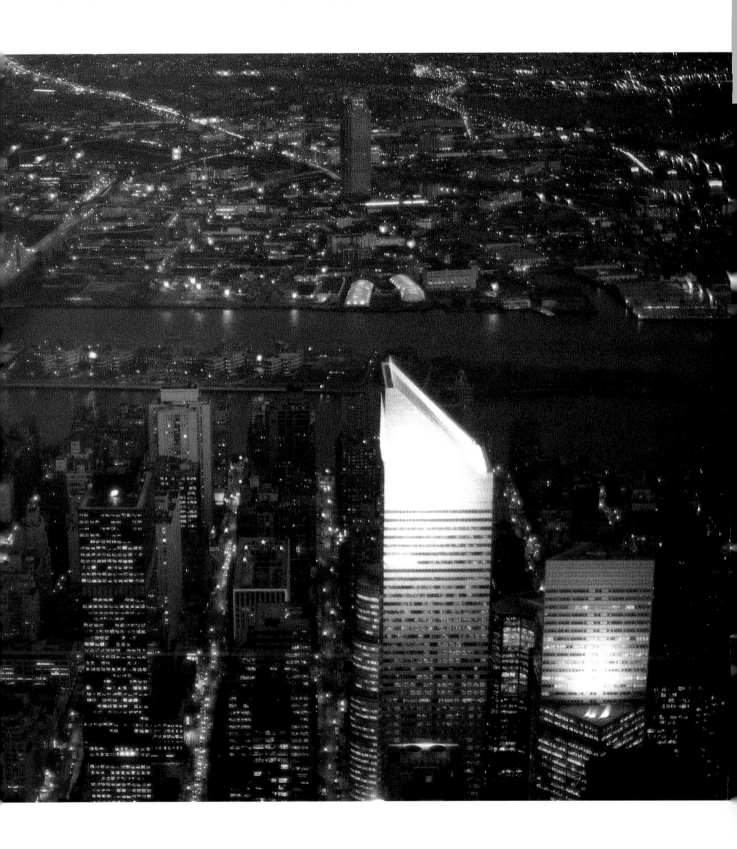

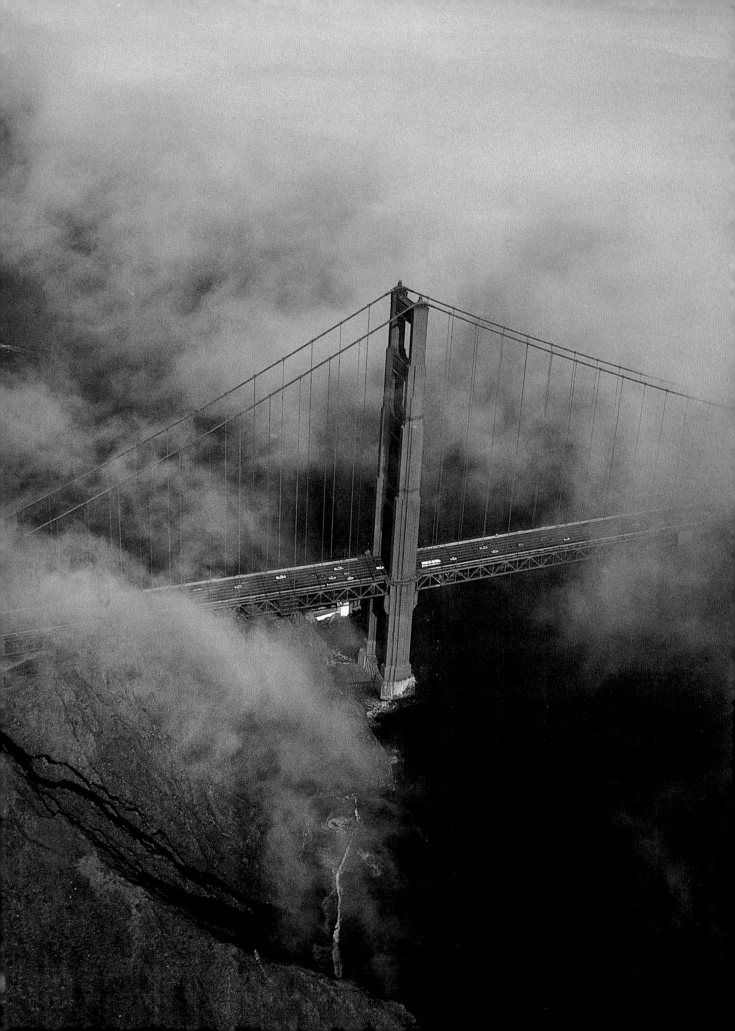

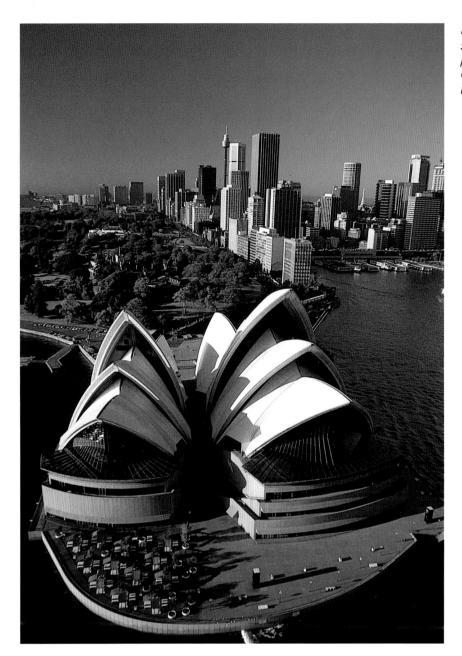

Urban Aerials. Cities present a variety of problems because of local air traffic around and over them. The FAA (Federal Aviation Administration) has strict regulations pertaining to these areas, and it is a good idea to understand the rules for any location over a city. It is vital to keep your eyes peeled at all times for other aircraft and alert your pilot to them. You will be restricted by how low or high you are allowed to fly over buildings, depending on the weather conditions, the noise-tolerance codes in residential areas, or just the time of day.

Mountainous Terrain. Flying around mountains is tricky. Buffeting winds and other atmospheric conditions can be a hazard. Make sure your pilot has experience flying in this kind of terrain and that he knows about cross winds, up drafts and down drafts, etc. Weather can close in suddenly in mountain areas. Try to hire a pilot with IFR (instrument flying rating) standards, and the necessary IFR equipment in the aircraft.

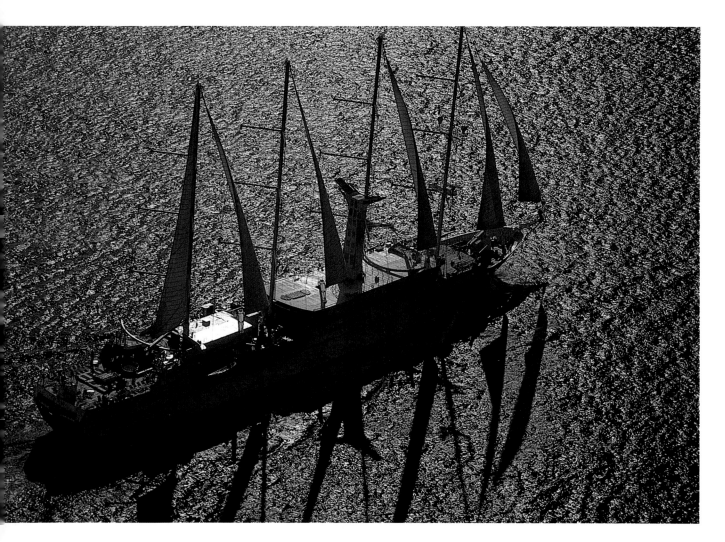

When shooting directly into bright, sunlit water, you must close down your apertures to prevent the scene from becoming overexposed. In the image above, a graphic effect was achieved by stopping down enough to make the ship and sails a silhouette. On the opposite page, bright sunlight was used to create a reverse effect, darkening the water and exposing for detail in the ship.

Exposure Considerations. When photographing in low light, at dawn or dusk, the use of a gyro-stabilizer is important. Fast films will also help, but you must remember that you will sacrifice image quality because of high grain. With the gyro you can shoot using ISO 100 film at approximately 1/30 sec. and, in still air, down to 1/15 or 1/8 sec. with wideangles. Over water, it is advisable to use a polarizing filter to bring out color and reduce flare from the surface reflections. The best exposure is gained when the sun is high over the water. Early and late in the day, the water will go dark because of the slanting rays of the sun. Filters rarely eliminate haze or smog to an appreciable degree. You need to start with the best air conditions possible. If you don't have them, wait for them.

Weather Conditions. Weather is a principle concern on any assignment. You have a schedule to meet, but the day you go up may be miserable—which is why it is a necessary point of budgeting in extra weather days for all assignments. And what may appear or start out as acceptable weather on the ground, can turn just the opposite once you are airborne. Haze and visibility can change dramatically.

You must carefully learn to assess weather conditions: Use a good weather service, and check forecasts daily. An excellent service is Universal Weather and Aviation, based in Houston, Texas (713-944-1622). They supply satellite forecasts worldwide, and I have found them to be as accurate as *any* weather forecast *can* be.

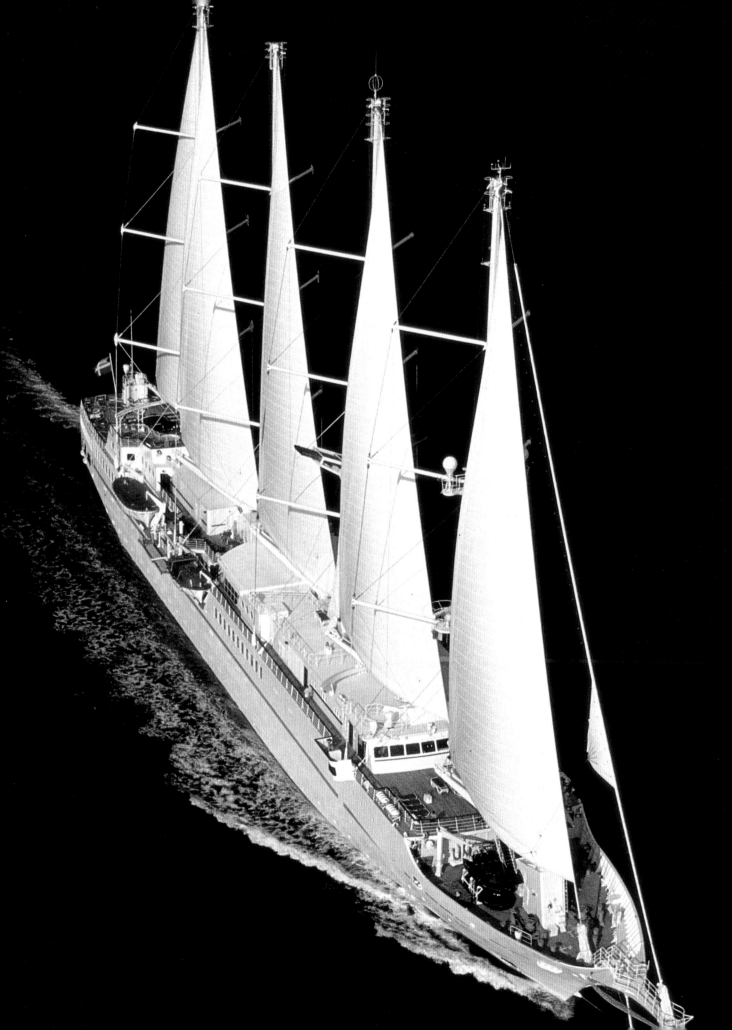

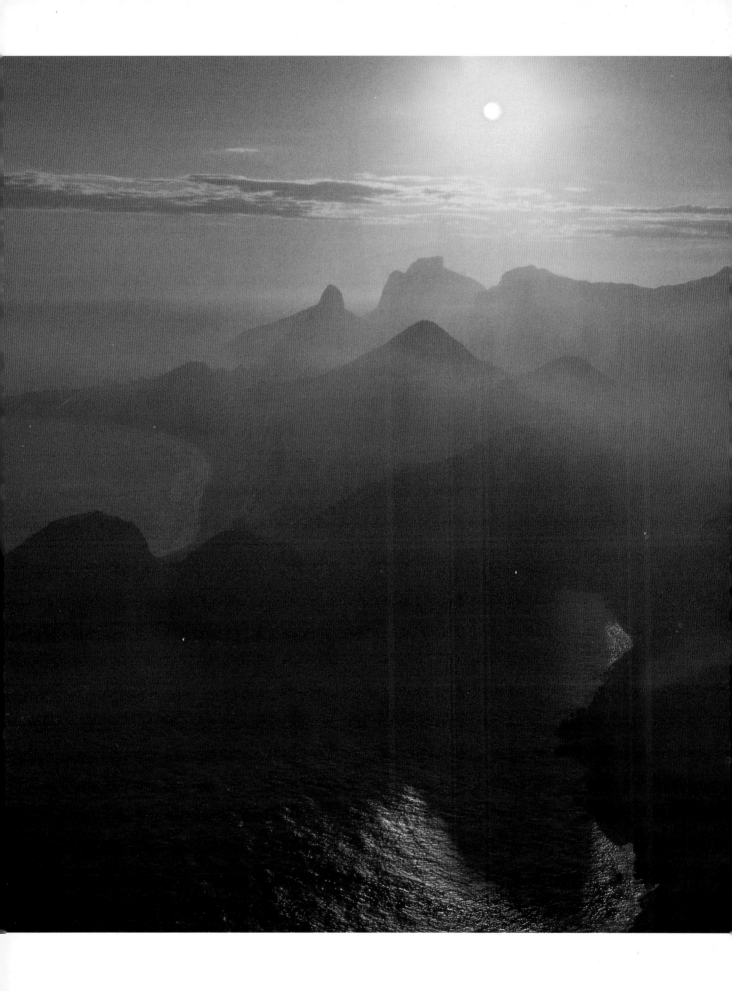

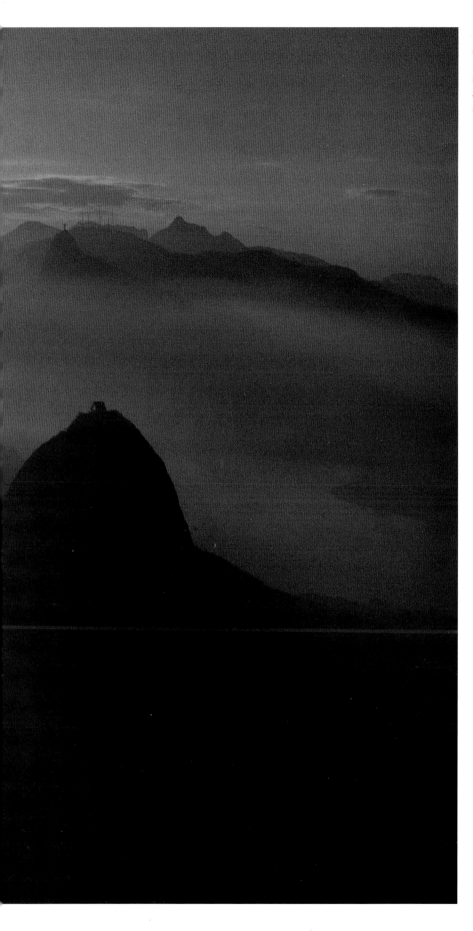

When cloud cover is present in a scene, it can add impact by separating colors into layers of light and dark tones, as in this Rio de Janiero sunset. An orange filter was added to deepen the colors.

On Location: Bali, Indonesia

When you are on assignment at a specific location, it is necessary to make sure all of your technical and creative resources and skills come together. You must not only decide what lenses and films to use but also how to communicate with your pilot over a location. When you are seeking the best compositional elements for the shoot, you must be familiar enough with the location's details to be able to know precisely how far up to direct your pilot, when to ask him to vector over a certain position more than once, and how to change position when needed. Some locations are easy to approach because they have such a range of elements of color, composition, and pattern for you to work with. Others are more difficult to photograph—you may not be able to get close enough to your subject, the weather may not permit you to fly during the best light, or you just may have a boring subject.

On a trip to Bali, Indonesia, I was fortunate to have some of Bali's ancient temples as my aerial subjects. Photographing them was not only a visual challenge, but a technical one as well, and it taught me a variety of compositional solutions that I have used on other location shoots. The assignment was to photograph Bali for travel brochures, collateral materials, and stock. I spent the first few days scouting Bali, shooting, and making arrangements. The local representatives for my client told me that there was no helicopter available in Bali. They were wrong. I discovered the helicopter by accident. I went to the airport to look at a twin-engine Piper Chieftain that I'd been told was the only aircraft available for charter. It wasn't my first choice, as the Chieftain's low wing gets in the way, and, of course, it cannot hover. Next door to the Piper office I saw the helicopter office. The manager was eager to rent me his Indonesian-made twin-turbine chopper. I went with him to inspect it immediately.

The big helicopter, freshly painted white and yellow with blue trim, appeared new and well maintained. The twin turbines added a life-saving bonus: If one fails, you keep flying. I booked the helicopter for a flight on a weather-contingency basis on a clear day. I took the craft and started out. Our pilot slowed the helicopter over Bali's mother temple Besakih, located on the slopes of the great volcano Gunung Agung. I slid open the door, leaned out, focused my 25-50mm zoom lens, and fired my Nikon. Mt. Gunung Agung, Bali's sacred 3,000-meter-tall volcano, revered as the "navel of the world," loomed over us. The huge cone, gently wreathed in clouds, had vented an enormous and destructive eruption in 1963.

Positioning the Helicopter. As I leaned out over the slopes of Gunung Agung, the wind roared through my voice-activated headset. Pilot Captain Sukonta, an Indonesian veteran of 25 years of flying helicopters, was seated in front of me at the controls. I tapped his shoulder to get his attention. "Fly low, very low over the Mother Temple." We drifted gently down like a butterfly towards Besakih. The mother of all of Bali's thousands of temples looks rather tiny from 3,000 feet. Monks and tourists waved their arms at us.

I directed Captain Sukonta to circle to the right, then go forward. Leaning out of the open door, I focused my 35-105mm zoom and fired my Nikon repeatedly. Blown off course by gusts of wind, we drifted away from the target. I vectored Captain Sukonta into position. "Right turn here, now straight ahead—good—now turn left, lower please." We descended rapidly. A white clad monk waved his arms wildly at us. He may have thought that we would crash into and desecrate the sacred shrine of shrines.

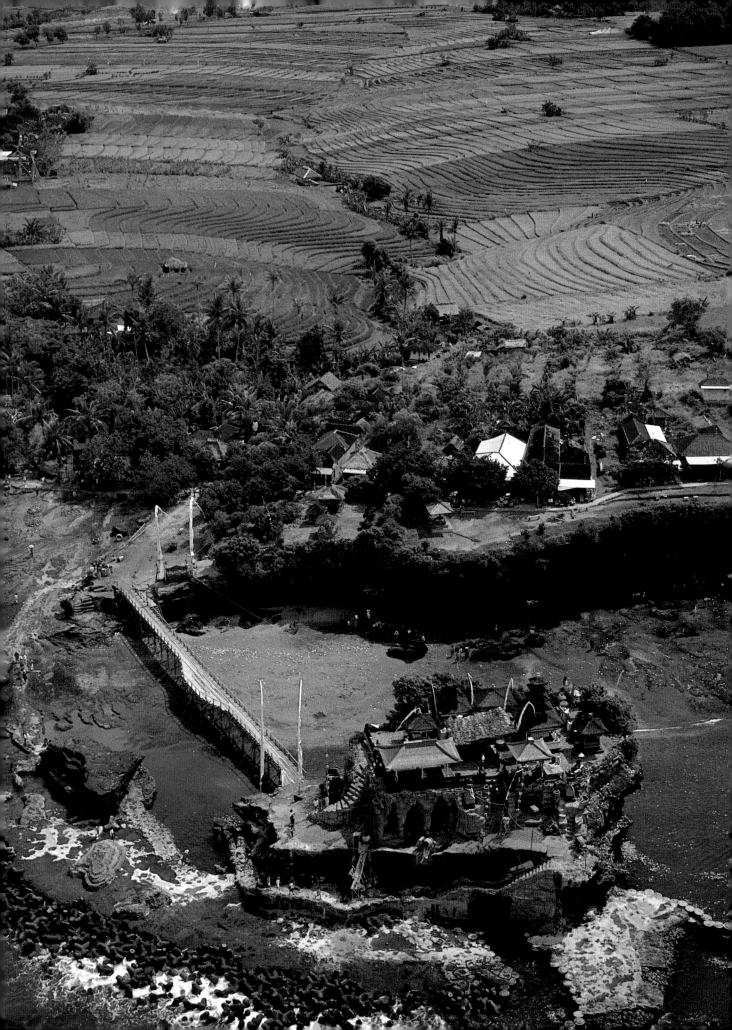

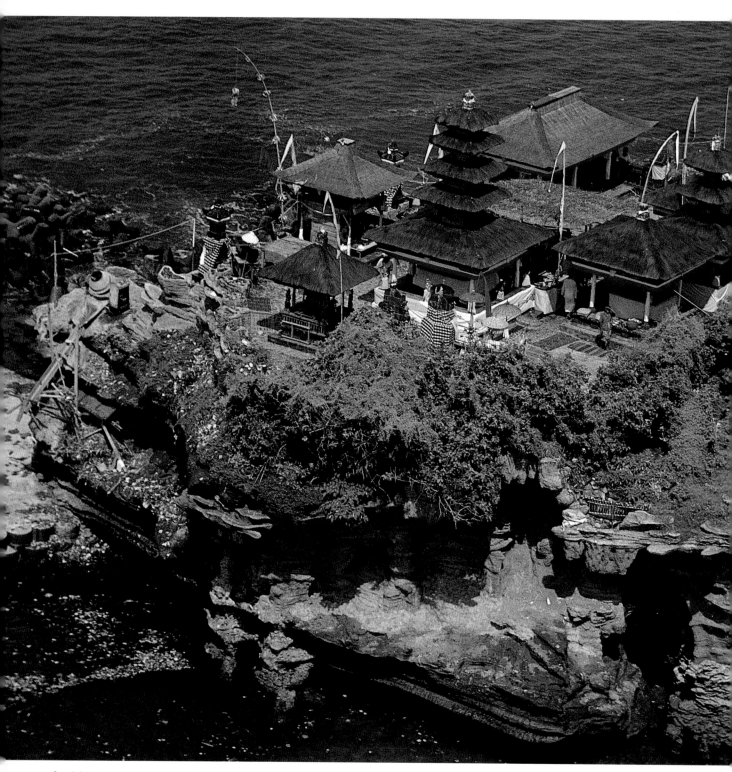

In this photograph of Bali's ancient temple at Tanah Lot, the architectural details are shown to effect by using a wide-angle lens.

A Choice of Lenses and Other Gear. We veered off and away from the mother temple. "On to Mount Batur," I called over the mike. No response. Captain Sukonta had turned off his headset to avoid the roar of the wind. I tapped him on the shoulder.

"Batur, the lake and volcano please," I repeated, and closed the aircraft door. With the door closed, the NBO twin-turbine helicopter can make about 120 knots (about 135 m.p.h.). Captain Sukonta had instructed me not to open the door until he slowed down to under 50 knots. With the door open he must fly slowly, 80 knots maximum.

Mount Batur erupted in 1926, killing hundreds of villagers. The mud and lava flows still stained the mountain side as we reached it. Tortured fissures that resembled an elephant's wrinkled skin covered the lower slopes. We floated over the still smoking cone. "Stop," I directed. Captain Sukonta slowed the helicopter, then hovered. The big turbines changed pitch, groaned, and rumbled, a combination of sounds which always makes me a little nervous.

I used my 25-50mm zoom lens with a polarizing filter, and zoomed to 25mm in order to capture the panoramic scene of Lake Batur and the volcano itself. Twenty-four or 25mm is about as wide as you can go in a helicopter and still stay clear of rotor blades and skids. In addition, you must ask the pilot to bank away from your subject in order for you to clear the rotors when you shoot at 24mm or 25mm focal lengths. When the pilot banks, the helicopter moves away from the target. Therefore, you must vector your approach in a way that gives you enough time to shoot while banking.

My regular complement of zooms in the air is 25-50mm, 35-105mm, 80-200mm. The 35-105mm is the workhorse. I use fast prime lenses whenever the light is too low for zooms; for example, at dawn, sunset, or during heavy overcast (although I almost always avoid shooting in a heavy overcast or on dull, cloudy days).

Single-focal length lenses are sharper. Zooms usually must be used at maximum apertures, especially when polarizers are attached, which causes them to be a trifle less sharp. Therefore, sometimes even in bright light, I'll switch to my prime lenses. While in the air, I also use a digital spotmeter to measure distant, small objects. Otherwise, I rely on my camera meters, on bracketing, and on experience. I take at least three bodies with me in the cabin, and my assistant loads them as fast as I empty them. The camera bodies are equipped with quick releases, as is my gyro-stabilizer. On this assignment, I snapped the empty camera body off the gyro, released the lens, removed the strap off my neck (I wear the camera around my neck to avoid dropping it out of the aircraft), grabbed a reloaded body, snapped it onto the gyro, affixed the lens, and resumed shooting. Intent as I was on this subject, no time could be wasted—the light might have changed quickly, or we might have suddenly flown out of position.

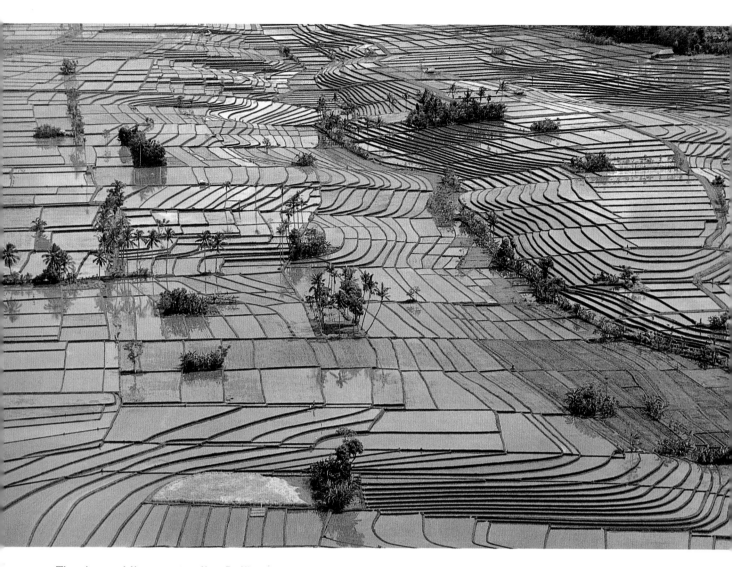

The rice paddies surrounding Bali's water temples are an endless source of graphic patterns. In these images the geometric patterns are explored with a zoom lens set at different focal lengths.

Contours and Geometry. I leaned far out to frame the volcano and the wide lake surrounded by distant peaks. The air was cool at 5,000 feet, the height of the volcano rim. I tapped Captain Sukonta. "How far to Tanah Lot, the water temple?"

"About 15 miles," he replied. I glanced at the clock on the instrument panel. We had 45 minutes remaining on my planned two-hour photo flight. "Please fly there."

We skittered over mile after mile of vivid green rice paddies. Their pattern and color greatly intrigued me. "Please stop," I requested. Captain Sukonta slowed down. I opened the aircraft door after a struggle and leaned out. The rice paddies were carved out of, and looped around, the hillsides, forming S-curved terraces. On the flat lands, I saw geometric patterns made of green rice plants rising out of the wet fields. A few straw-thatched huts dotted the paddies. Delighted by the abstract quality and asymmetry of these often-photographed symbols of Southeast Asia, I fired away.

Whenever I'm confronted with an unusual but much-photographed scene, I try to slow down and discover a fresh viewpoint. The rice

paddies presented wonderfully geometric abstract patterns. To photograph them I used a wide-angle lens, taking in the entire scene, then I changed to my 35-105mm zoom lens extended to short telephoto in order to see and to create my own kind of abstract compositions.

I noticed that my polarizing filter intensified the bright green of the rice plants and the green leaves of the surrounding palm trees. Despite their apparent brightness in the sunshine, green fields and trees usually read a stop or two darker than they appear. I knew from experience that my exposures should be approximately 1/250 sec. at f/4 or f/5.6 in bright sunshine while using my zoom lens with a polarizing filter attached and ISO 50 film. But my camera meter indicated only 1/125 sec. at f/4, or less. Therefore, I shot with my meter reading a stop or two underexposed, and bracketed, of course.

I wanted to spend more time over the rice paddies with their elegant hues and shades of green amid the shimmering ponds, but always aware of costly helicopter time, I had to move on. "Captain, please fly to Tanah Lot," I directed.

Tanah Lot is the famous, much photographed "Water Temple," built of parasol-shaped pagodas stacked on a craggy rock formation that juts out into the Indian Ocean. It's surrounded by water at high tide. Hordes of tourists go to Tanah Lot for the sunset behind the temple, which, if you are lucky, beautifully frames the temple. A few days before, I had arrived early, well before the sunset, to scout the location.

"Lower, lower," I directed, anxious as always to test the pilot and the helicopter, and to get near to the subject. We flew low over the tidal flats surrounding the temple at about 200 feet.

"Not too low," cautioned Captain Sukonta, "It is dangerous." Flying a helicopter in a hover too low over land or water can cause updrafts that destabilize the aircraft, and may cause a sudden descent.

We circled the temple. This aerial view was new to me. The famous temple of Tanah Lot appears in virtually every book or brochure that I have ever seen on Bali. What I had not seen until my assignment were aerial photographs of this famous temple on the rocks. I fired away repeatedly, zooming in and out as we slowly circled the temple. Another glance at the clock on the panel, and I realized that we were running out of time. So often when I am absorbed in interpreting a new place or scene, I am compelled to abandon my photography due to the constraints of budget, lack of fuel, and the need to photograph other scenes before being content that I've explored all of the possibilities.

I was fortunate to have captured Tanah Lot from the air. While I needed more time than the few minutes remaining from my budgeted two hours, I tried, in the time allotted, to see the temple in a fresh way. I shot as close up as I could, then I pulled back to reveal the temple in its striking setting on dark, sandy tidal flats that are beaten upon by white, fringed surf. I coaxed my pilot to fly low, then I asked him to circle up and around the temple. I explored it as though I might never see it again, and truly I might not have. At last, I had to stop shooting.

We landed. I opened the sliding door, removed the gaffer tape from my seat belt, unbuckled, and climbed out. I bowed to the captain and his sturdy helicopter, fingers pressed together in the traditional Hindu prayer gesture, and thanked the Gods of this celestial island for their favor of sunshine and safe flying.

MAKING IT YOUR BUSINESS

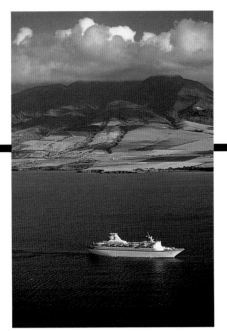

The art of getting known, and getting paid

Aerial photography, like most photography today, is highly competitive. Your work can't just be very good; it must be distinctive. It must have something to offer your prospective clients that other photographers do not. Once you find your niche in this competitive field and master its many technical and creative concerns, you must then determine a strategy for marketing your specialty. Knowing how to make client contacts, how to present your portfolio, and then how to negotiate an assignment contract all take a sizable amount of time and footwork. You must develop an acumen for business and for dealing with the people who will give it to you. A professional approach in everything you do is a sure key to success—and to survival in today's crowded commercial workplace.

THE NICHE

Every city has an aerial photographer listed and advertised in some professional source book. But how different can you say you are from anyone else you find listed? It's important that *your* aerial photography is distinctive within its particular specialty. My own niche is aerial photographs of ships for cruise lines. I have done this so long and so well that I am now regarded as an aerial photographer who can bring back solid images of these seagoing vessels. A true niche is one in which you have few or no recognized competitors. How do you begin to find one? Start by closely examining the field of aerial photography listings in any professional advertising and photography source books. These include *Corporate Showcase*, *The Gold Book*, *The Creative Black Book*, *American Showcase*, *The Art Directors' Club Annual*, as well as such magazines as *Communication Arts*, *Photo Design*, *Graphis*, and *American Photographer*. Another excellent source of information is *The Photographer's Market*, published annually. (For a more complete listing of resources, see page 141.)

Try to determine how much work is being done, who's doing it, and where your work fits in with that of the work published in the books. As you are studying the work, ask yourself these important questions: Which areas of aerial photography seem crowded? Which specialties are *least* represented? Analyze your own work. Do you have a new idea for an aerial project? What is the market for that idea? As you research your intended market, seek out photographers or other professionals who might be able to give you firsthand information on the aerial photography options in your region. In this era of international and multinational industrial and financial corporations, there are many opportunities to carve out a niche for your work. Once you've found it, you can plan to promote and market your photography in a variety of ways that will make clients take notice—and hire you.

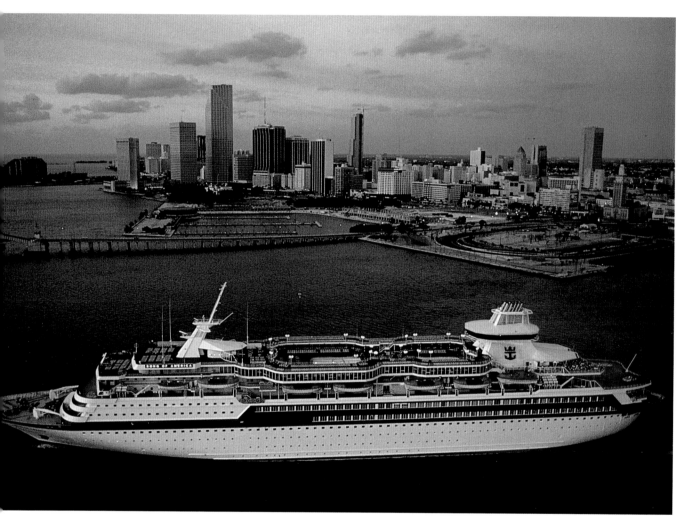

Your images must reflect your niche in photography; they should show prospective clients that your work offers subjects different from every other photographer's.

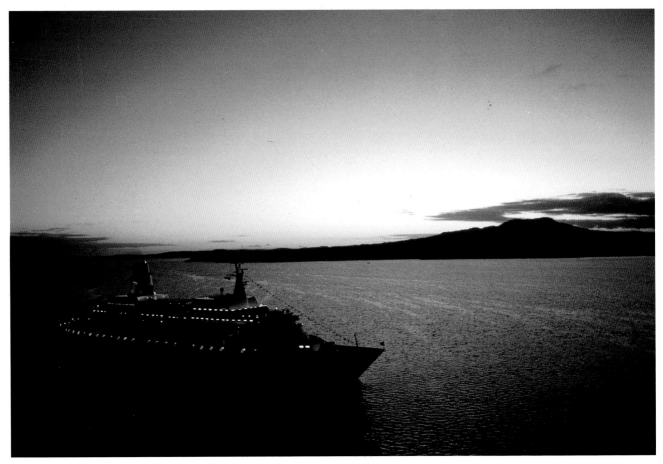

Portfolio images must be strong enough to make your work stand out among the many portfolios each client reviews.

THE PORTFOLIO: YOUR CALLING CARD

When you make that first step to presenting your work to a prospective client, your portfolio is usually what they see. So to make a good impression, your portfolio must contain high-quality images and always be kept up-to-date. If you're just entering the field, start out with your best photographs, even if you have only one or two assignments and a few images to show. You want to prove your ability to take great photographs and show your professionalism.

If the images in your portfolio are excellent but are presented poorly, clients may not look beyond the first few shots. After many years of procrastinating, I'm finally getting tearsheets of my ads and printed editorial work laminated. This will enable potential clients to see my work in the best light and will give them a solid example of its professional quality. Laminated work also holds up to many portfolio mailings and deliveries as it is sent from one client to another, and laminating is worth the initial investment. Although there is a large selection of loose-leaf–page portfolios, often I find that pages come out of the loose-leaf type, and prints never seem to stay straight inside the plastic pages. But, no matter what kind of portfolio you choose, make sure it displays your work to its best advantage.

Also, don't overload your portfolio. Because most clients see dozens of portfolios in a given month, they don't want to waste time looking at an enormous collection of slides and prints. Be critical—and ruthless—when you edit your work. Although your portfolio must be general in some instances, make prospective clients feel that you've tailored your portfolio just for them. If you've recently completed a job for a related business, make sure to include it for that client. Do *not*

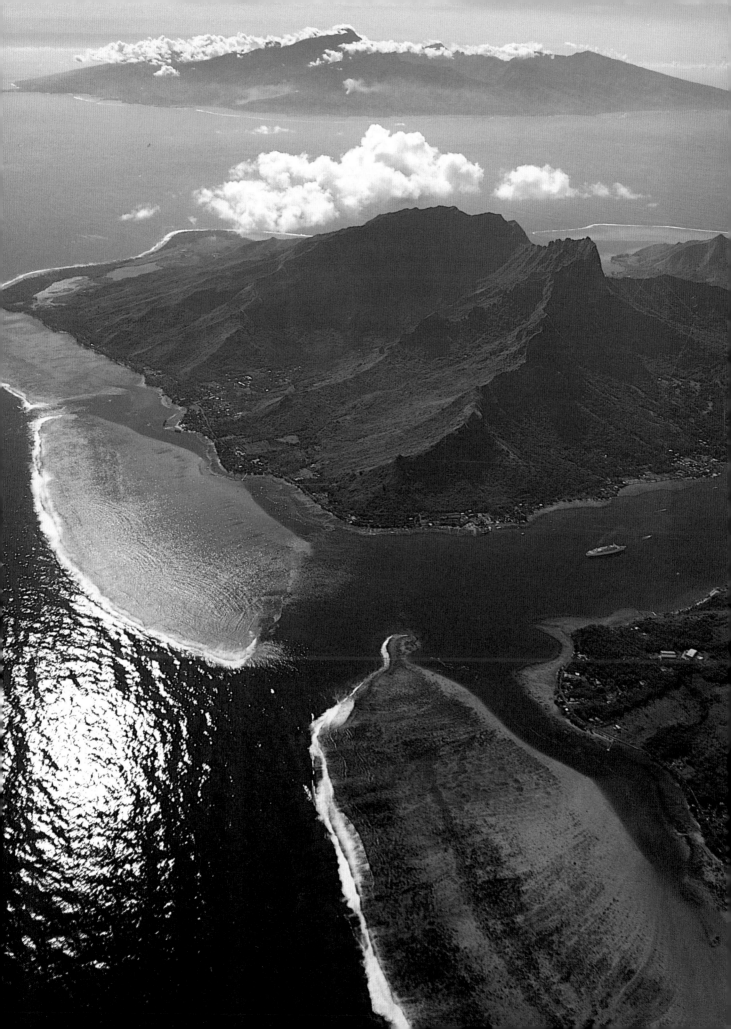

submit work that has no relation to the assignment you are seeking. For example, do not include industrial aerials if you are sending your portfolio to a hotel chain.

When you are sending your portfolio to clients, you'll also need a cover letter expressing your assignment ideas and a short resumé of your work. Here, too, first impressions are important. You must be able to communicate as clearly in words as you do in your images: You must be able to sell your ideas on paper. Photographers who cannot express themselves verbally cannot compete in business.

Your portfolio will make many rounds, and you may get many rejections at first. Don't get discouraged. Keep sending it out, and keep making calls for interviews. As your persistence grows, so will your assignments and your portfolio. Portfolios are individual creations: You must put together the kind and style that will reflect your vision and your desired niche. Keep quality a priority in every part of it. Do not use anything that looks second rate, not the portfolio itself, nor the images inside, nor the ideas that went into making them.

A FEW TIPS ON PORTFOLIOS

- **Match your work to the clients you are soliciting.**
 Your clients want to see that you can photograph a specific subject. Do not send images of industrial aerials to a hotel and travel client.

- **Include all published work.**
 A good portfolio will show clients that your work is strong enough for the printed page. New clients want evidence of professionalism as well as talent. Send them your important published work, whether in the form of tearsheets, an ad brochure, or a self-mailing.

- **Do not send originals.**
 Send *dupes* of all slides or transparencies of your work. If your dupes are not of sufficient quality to show clients, take originals along with you if you get the interview. Do not trust original art to messengers.

- **Update your portfolio regularly.**
 An updated portfolio is a sign that you are out there working with people seeking your talent. Nothing is sadder or less likely to attract new business than a photographer who still shows "great" shots of 10 years ago.

Editing your images for portfolio presentation is a difficult process, but it is the most important way of getting to the best of your work.

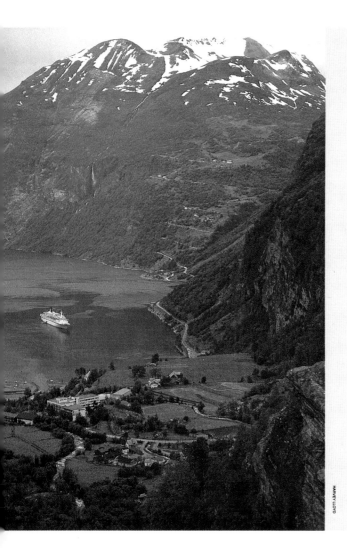

Sailing
Norway's
majestic
fjords
is a

MIDSUMMER NIGHT'S DREAM

By Stephen Drucker

Like most New Yorkers, I'm used to being invisible. When I travel, I insist on it; I always want to pass for a native.

But even I doubted that I was going to be able to finesse my first cruise; there were too many gaffes to make. Like Sam Dodsworth, I might dress for dinner the first night out. I might call my ship a "boat." I might act like I'd never seen a baked-Alaska parade before.

I prepared studiously. I packed twice as many clothes as necessary, memorized a booklet entitled "Ship Tips" and heeded all friendly advice. Bring books, everybody said. I brought books. (I never opened them.)

What nobody told me was this: on a ship, the little gland that secretes anxiety—the one that makes you prepare for your cruise compulsively—shuts down. For 12 days, as the *Royal Viking Sky* plied the Norwegian coast, I regressed to a happy preverbal state. Like a baby, I was rocked by the sea and fed six times a day. And, given the Royal Viking style, I definitely felt like a baby of silver-spoon origins.

I can't think of a better way to visit

A ship glides into the tiny Norwegian port of Geiranger (left). This captain (right) didn't go down with his ship.

Norway than by ship. The country is deceptively big, very expensive, and doesn't exactly sizzle. For a fixed price, a ship shows you a lot of Norway (3,800 miles in our case), and the staff works hard to amuse you along the way. A Norwegian ship, like the *Sky*, is all the better: our sailors' pride in their home waters was infectious.

On a fjord cruise, there is an inordinate amount of time to enjoy the scenery. Most ships sail during June and July, when the midnight sun is in action. For almost two weeks on the *Sky*, I went to sleep with the sun and woke up with the sun. It was haunting. It could also make a person crazy, though not in two weeks.

Our itinerary was brilliantly choreographed. The *Sky* sailed from Copenhagen and spent several days cruising the fjords, several at sea, several in port. Before leaving New York, I read and reread that itinerary, searching between the lines, trying to anticipate which days would be the best. It never occurred to me that the best days would be the ones in which the *Sky* played the biggest part.

One such day was our third at sea.

OCTOBER 1987 • TRAVEL & LEISURE 89 ——

EDITORIAL PROMOTION

Trade-magazine or national consumer-magazine coverage will complement your self-promotional efforts. Editorial coverage gives you credibility and is *free*. When you get two, four, or even eight pages of your work in editorial publications, you have an automatic audience: the magazine's subscribers and those who buy it at the newsstand. To get this kind of exposure, you must first study the publications you wish to be published in. What images of your work can they use? What ideas of specific interest to their readers can you develop into a related assignment? Think of some story ideas and put together a layout of images and text to send to the publications's editors. If you have no current work you feel will interest a particular magazine, think seriously about going out and creating an original assignment for it. If the magazine does not use it, you can always increase your stock photography files with the new work.

Try to obtain the name of the editor who you know is in charge of reviewing possible story ideas. This is important: Many ideas are returned simply because they went to the wrong person to start with. Look at the magazine's masthead; don't send your ideas and images to the executive editor if there is an articles editor listed. If you're unsure, call the magazine and ask who you should submit it to. Most publications will send you submission guidelines. This is also a good

rect. Even I—the archetypal Cancer, who doesn't transplant well—took quickly to my cabin and could have lived in it happily for a 100-day world cruise. It was solid and soothing: the decorator's efforts didn't wink at me.

I lived the high life, well above the waterline. But the *Sky* is truly a one-class ship. Standard cabins look much the same as the better grades; the difference is in the silence (and prestige) of an upper deck, a big window instead of portholes, and in the nine penthouse suites—democracy ends here, I suppose—a butler and a terrace.

Approaching the Arctic Circle, we reached Bird Rock, a famous nesting ground. At the first announcement, the birders bolted from the *Sky's* dining room. A few birds go a long way for me, so I dropped anchor and watched our approach through the restaurant's huge windows. (I would watch the bonfires of midsummer night's eve the same way the following week.) At Bird Rock I learned the difference between the Norwegian and American temperaments. We were informed by the ship's captain that he couldn't blow his horn just to coax those shy birds out of that big rock. Back home, we'd have honked.

The fifth day out, we reached the North Cape, which gave its name to our cruise. This spot, just about the northernmost point on the European continent, is reached from a town called Honningsvaag, where the *Sky* docked. There we were, 800 miles from the start of the Arctic ice cap, 1,600 miles north of Copenhagen (which, on my mental map, is way up there), and we were met by a likable pack of teenagers with pink-streaked blond mohawks and safety pins in their ears. *(Continued on page 166)*

(Continued on page 166)

Stockholm, with its pastel houses and cobbled streets, is a favorite stop of ships cruising in Scandinavia and the Baltic Sea.

chance to make a personal connection with someone who will see your work later and perhaps will want to interview you for an assignment. Submit a cover letter, and note your correct address and telephone number. *Always* include a return envelope and *sufficient return postage*. This is a courtesy editors expect from anyone submitting work for consideration.

Getting hired to shoot the photographs that will illustrate stories in such publications as *Life*, *Travel & Leisure*, *National Geographic*, and *American Photographer* is valuable because they will be seen by potential clients; this is part of the important process of getting known in your specialty. This may not be easy, so remember to be realistic. Magazines rarely run features on aerial photography alone; you will have to come up with a story idea that will include several aerial ideas.

After you have received any kind of editorial coverage, you'll have either tearsheets or whole magazines containing your printed work. Ask the publication for copies of the issue (and be ready to pay for them if necessary). I always order at least 100 copies of any publication my work is featured in. When especially effective pages of my work are run (as with a *Communication Arts* article cover story on my Royal Viking Line coverage), sometimes I may either request the color separations used in the printing or have reproductions made from well-printed tearsheets or page proofs.

Getting your images published in editorial layouts is an important part of self-promotion. Your published work will be seen by a large audience, and publication does not cost you any money. Here my work was published in Travel & Leisure *magazine in a series on Norway.*

SELF-PROMOTION

I never imagined that photographers themselves would become big business for other entrepreneurs. But that's what source books are all about. They advertise the work of the top photographers in publications that will benefit from showing that work. The proliferation of source books such as *American Showcase*, *The Creative Black Book*, *New York Gold*, and *The Photographer's Market*, is a strong indication of the commercial and editorial assignments available. But in this instance, since *you* place an ad, your money circulates your work to the book's audience. Because this can become expensive, you must decide if the investment is worth it. First, you must decide where your specialty fits. Next, you must find out which publications will read the source books you advertise in to make it worth the investment. For instance, if you work primarily in corporate or industrial photography but want to add a specialty in aerial work, advertise in *Corporate Showcase*; its client base will be closer to the audience you want than *The Creative Black Book*. Your work will not be overwhelmed or hidden within 100 other subject categories. A bonus from these advertisements is that you receive 1,000, 2,000, or more reprints of them *free*. In some cases, the cost of printing a four-color reprint yourself would be the major part of your total cost of buying a single ad.

ADVERTISING IN SOURCE BOOKS

- **Make sure the prospective source book reaches your target audience.**
 Different source books cater to different audiences. Find a source book *directly* representative of the audience you want to sell to.

- **Determine the cost-effectiveness of advertising in a specific publication.**
 If there are only a few potential clients for you in a particular source book, you could end up paying between $2,000 and $5,000 to reach just a few people. Direct mail on a regular basis would be a better alternative.

- **Study the publication to compare how your work will stand out in it.**
 Notice how many ads look alike, and how many have strong design and four-color printing. Study the type design used in the ads and the information included.

- **Think about having a professional design your ad.**
 If you cannot design or create an ad for the source book yourself, hire someone who can. If your ads don't work, you'll lose the money you spend for the ad.

- **If your ad design works, repeat it for future insertions.**
 Repetition is a classic advertising method. Once you create a style and design for your ads, you'll be able to reuse the design and simply update the ads with new images. Making an impression takes a long time in the media-cluttered environment of advertising.

Harvey Lloyd ASMP

310 E. 23rd Street
New York City 10010
Tel : 212-533 4498

Recent clients : Boeing, Curacao,
TWA, Young & Rubicam, Kuwait
Airways, Philadelphia, Hill
& Knowlton, etc.

Boeing ''FLIGHT SONG''
Director : Harvey Lloyd.

DIRECT MAIL

When advertising in a source book is too expensive, direct mail is often a cost-effective alternative. This approach requires the use of a mailing list. You can create one yourself with much research and file-keeping, or you can buy one from businesses that have subscriber lists of your specialty audience. At present, I use direct mail to a small list of about 150 to 250 clients. Your mailing list must be accurate: Regularly update all names and addresses.

Once you've decided on direct-mail promotion, you must think about how you will design your mailing. Recently, a friend showed me a letter she was going to send to potential direct-mail clients, which included a four-color, printed example of her photography. The letter began: "Dear Sir or Madam,". I stopped reading immediately. With today's "junk" mail, such a letter is certain to get thrown in the wastebasket. I suggested that she try my approach instead: In each of my direct-mail promotions, which I send out three or four times a year, I enclose a type 'C' color print of a recent assignment. Sometimes I sign these prints. The accompanying letter (on my own letterhead) starts with a catchy line, such as " 'I only have two hands, Harvey,' said the pilot." A couple of brief paragraphs tell the story of that shoot, and a paragraph about my specialty completes the page. While these mailings rarely produce immediate business, an associate tells me that whenever she calls new or potential clients, their reactions to my promotions are positive. The mailings do get noticed.

Follow-up is the most important part of direct-mail pieces after you send them out. Call up potential clients and make them pick the matter up again and look at it. Keep in touch with these prospective clients: They are busy and probably see many mailings. When you call, remind them of your work and the mailing you sent. Ask them if they have a shoot coming up that you can bid on or make a proposal for. If there's even a glimmer of interest, write a proposal, make an offer—get the *process* going. Be determined and motivated. The clients will more than welcome your interest and self-promotion.

Recently, while on a personal shoot and business trip to central California, I called a vice-president-cum-creative director at an agency that had just taken over a major client of mine, one that had been quiet for a year. The director knew my work and had recently commented favorably on it. I told him over the phone that I would be in the vicinity and would like to see him for lunch. When I arrived, he greeted me with enthusiasm but regretted that a sudden crisis made it impossible to have lunch together. He could only chat for five minutes. I said that I understood, and asked if I could have the schedule of his needs for the next six months. He grabbed a photocopy, saying, "This is all I have, my only copy, but you can have it." I took it, thanked him for his time, told him I would get back to him, and flew back north. Upon my return I immediately wrote a schedule of what I might do for him in the way of possible projects, and sent the outline to him by express mail the next day. When I telephoned him a day later, he was delighted to hear from me and said, "Thanks for saving me time to research all of this. We need the work done, and I will talk to our co-creative director and get back to you." I know that my follow-up gave me a strong shot at a very large account, and that I have protected my position with a very important client. Follow-up is essential. Do *more* than you think you are required to do. It pays in the end—when people are thinking of people to do the job, they will probably think of you first.

HARVEY LLOYD
A S M P

310 EAST 23RD STREET · NEW YORK CITY, NEW YORK 10010 · 212 533 4498

PHOTO REPS

I have no photo rep, and I often regret it. A good rep can help raise your fees, and increase your assignments. But the truth is that there are many excellent photographers, but not as many excellent reps. Your best rep is yourself—you know better than anyone what you want to do. But sometimes you just can't get the footwork and the paperwork done because of your schedule. This is where photo reps come in. When you seek out a rep, remember that they expect to make a good living by representing your work. You have to be very aggressive in the business to attract an excellent photo rep. Narrow specialties, such as aerial photography, are not likely to attract reps that will go all out to help your work get around. Do not try your luck with beginners, either. They are unlikely to succeed in a business where the biggest art directors do not even have the time to see well known reps.

A good rep is like a good client, and those who have them are fortunate. Nurture them, and treat them fairly. Understand their working conditions and the market at large in which they are representing you. Never resent the percentage of fees that you pay them. Work this out before you decide to contract a representation with them as business associates.

Direct mail is one of the most efficient ways to promote your work. You have total control over its presentation and design; therefore you can present your work to its best advantage.

THE ART OF NEGOTIATING

Once you've promoted yourself and gotten your work to prospective clients, you'll start getting prospective leads and assignments. People will call to interview you and to offer assignments. All of your work up to now has prepared you for these offers—and you must be able to effectively and professionally deal with all elements of the business relationship between you and your client.

In aerial work, as in other areas of photography, you must negotiate with clients to close potential deals on terms favorable to *everyone*. A fair deal benefits both you and your client. You are in business to sell your services if the price is right. The client wants to get your services for the best price. Planning the assignment, bidding on it, and budgeting must be done carefully before both of you can negotiate a mutually acceptable contract.

Preliminaries. Aerial photography often includes a number of details, such as arranging locations, scheduling people, hiring pilots and aircraft, and making reservations. The more you can handle yourself, the more of an asset you are to your client. By being able to immediately tell your client what you will be able to take care of during the assignment, the more credibility you will establish. From the initial proposal to the final delivery of work, always try to think of how you will save the client time. This may result in future assignments from the same client. I always write proposals that completely and clearly outline everything necessary for a particular job. At the outset, I inform the client of potential problems or additional expenses so that there are no surprises afterward.

A negotiation usually involves two questions: What is a mutually agreeable fee or budget for the job? What rights does the client want for promotional or advertising uses? I always put together budgets that give the client price options. I don't want to lock myself out of negotiation by submitting only one price, which the client could consider to be either too high or too low. As for advertising and promotional use, remember that you and the client are not adversaries. In the area of promotional and advertising rights, both of you have something to gain. You must consider the client's needs here, as well as your own. Don't be greedy regarding payment, but don't underestimate your value either. If you seem indecisive, the client will be uncomfortable negotiating with you or, even worse, will try to get the better deal. Ask for a fair price, but be flexible depending on the complexity and schedule of the work. Finally, be *clear in your communications* at all times during the negotiation process. Make sure both you and the client thoroughly understand a prospective assignment.

Pricing Your Work. Firsthand experience in negotiating assignments will help you gain a perspective on what to charge for your time and work. But be sure to look at the market and study the pricing of other photographers doing comparable work. Although each assignment and each client will differ, I usually give the following price options when bidding or budgeting: a low price for a simple version of the job; a price I think is fair and will enable me to accomplish the assignment well; a high price for a more complex version of the job. The client will often choose the middle option, sometimes the high one, but rarely the low one. There are some associations and publications that can help you with pricing your work, such as the American Society of Magazine

How To Help Your Agency Help You

In a series of separate interviews recently, a number of prominent Stock Agency owners and managers were asked, "What can contributing photographers do to help their agency make more money for them?"

The responses were quick, consistent, and from the photographer's viewpoint, a bit close to the bone.

—"Complete and accurate captions can double the value of your stock photos."

—"Model releases are money in the bank."

—"Adding new material can trigger a sharp increase in your sales."

—"Organizing your submissions as our agency photo files are organized will speed your material into the pipeline faster...make money sooner."

—"It pays to be as businesslike with us as you are with your own clients."

—"Work *with* us...we are equal partners, with equal responsibilities."

—"Pay attention to our shooting advice. We're in touch with the market...every day."

—"Be realistic."

—"Listen."

Top-money stock photographers, the agency people agree, know and put into practice all of the above. And while there is no magic formula for success in stock photography, these "working professionals" consistently pull ahead of the pack. "These are the kind of contributing

file, consult with your agency. They have the experience necessary to be realistic. If you are new to the agency, allow 12 months for a tentative evaluation - as much as two years for a dependable assessment. Even the best agent can't guarantee exactly how your stock will sell in the future. There are too many unpredictable variables; market trends, the popularity of your particular shooting style, hot subjects, cold streaks, big individual sales, recession, death and pestilence. Over a period of 1-2 years, these variables usually cancel each other out, but you never know for sure - they sometimes add up, in either direction.

Your agency is in the best position to know your competition. They know how many other photographers within the agency, or within the field, have material similar to yours? Does your material contain an effective percentage of the perennial favorites of stock buyers - high tech, travel scenics, family? Does your style fit the current market? (Advertising clients may be moving away from an editorial approach to a more illustrative style.) "A big downfall of many stock photographers," agents say, "is in not analyzing their own work realistically. They seem to lack an overall perspective of the field."

Let your agent help. Don't be defensive. Listen and learn; it can influence how successfully you shoot stock in the future. You should of course analyze your stock *before* choosing an agency, but it's an on-going process. Set goals. If they are realistic, your energy can be spent in meeting them, not in quibbling with the agency.

The Relationship: On-going relationships, for better or worse, are the direct result of attitudes. If both you and your agency acknowledge that

interviewed, a contributing photographer is selected to act as a "Photographer Liason" each year. He or she is part safety-valve/part ombundsman, listening when photographers let-off-steam and passing along grievances, minus some of the emotion, to the agent. Informal mediation is accomplished, doors are left open, and a climate for creative ideas is produced.

Professionalism: "Some photographers just wouldn't stay in business" one agency complains, "if they treated their clients the way they treat us. They are so casual and slipshod. We have experienced more than one who will drop off a shopping bag of pictures with the instructions, 'Here, you can caption these, it's too much drudge work for me.' The real pros, and the real money makers, follow-through. Agency staff time spent redoing your work benefits no one. Listen to our guidelines, prepare your material well, and we'll go out and make money for you."

Editing and Organizing: An intelligent edit, organized by categories similar to the agency's system, will simplify the agents job and get your pictures in the market faster. "The less energy we have to put into organizing a chaotic submission, the more time we can spend selling for you" is the way one agency expressed it. Also, it's preferable to send new material that has in-depth coverage of each subject. Although single shots that are excellent will always sell, a mixed bag of subjects has less value to an agency file than good coverage of one topic.

Captioning: "Photographers who have not worked in the selling end of the business don't understand the value of captions. A full and accurate caption can often be the deciding factor in selling a picture competing with an equally good shot that is vaguely captioned."

There is no question about the tedium involved, but agents know from experience that you can effectively increase your sales by having thorough captions. Even if agency personnel are available to translate your scribbled notes, (and you're willing to pay), they can't be as accurate as the photographer who was on location. Don't be a one-word caption writer, trusting to your memory for details when and if the picture is sold. There may not be time to contact you, especially if you are on assignment and the potential client has a tight deadline. And describing a picture on the telephone can be surprisingly

confusing. In captioning, follow the old journalism guide of who, what, where, when and why, for each picture. Remember the old axiom, "The more you tell, the more we sell".

Model Releases: "Get them, file them, mark "MR" on the mount, but above all, be truthful", the agents agreed. "Model releases are like money in the bank...I don't understand how photographers can neglect getting them." Each agency has their own system for recording and confirming the existence of model releases. The ideal, from an agency viewpoint, is to submit a Xerox of the release with the picture.

Fresh Material: It is not uncommon for photographers to run hot and cold—to start by submitting an exciting selection of their work, with promises of more to come. Then a butterfly passes, the photographer runs, and the agency waits. After a couple of sales statements, the photographer wonders why the volume is lower than he expected.

Stock photography, over the long haul, is a "numbers" game. The larger the number of photographs on file, the larger the figures in your sales statements. Part of the photographer's responsibility, in the agency/photographer partnership, is to keep supplying fresh material. A steady flow, however, is preferable to deluging your agency with a year's work at one time. (Picture the poor agent when 10 of his photographers return from Christmas vacation having each edited 5,000 pictures for him.)

It helps sales if you keep in touch with the agency, picking out needed subjects from "want lists" and request guidelines. Most agencies supply want-lists periodically. Talk with your agent. Ask what sells, what doesn't and then, FOLLOW UP. Agents complain that there is often more talk than follow-up, but they insist that if you supply photographs the agency says they need, your odds of selling are way up.

Why Isn't My Work Selling: Ask that question of any agent and the answer might well be, "All of the above". The main thing really is how you ask the question. If you think your sales are off, raise the issue in a positive way. Don't go on the attack (or grumble and blame). "Talk to us and we may be able to analyze the problem. After all, you should assume that we *want* to sell your work since it benefits the agency as much as it does the photographer."

The American Society of Magazine Photographers (ASMP) publishes the Stock Photography Handbook, *an informative guide to pricing your work, negotiating contracts with stock agencies, as well as many other business concerns.*

ASMP
Stock
Photography
Handbook

A Compilation by the American Society of Magazine Photographers

Photographers (ASMP), Advertising Photographers of America (APA), or Professional Photographers of America (PPA). Use these guidelines only as an example. The quality of your work or the complexity of an assignment may justify a higher fee.

Also ask yourself what the job itself will entail: Will it give you a great deal of pleasure? Will it enable you to explore new creative territory? Will it enhance your stock sales? I have turned down some high-paying jobs (not many) because other assignments seemed more attractive to me for personal rather than monetary reasons. I wanted to take the pictures that the assignment offered.

Bidding. I do not like to bid on jobs when I think a number of other photographers will also be bidding. My specialty is unique. If a client wants what I have to sell, we can negotiate a fair price. On the other hand, I *will* bid among other photographers if the request seems legitimate and I am told who else is bidding with me. During the bidding process, I rarely specify day rates, preferring to make an overall budget for the entire job. The bottom line on any bid is my fee plus expenses. How I divide this figure rarely interests the client, as long as he or she agrees with the final price and my proposal. As such, I always budget for economy-class airfare and shared hotel accommodations. I also limit out-of-pocket expenses. In this way, my own fee increases, and I also have more money to use for production expenses—aircraft, film, location expenses—all of which are good in the end for the client, the project, and future assignments. (For a detailed discussion of bidding and an example of the business forms used in budgeting your work, read through some of the publications mentioned above.)

When bidding, as when doing general business, you should formulate a plan before talking to your client or writing a proposal. To make your bid as complete and realistic as possible, ask yourself the following questions:

- Am I the sole supplier of this assignment?

- If I am bidding against others, do I know them?

- Is it a legitimate bid, or is my work being used as a "decoy" bid for someone else?

- What purchase rights are being asked for in the bid, and do they meet my needs as well as the client's?

- Is there unusual risk in the assignment? If so, how will this affect my bidding price?

- Would I be better off giving a day rate or making an entire budget?

- Does my assignment budget pay well enough for me to include extra weather days?

- If an all-rights deal or a buyout is demanded, how much do I want for these rights?

- Have I questioned the client sufficiently and gotten all the information necessary to make an informed and competitive bid?

Once you've asked yourself these questions, determine your prices and proposed bid. I write down my proposal and bidding strategy one day and think about it overnight if time permits. Then I look at it again, modify it if necessary, and send it off. I *never* send off a bid or proposal in the heat of the excitement of getting a new job. I also try to observe the rule of never giving a price quote on the telephone without first asking to think about it and calling back. Of course, I always follow-up and keep in constant touch with the client until a decision is made. And, if it happens that I lose a job, I'm always gracious about it, keeping the door open for future assignments. Business success comes from delivering a superior service, pricing according to the market, and maintaining excellent relations with clients and customers.

Preparing a Budget

When you and your client have successfully negotiated a contract bid and determined the assignment preliminaries, you must prepare a realistic budget of the work to be done. Budgets should reflect all expenses you will incur on the shoot, but should also include padding for unforeseen expenses, extra equipment needs, and any billing charges you incur during off-location work that is still a part of the assignment. The following is a list of important points to consider when preparing your budget.

Production Time. Determine if your assignment will necessitate preproduction time, used for setting up details for particularly involved shoots, and whether you will bill the client directly for this. While you may not be able to do so, you must know if your agreed-upon fee covers this extra time. The same applies to any postproduction time and work, especially editing of your slides.

Weather Days. You will almost always need to budget extra days in case of bad weather conditions. The day you are scheduled to shoot may be completely unsuitable for work. Consult with your client to determine a fair estimate of extra days to work into your budget and schedule.

Special Equipment. If your assignment requires the use of a gyro-stabilizer, land or marine radio use, special lenses or camera bodies, or camera-maintenance charges, some of these can be included in the budget estimate. Be specific in your billing—when you budget for equipment checks, list the various services used, such as collimating for lens alignment, meter checks, and lens-sharpness testing. Your client may want you to pay for some of these charges yourself. Determine fairly whether you can accommodate these or not.

Aircraft Estimates. When preparing your budget, you should overestimate fees for any helicopters and light aircraft rented out of the United States. These charges can run as high as twice the cost of prices in the U.S. Keep in mind that you must pay for the travel time to and from the aircraft base. This time is usually charged at the same rate as shooting flight time, although at times you can negotiate a lower price when an assignment requires a great deal of shooting time.

Film. Budget for *plenty* of film and processing. Do not underestimate this essential item. You must bracket when shooting aerials, and you should always be ready to take more images than needed of any location. I usually bill film at a price of several dollars higher than cost to cover such expenses as sleeving, film handling, and editing.

Insurance and Liability. Make certain you and the client determine all liability and insurance coverage costs. These will vary from assignment to assignment; be sure that you have all insurance forms confirmed before you go on location.

Assistant's Wages/Fees. This is an important part of any budget, and requires a thorough listing of all necessary salary and other important fees for the job. It is very advisable to maintain an up-to-date log of these extra fees.

STOCK PHOTOGRAPHY

Whether or not you obtain a specific number of aerial assignments, any photographs you take can earn substantial extra income as stock images. These are photographs, aerial or general subject matter, that you can distribute to stock agencies for year-round use. Sales of one image can reward you with a single high payment or a steady stream of royalties for multiple use. At the outset, you must be aware of two important considerations when using your imagery for stock: First, you must start with a fairly high number of images to submit; most stock houses require a minimum of 1,500 to 3,000 slides for a beginning file. You must also find a stock agency that closely meets your needs as an aerial photographer.

Building a Stock Library. To accumulate a file of images for stock-sale use, start looking at what you have already. How many photographs can you send to prospective stock houses? Make dupes of the ones you think are usable and those you have that are not already assigned out to a client.

To accumulate more stock images, make separate stock assignments for yourself by scheduling extra time during every shoot. I always let my clients know that I do stock photography. After first fulfilling the client's needs, I edit and select a number of the best from

USING STOCK SUCCESSFULLY

A good stock house is a great resource for the working photographer. To find a stock agency that fits your needs, follow some of the guidelines listed here before you start your search:

- ***Start with a sizable number of images.***
 Most agencies require a minimum number of slides before they will even look at your work. This number can range from 1,000 to 3,000—any of which they must approve to keep the file. Depending on the stock house, you may have to also submit specific subject matter. Call the stock agency first and find out exactly what it requires.

- ***Contact a number of stock agencies.***
 Shop around; talk to a number of houses. Tell them what you do. Ask them how and in what form they want to see your work on a first-delivery basis.

- ***Visit any agency you are considering.***
 See how the premises are organized, the size of its files and distribution systems, and how many employees are handling the work. Is the staff busy and friendly? Are the operations business-like and professional?

- ***Determine where your stock fits in.***
 Do you know what stock categories your work falls into? Many stock houses now print catalogs that are a good representation of the photographers they sell for. Look at the work in the catalogs, and compare it with your own. The leading stock agencies are competitive, selective, and, like the best reps, have more talent coming to them than they can handle. Submit only your very best work.

every shoot to send to my agency. The staff usually makes a final selection. When on vacation or journeying for pleasure, I always shoot for stock. Any photo opportunity is a potential stock royalty.

Finding a Stock Agency. There are innumerable stock agencies around the country and worldwide. When you sell your work to one, you are selling the rights to reproduction of your images—not the images themselves. In most stock contracts, the term "lease of rights" is used rather than "purchase of rights." Keep this important distinction in mind when seeking a stock agency to distribute your images.

An excellent reference to all aspects of stock photography is the American Society of Magazine Photographers's (ASMP) *Stock Photography Handbook*. This volume, updated frequently, will show you how to locate a stock agency, determine whether you should distribute your own work, price your work, or negotiate a price contract with an agency. It also gives examples of the necessary forms and permission contracts you must have when using stock. Other helpful publications are the Picture Agency Council of America's (PACA) *Stock Directory*, and the catalog for the American Society of Picture Professionals (ASPP). This directory lists researchers, editors, photographers, and other members who can provide valuable guidelines. (For further information on these publications, see the Appendix on page 141.)

When you contact a stock agency, submit a proposal as well as sample slides. If you agree to work together, the agency will give you detailed outlines of how to send your stock work as you shoot it. Stock sales start slow but once you and an agency establish a steady working relationship, it can lead to consistent rewards. The field is competitive. Your work must have a solid, defined market for the best results. Know your stock house thoroughly. It will guide you as to the specific images they need that will sell. With that information, you can go out and take the pictures for those markets.

Distribution of Stock. I distribute my stock through The Stock Market, an excellent agency in New York that I have a longstanding relationship with. The people there really care about my work and they are very honest when it comes to telling me exactly what I need to do (or not do) when getting stock images for them. Its filing system is excellent: It is neat, organized, and has an international distribution network. You might prefer to distribute your own stock work. Be aware that it is hard, takes a good amount of time, and often you will reply to requests for your work that may not lead to worthwhile good sales. A good stock house frees a photographer to do what he or she does best: take photographs. When you are doing the stock paperwork yourself, you have less time for taking photographs.

Stock agencies are not a get-rich-quick scheme. You must devote a great deal of effort and time. Also remember that you must assure any stock house you work with that you will *continue* to supply stock. Agencies need to know that you will be serious about going out on new assignments, that you are willing to take direction, and that you will be open to a longstanding commitment with them. You must be patient. The rewards, while often substantial, can take years to come, but it is a sector of photography that can give you security in the long run. You can make $25,000 to $40,000 a year in accumulated stock work after a period of years. Some photographers make much more.

Stock photography can be a lucrative way to expand the use of your images. On every assignment I always take time to photograph images, such as these, that I will add to my stock file.

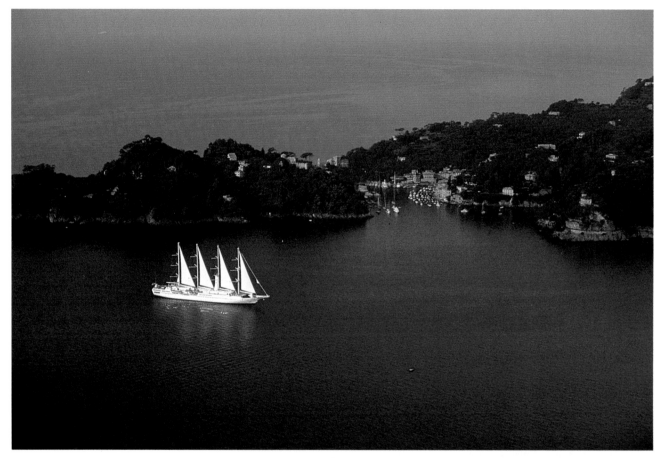

AERIAL PHOTOGRAPHY

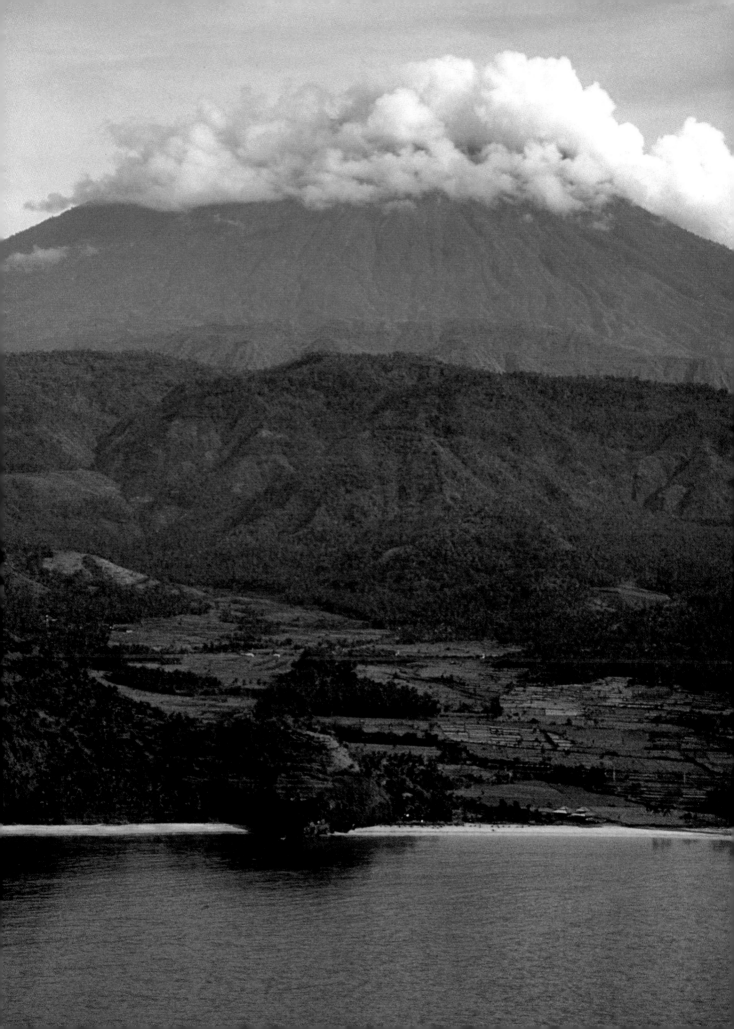

Personal property is protected by copyright and you must obtain a property release in order to photograph it. Before you photograph a subject on assignment, make sure to obtain the proper releases and copyright permissions from the appropriate sources.

Releases and Copyrights. If you take closeup photographs of someone's house, yacht, or other personal property, you cannot use them for commercial reproduction (stock or otherwise) without a property release. This is much like a model release. All releases must be obtained from the property owner. National parks, too, have a policy against "commercial" use of photographs taken of them or within their boundaries, even though they are designated "public" lands. (Editorial use falls into another category, with its own release regulations.) It is important that you *always* know the release regulations of any subject or property you photograph for assigned or stock purposes.

The copyright law gives photographers absolute ownership of their photographs (except under a special provision called "Work Made for Hire"). Carefully study all the copyright laws that apply to your work. The ASMP handbooks on this subject will give you all the information you need. You can also obtain information directly from the Office of Copyright in Washington, D.C. I work by the principle that I absolutely own my copyright unless I desire to negotiate any part, or all of it, for sale to another individual or company.

When working with clients on assignments, my aim is to give them what they need and pay for, and to retain copyright and stock rights for myself. The photographs I submit to my stock house are always stamped or have written on them restrictions against leasing them to competitors in the same field as the original client. In addition, I also wait about a year after a client shoot before allowing that work to enter the files of a prospective stock house. Of course, if the work is for my personal use or if it is for a client who has not bought exclusive rights or paid for the delay time, I don't hesitate to send the work out for stock. Magazines usually want first-publication rights for contract, a request I carefully observe when dealing with them.

MODEL RELEASE

For and in consideration of my engagement as a model by ..., hereafter referred to as the photographer, on terms or fee hereinafter stated, I hereby give the photographer, his legal representatives and assigns, those for whom the photographer is acting, and those acting with his permission, or his employees, the right and permission to copyright and or use, reuse and/or publish, and republish photographic pictures or portraits of me, or in which I may be distorted in character, or form, in conjunction with my own or a fictitious name, on reproductions thereof in color, or black and white made through any media by the photographer at his studio or elsewhere, for any purpose whatsoever; including the use of any printed matter in conjunction therewith.

I hereby waive any right to inspect or approve the finished photograph or advertising copy or printed matter that may be used in conjunction therewith or to the eventual use that it might be applied.

I hereby release, discharge and agree to save harmless the photographer, his representatives, assigns, employees or any person or persons, corporation or corporations, acting under his permission or authority, or any person, persons, corporation or corporations, for whom he might be acting, including any firm publishing and or distributing the finished product, in whole or in part, from and against any liability as a result of any distortion, blurring, or alteration, optical illusion, or use in composite form, either intentionally or otherwise, that may occur or be produced in the taking, processing or reproduction of the finished product, its publication or distribution of the same, even should the same subject me to ridicule, scandal, reproach, scorn or indignity.

I hereby warrant that I am $\frac{\text{under}}{\text{over}}$ twenty one years of age, and competent to contract in my own name in so far as the above is concerned.

I am to be compensated as follows:

I have read the foregoing release, authorization and agreement, before affixing my signature below, and warrant that I fully understand the contents thereof.

DATED _____

_____ L.S.
WITNESS

ADDRESS

_____ L.S.
NAME

ADDRESS

I hereby certify that I am the parent and/or guardian of
an infant under the age of twenty one years, and in consideration of value received, the receipt of which is hereby acknowledged, I hereby consent that any photographs which has been, or are about to be taken by the photographer, may be used by him for the purposes set forth in original release hereinabove, signed by the infant model, with the same force and effect as if executed by me.

_____ L.S.
PARENT OR GUARDIAN

ADDRESS

Photographer: 1 - Fill in terms of employment.
 2 - Strike out words that do not apply.

EPILOGUE

The Royal Viking *Star* is due to pass under New York's Verrazano-Narrows Bridge at dawn, which is approximately 6 A.M. on this early September day. Forty-five minutes before, I contact one of *Star's* officers via Marine Operator and radio-phone. He assures me that the ship is on time. We board the chopper. I gaffer-tape my seat-belt buckle. The pilot is affable and experienced.

Behind the helipad, lights on the Queensborough Bridge twinkle through the early morning mist. The sky is dusky orange. Our craft rises off the pier, and a minute later we wallop the air over the Brooklyn Bridge. To my right, through the open door, the skyline of Manhattan is suffused with pink and gold. The air is absolutely still and warm.

We circle out over the Verrazano-Narrows Bridge and sight the *Star*. The white ship sails the calm and glowing bay, framed by the distant pylons and arches of the bridge. A pale red sun rises from the mist. We wheel around as the *Star*, half-hidden in the soft light, slides by the Statue of Liberty. I make images of the statue, the tip of Manhattan island, the towers of the World Trade Center rising 100 storeys into a sky that is now a deep mauve. Circling again, I see long shafts of light stream through the city awakening below.

The light changes. The sky turns saffron. We swoop in closer, and I frame the orange ball of the sun against the bridge and the mast of the *Star*. The ship sails past the two huge towers. Now the sun winks brightly. Golden light dances on the river, silhouetting the ship as it passes the spire of the Empire State Building. I catch my breath. It is only 6:40 A.M.! A dawn of dawns.

In making aerial photographs there is no substitute for experience. The earth and the sky, viewed from the air, are more beautiful than you can imagine. Each time you fly, you learn; about the aircraft, its pilot, and yourself. You learn to work in tight quarters, keep track of your gear, communicate with the pilot to vector you over the subject in good light, at precise angles, as you calmly and carefully compose eloquent images. Soon, you become accustomed to the skies, feel at home.

Tools are only servants; cameras and lenses, propellers, rotors, and engines just help to give life to our dreams and visions as aerialists. When, once again, we soar aloft over the land or sea, wheel and hover in the air, and gently press the shutter, and then capture it . . . we are made more human.

We can bestow the gift without price for *all* to share, our yearnings and our passions made visible; unlike Icarus, shorn of his wings and plummeting into the sea, we are given fresh wings for all time. We fly and photograph because, earthbound as we are, our spirits yearn to be free. *"Yo lo vi,"* said Goya, "I saw it." Like him, I have been in the right place at the right time. At the Panama Canal or Tahiti, Bali, Hong Kong, Rio or Istanbul, I have been held suspended by inexorable laws of time, space, and gravity. Aircraft, ship, landscape, pilots, locations, cameras, film, customs, visas, language—all must come together in the end—you must be ready and able to make your visions tangible.

The art and craft of aerial photography is a grand choreography. Craft, yes; precision and danger, yes. Poised, dazzled, enraptured, we must still remain conscious and consider how to make these dreams from the air come true, and bring them down to earth.

Early morning light suffuses New York's Statue of Liberty and World Trade Center, as seen on this page and the overleaf.

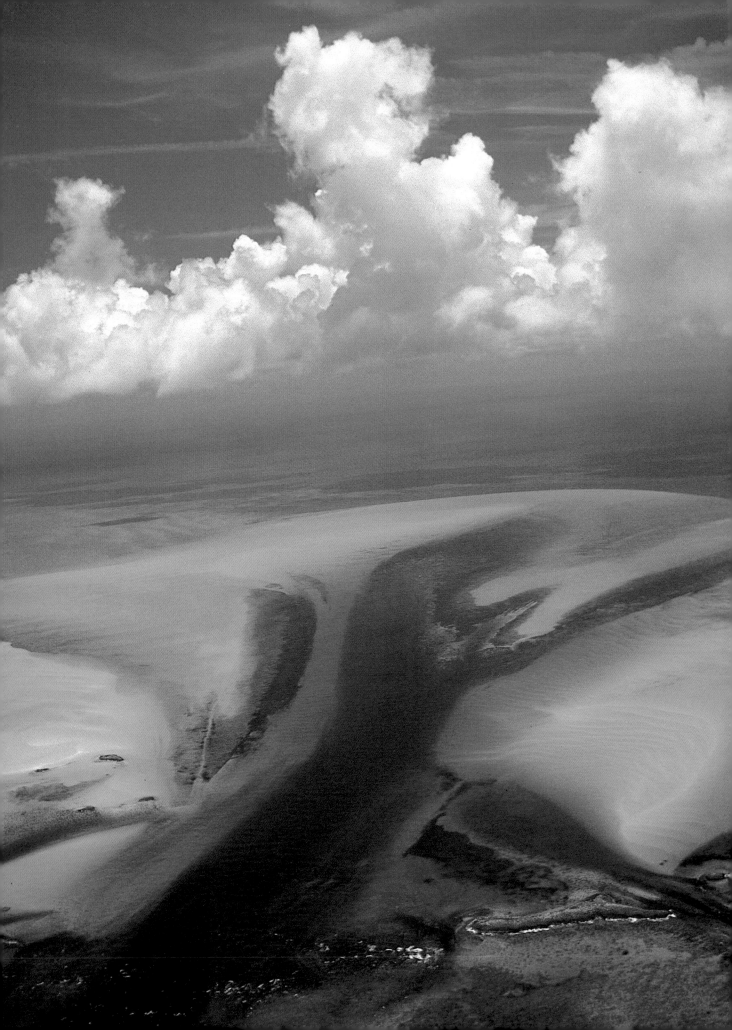

APPENDIX

The following is a list of organizations, publications, and companies that will supply important information on resources and products for aerial photography.

Advertising Photographers of America (APA)
27 West 20th Street
New York, NY 10011
212-807-0399

American Society of Magazine Photographers (ASMP)
799 Broadway, Suite 204
New York, NY 10003
212-614-9644

American Showcase
724 Fifth Avenue
New York, NY 10019
212-245-0981

The Creative Black Book
115 Fifth Avenue
New York, NY 10003
212-254-1330

Flying Magazine
1515 Broadway
New York, NY 10036
212-719-6000

Ken-Labs *(gyro-stabilizers)*
29 Plains Road
Essex, CT 06426

Ken Hansen Photographics
920 Broadway
New York, NY 10010
212-673-7536

Photo District News
49 East 21 Street
New York, NY 10010
212-677-8418

PhotoSource International
Pine Lake Farm
Osceola, WI 54020

Plane and Pilot Magazine
1600 Ventura Boulevard
Suite 800
Encino, CA 91436

Professional Camera Repair
37 West 47th Street
New York, NY 10036

Professional Photographers of America (PPA)
1090 Executive Way
Des Plaines, IL 60018
312-299-8161
(publishers of
Professional Photographer
magazine)

The Stock Market
1181 Broadway
New York, NY 10001
212-684-7878

INDEX